WET-IN-WET WATERCOLOR

The Complete Guide to an Essential Watercolor Technique

WET-INTO-WET WATERCOLOR

The Complete Guide to an Essential Watercolor Technique

Carl SPECKMANN

Watson-Guptill Publications
NEW YORK

With my love and gratitude to our Creator, for sharing with us the creative spirit; and to my wonderful family and friends, especially my husband, Rick, who has encouraged and supported me in my artistic endeavors from the very beginning, my children, Katie and Ben, and my parents, Stan and Joanne Johnson.

Gail Speckmann has won numerous awards for her watercolor paintings in juried exhibitions. She is a signature member of Watercolor West. Gail teaches painting workshops in the U.S. and Canada and has led several painitng/photography tours in Europe and the United States.

Note: All paintings reproduced in this volume are by the author and are painted with water-based paints on paper.

Title Page:
Reflected Glory (detail)

Copyright © 1995 by Gail Speckmann

First published in 1995 in the United States by Watson-Guptill Publications, a division of VNU Business Media, Inc., 770 Broadway, New York, NY 10003. www.watsonguptill.com

Library of Congress Cataloging-in-Publication Data

Speckmann, Gail.
 Wet-into-wet watercolor : the complete guide to an essential
watercolor technique / Gail Speckmann
 p. cm.
 Includes index.
 ISBN (hardcover) 0-8230-5715-1 : $29.95
 1. Watercolor painting—Technique. I. Title.
ND2420:S64 1995
751.42'2—dc20 94-46212
 CIP

ISBN (paperback) 0-8230-5714-3

Manufactured in Hong Kong

First paperback printing, 2001

2 3 4 5 6 7 8 9 / 09 08 07 06 05 04 03 02

Senior Editor: Candace Raney
Associate Editor: Dale Ramsey
Designer: Jay Anning
Production Manager: Ellen Greene

Acknowledgments

I acknowledge, with gratitude, the art instructors and teachers of watercolor who have come into my life, through word and action. I especially wish to recognize Virginia Adams and Judith Blain, my early teachers in watercolor, who set me on the pursuit of this medium. My thanks to all who have shared their knowledge with me. I strive to pass the favor on, attempting to give freely of what I have learned and experienced.

Because I believe that the wet-into-wet process expresses the unique character of the materials, I sought help from art materials suppliers to explore the variety of products available. I am very grateful for the generous help that I received from the following companies: Binney & Smith (Liquitex); Canson-Talens (Arches, Rembrandt); Crescent Cardboard Company; Savoir-Faire (Isabey, Lanaquarelle, Lascaux, Sennelier); Creative Art Products Company; Silver Brush Limited; Daler Rowney, U.S.A.; Daniel Smith, Inc.; Dick Blick Art Materials; H.K. Holbein, Inc.; Martin/F. Weber Company (Whatman and Permalba); Strathmore; St. Cuthbert's Paper Mill (T.H. Saunders Papers); Teltex International Corporation (Fabriano); Twinrocker Handmade Paper; and Winsor & Newton.

Special thanks go to Dierdra Silver and Lee Nelson (Silver Brush Limited); Peter and Tim Hopper (H.K. Holbein, Inc.); Margo Christenson (Martin/F. Weber Company); Lynn Pearl and Wendell Upchurch (Winsor & Newton); Katherine Clark (Twinrocker Handmade Paper); and Pierre Guidetti and Stacy King (Savoir-Faire); they all were especially generous with information and materials.

A word of appreciation also goes to my family and friends for their help while I worked on this book. Thanks also to the collectors of my paintings through the years for their support of my artistic career. I am grateful to artist and author Doug Lew for his encouragement in my writing of this book and helping me to understand how to photograph my work. Thanks to Candace Raney at Watson-Guptill Publications for encouraging me to write this book, and to Dale Ramsey for his excellent job of editing. I thank Jay Anning for his graceful design, and Ellen Greene for superbly managing the production of the book. Writing *Wet-into-Wet Watercolor* has been an enjoyable and rewarding journey.

CONTENTS

1 A Painting Philosophy

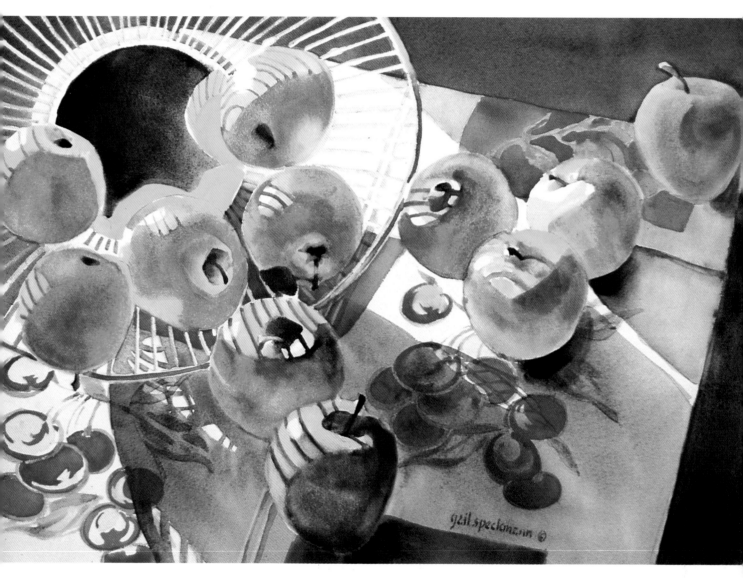

APPLES OF GOLD
14 x 21"

I am always intrigued at how paintings that are created wet-into-wet retain the look of being wet and freshly painted. Once they are framed with their shiny glass covering, the wet appearance is complemented and accentuated. The still-wet look derives from the technique, from allowing paint to express itself on a wet surface and respond the way it does naturally. The wet-into-wet process can be worked in a multitude of ways in order to express the artist's vision, but there is always a respect for the natural properties of the wet pigment on the wet surface and a pleasure in the surprising results. Working wet-into-wet involves a fascination with the paint, the paper, and the brushstrokes, as much as with the subject being conveyed. The pleasures of painting wet-into-wet are as available to the beginner as to the seasoned painter. I hope this book will encourage painters at all levels to increase their painting vocabulary by exploring the many possibilities offered by painting wet-into-wet.

FINDING A CREATIVE HARMONY

In the learning process one must be willing to set aside rigid expectations and deal with what is actually occurring: "This is not what I expected, but it is interesting. Let's see where it leads me." As with parental expectations of children, one must treat each painting as unique—work with what is happening and pull the best from it—and not be disappointed if it does not entirely fit your initial image. Often the most creative and satisfying painting comes from not knowing exactly what is going to happen. Armed with enough knowledge and skill to ride the crest of an experience which is not completely under your control, the challenge comes in striving for a discipline in a technique that by its very nature is undisciplined. The more familiar you become with the materials and the reactions of one to another, the more in harmony become your expectations and the actual results.

My philosophy is that if you learn to put your energy into the approach that calls to you, you will be energized and be able to do your best work. When you force yourself into a direction that is unnatural for you, you are less likely to succeed. If you are drawn to the freedom and "juiciness" of the wet-into-wet look, it may be calling to you. Although the techniques may at first feel strange, if you can allow yourself to relax and explore, you will start to feel the joy of the process.

I once asked an artist who was doing a detailed pen and ink drawing about what she was feeling while working. She replied, "Oh, I just get caught up in the rhythm of the motion and the variation of the angles. The drawing almost creates itself." I was surprised. That is exactly how I feel when I paint. We had both found where our natural inclinations and interests lie. It is of utmost importance to discover this and then develop your artistic abilities in harmony with it.

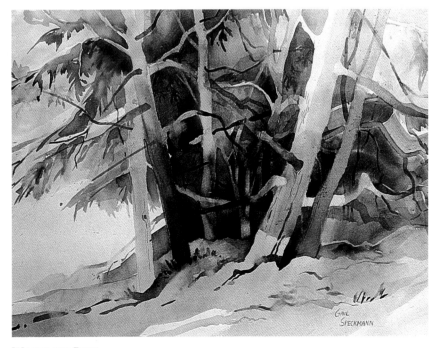

WOODLAND PINES
14 x 21"

CAPTURING THE ELUSIVE MOMENT

One of the joys and challenges of art is the capturing of a moment in time. When painting wet-into-wet this is also true of the process itself, for the flow of the paint and the mark of the brush record a moment in time. The vitality that went into the painting is mirrored back to the viewer. It is to the artist's advantage to make full use of the energy of the process to express the forms and textures that are natural to the medium. What I call *integrity* is apparent in a painting when it utilizes the unique characteristics of the water and the paint to most fully express the theme of that work.

Particularly when working on an entirely wet sheet of paper, it is important to respect and preserve the rhythm and flow of those images which you create as you move from looser to more defined shapes (as the paper gradually dries). Often the best finished work results from judiciously reinforcing edges while respecting the basic structure of the initial wet stages. To go back to work on a painting, superimposing unrelated imagery and inharmonious strokes (especially without rewetting) can be jarring and detract from the beauty of wet-into-wet passages.

Often I am asked by people, "Do you have to be in the mood to paint?" To which I reply, "I walk into my studio and I get in the mood!" The inspiration comes from the process itself. If I am not working in a particular direction at the moment, I may look through my photographic files for something that triggers my enthusiasm. More often than not, though, the real excitement comes when I get involved in the actual painting and the dialogue begins between the medium and me.

Planning

It is helpful to begin with a basic idea about what has inspired you to paint a certain subject. It could be one of many aspects: a special lighting, a rhythmic pattern, an atmospheric condition. A painting is not so much a record of things, but of moments, emotional responses, and harmonies. Cut to the heart of that which has drawn a response from

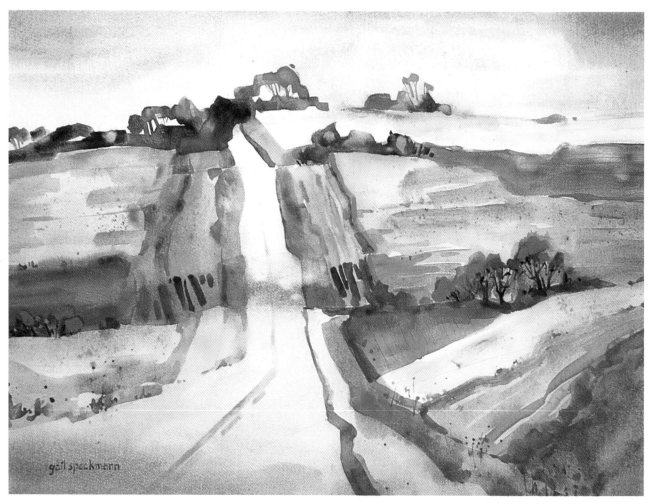

THE OPEN ROAD
21 x 29"

Ideally, a painting should be compelling both at a distance—with strong, readable shapes and design—and at close range—with interesting, subtle textures, glazes, and details of brushwork.

you and build on that. Whatever has inspired you to paint should help dictate many of the choices to follow—type of approach, materials used, scale, and so on.

Plan first; then submerge yourself in the process. Having found the theme of the painting and the design, you can do quick color studies to discover and eliminate areas of uncertainty in your conception. Play with the design elements, rearrange parts, and try out textural patterns.

Make sure that all the materials you will need have been laid out before starting the painting, because once the painting process begins, you want to be fully engaged in it. You do not want the flow of the process interrupted by avoidable difficulties, like running out of pigment. I always have my plan subconsciously with me, but while I am painting I want to be fully immersed in what is happening on the paper.

Learning

Again, things will not go exactly as planned—this I can promise you. The good news is that results often may be better than you envisioned. If things head in the other direction, do not panic. There are often ways you can work through things that appear to be mistakes. Work is more correctable than one might think. Often, when I am partly through a painting, I think to myself, "How am I going to pull this together?" Forging ahead, I usually succeed.

When I have a painting that does not succeed, I use that paper for experimentation, trying out brushstrokes or glazes. Nothing is truly wasted then. Also, if I end up with too much paint that I cannot save, then I use that to play around with on my scrap paper. We can learn much from the free explorations we do with extra paper and paint.

Do not be afraid to learn from others. The spirit of openness that I have seen among artists benefits us all on our common journey. We don't create in a vacuum, totally from within ourselves. The advancement of art is a collaboration, even when we may feel it to be a solitary pursuit: we further the creativity of artists who are our peers and who have gone before us.

Study the work of great artists to learn what has held up over time. Go to galleries and exhibits. Approach work with a detective's attitude in searching out parts which inspire you. Learn from nature. When you are moved by the beauty or power of a scene, analyze the part that attracts you. Think about how you could incorporate it into your own work.

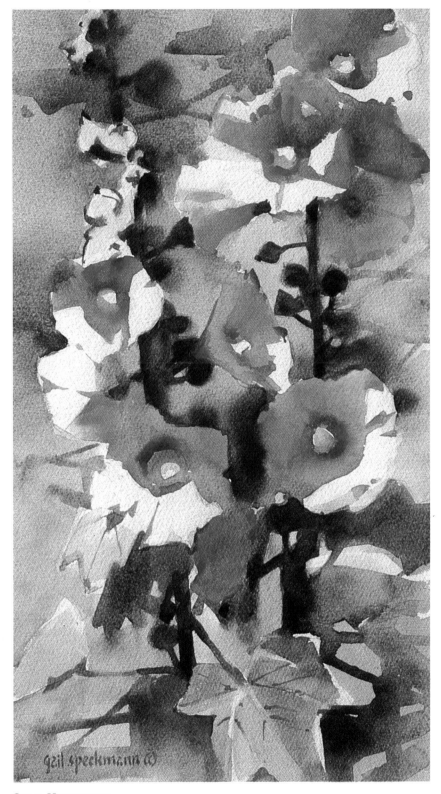

CORAL HOLLYHOCKS
21 x 13"

2 *Materials*

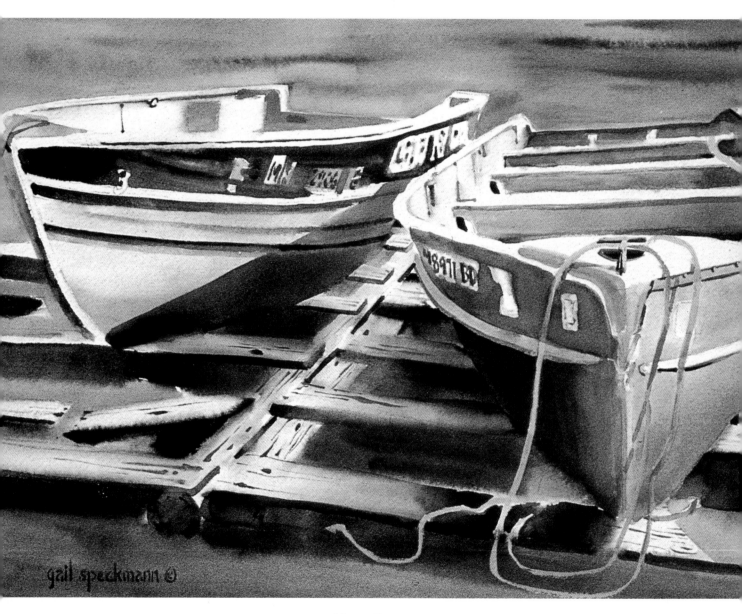

MARINE DYNAMICS
15 x 20"

It is difficult, if not impossible, to be successfully creative without knowledge of the basics—knowing what are the capabilities of your tools and materials. We artists are continually responding to creative possibilities that our materials offer to us. Only by knowing the materials intimately can the full range of expression be set free. As an artist, I am like an orchestra conductor. I cannot expect an oboe to sound like a violin, but I should expect it to do everything an oboe can do. So it is with our materials. I cannot expect them to yield results untrue to their natures, but I should explore every possibility within their natures. We owe a debt of gratitude to those who carefully and with integrity grind our pigments, assemble our brushes, and form our papers; they ensure the quality of materials that is so crucial to achieving good results in our work.

PAINTS AND PIGMENTS

The paints that I use create a very personal palette for me. I have tried paints from several different manufacturers and have selected my personal favorites. In general, the more expensive, top-quality products are worth the expense. They are more concentrated and, thus, go further, helping to offset the price difference. Also, I have found it helpful to know that different watercolor manufacturers have different philosophies, which can influence the properties of their whole line of colors.

It has often been suggested that an artist begin with a warm and a cool pigment of the three primary colors red, yellow, and blue. This is excellent advice. It is best to start out with a few important colors and learn to know them well. Gradually, you can add to the number of colors if you wish. Pay particular attention to any voids which you may be feeling in your color repertoire and attempt to work with a new choice in that color range.

Having said this, I have to confess that I try to limit myself to forty paints, the number held by two John Pike palettes, which I lay side by side, creating a complete wheel of colors. I delight in the variety of pigments available, both for their color range and their special properties. Some of the pigments that I use may be called (rather derisively by some) "convenience" colors. This often

means that these particular shades could be closely approximated by mixing together two or more pigments. I have chosen to include them in my palette either because I like the particular textural or handling quality of specific pigments, or because they are colors that I like to work with frequently. I appreciate their ready and consistent availability when I am in the heat of painting and do not want to take the time to mix some up.

I consider the permanence of the pigments that I choose. There are books written on this subject which can be helpful. I also believe that the manufacturers' guidelines are significant, for they have worked with their specific formulas over time.

As I mentioned above, the palettes I use are two John Pike palettes. I like the size of the wells and the small lip on each, which helps to dam the color but also allows you to easily coax paint over it to allow for mixing of pigment on the palette. A lid snaps on tightly for storage, allowing the pigment to stay fairly moist. Be aware of the potential for mold growth, however, if color is stored too long, particularly in a warm area.

Because I often like to mix small pools of color, I have discovered that if I take the divided lid of the Betty Denton palette (by Martin F. Weber Co.) and set it into the open space of

my John Pike palette, then I have a very workable arrangement for my purposes. I also like the design of the entire Betty Denton palette for use with smaller brushes. (I do find it too confining for my larger work.)

Watercolor paints are made up of ground pigment which is mixed with a binder of gum arabic. The gum arabic acts to secure the pigment to the paper. It suspends the pigment evenly in its undiluted state and continues to do so when diluted thoroughly with varying amounts of water. Other ingredients may include anti-bacterial and anti-fungal agents, inert material, drying agents, and oxgall.

What happens when the paint goes on a wet paper surface presents us with an exciting variety of results. The origin of each specific pigment greatly affects its behavior as it is laid down on a wet paper surface, so it is very helpful to know about their sources.

Inorganic, or Earth, Pigments

These are the pigments whose usage goes farthest back in time, to prehistoric cave paintings. They are the ochres, siennas, and umbers—available to us in their native and burnt (calcined) forms. Dense, opaque, and nonfading, they have the appearance of weight and substance.

When thinned with water, the pigment will break apart and become more transparent. Some very intriguing granulation can occur, particularly with the umbers, but it can be very challenging to lay down these colors evenly. The greatest success I have in laying these colors evenly is by floating them (lightly depositing with a brush) onto wet, unpainted paper and then brushing through to even out this earth color layer.

Earth colors can be "charged" into confined wet areas, but since they do not spread readily, they will require several touches. Sometimes I drop additional water into earth colors when they are laid into more open areas, to encourage the color to flow and break apart. Earth colors are quite easily lifted off, which is helpful for regaining lights, but difficult to overglaze without damaging their surface.

Inorganic, or Mineral, Pigments

Pigments made of ground minerals tend to be more saturated and vivid than earth pigments. They also tend to be opaque. Included in this group are the cadmiums, cobalts, ultramarines, manganeses, and oxides. Permanence is also very high in this category.

Inorganic *synthetic* mineral colors are produced by utilizing very strong heat. These colors are extremely per-manent. Among these are included cerulean blue, Naples yellow, cobalt violet, and cobalt green.

Mineral colors behave very attractively on a wet paper surface. Many send sediment outward to collect in the wells in the surface of the paper, creating lovely texture. (Manganese blue, cerulean blue, ultramarine, and the cobalts are favorites of mine for this quality.)

I find the cadmiums somewhat challenging to use in their more undiluted form on a wet surface. They have a dry nature, which often encourages "bleedbacks" to occur as water rushes into these color areas. Unlike most of the other mineral pigments, they also are more difficult to lift off once they have dried.

Organic, or Carbon, Pigments

Organic pigments, such as sepia and indigo, are made of substances containing carbon, often derived from living matter, either animal or vegetable. Synthetic carbon materials can also be used, frequently derived from petroleum. Organic pigments dissolve in water; the exception to this is when a carbon dye color is affixed onto inert material—such a pigment is called a *lake*.

Many organic pigments will stain the paper or other pigments (see the lift-off chart) and are often called staining colors. Carbon pigments have great intensity and richness when used fairly undiluted (and can overwhelm if not used with discretion). When diluted, however, the color becomes rather thin and somewhat deadened. There are no particles to sit up on the paper, and so all the color soaks in.

When organic paints are charged into wet, confined areas, they quickly spread out to the perimeter. I tend to use them in more open areas and utilize their exciting explosions of color. It is helpful to develop a feel for the amount of wetness that you need on your paper surface for the effect you desire. If your paper is too wet, exciting images will quickly dissipate and be lost.

Organic pigments are often too strong to mix well with other colors. I compare them to food coloring—a drop or two will go a long way in altering the color to which it is added. Start with a very little; you can add gradually. It then takes a lot to reduce its effects.

Staining colors are often best used as underlayers in color glazes, first allowed to dry, and then rewetted to glaze over. Some staining colors, like alizarin crimson, are more vulnerable to fading, particularly when applied in a thin layer.

Staining colors absorb into the paper and will not lift off once they have dried. However, if staining color has been laid onto a wet surface, and then you lift or overwhelm areas of staining color with water while they are still wet, it removes readily.

Burnt umber, an earth pigment, can granulate in a fascinating manner, as you drop water in and tilt your board.

Mineral pigments have an attractive way of moving from great density to a lovely dispersion of fluid color.

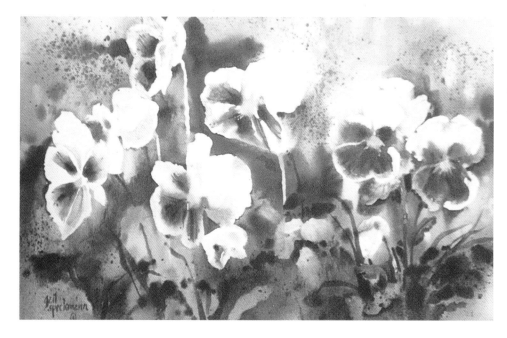

CHOOSING A PALETTE

I like having a broad number of colors available to me, but this certainly does not mean that I use them all in one painting. Actually, I prefer to limit the number of pigment colors within a work, usually to ten or fewer. I generally make my color choices before starting the painting. I may begin with a compatible color triad (similar in strength and character) and then fill out my range of choices to obtain additional value range or contrast. I label the color wells on my palette with masking tape as a quick visual reminder.

Thus, I do not advocate starting out with a great number of colors. Limiting them helps ensure harmony. To get to know your colors well, you could work with a small palette selection for some time. To begin with, a cool and warm version of each of the primaries, plus some rich, dark colors and a couple of more neutral earth colors may give a sufficient range. But I also suggest that you not rule out the addition of new colors over time. It can expand your range of expression and energize your work.

I think palette color choices are very personal and should grow and alter along with the artist. I pick some of my colors on the basis of their handling qualities for wet-into-wet painting, not just for their color. The following is a description of my palette and the reasons I favor certain colors, including brand names, because paints can vary considerably by company. The arrangement of the colors basically follows that of the color wheel (see page 80).

- Jaune brilliant no. 1 (Holbein): This is a wonderful convenience color I appreciate having readily available for clouds and snow. Conveying warmth, it has more of a peach color, yet it works psychologically as a yellow.

- Lemon yellow (Winsor & Newton): This cool, pale yellow creates a nicely expanding velvety glow when used in full intensity. It provides a good yellow with some body for wet glazing. I also like it as a glaze over darker color. It breaks apart, creating an interesting texture.

- Aureolin (Holbein): This is an especially nice, transparent yellow for glazes. It is a good mixer that warms and does not muddy colors.

- Indian yellow (Holbein): This warm yellow has an attractive transparency when used in wet glazes.

- Buff titanium (Daniel Smith): This color has a lovely, warm, sand-like hue. More transparent and warmer than Jaune brilliant no. 1, I also use this color extensively for the initial layer for shadow and sky color.

- Cadmium yellow deep (Holbein): Strong, but not harsh, this provides a warm underglow. It is somewhat more transparent than other cadmiums.

- Cadmium orange (Holbein): This intense, opaque color tends to sit up on the paper surface. It can be muddying when mixed with blues. Used as a thin overglaze, it can create a lovely "late afternoon" glow.

- Quinacridone gold (Daniel Smith): a rich, transparent gold which mixes cleanly with other colors, particularly nice with various blues to create glowing greens.

- Raw sienna (Holbein): Raw sienna has greater transparency than yellow ochre. I like this pigment in Holbein especially, since it remoistens more readily than other brands.

- Burnt sienna (Holbein): This earth pigment is a rich, surprisingly transparent orange-brown. It intermixes well with other colors. It is effectively used for neutralizing many of the blues, especially by glazing.

- Umber (Holbein): I like the rich brown color and granulation. Holbein's formula helps keep this color workable even after it has been rewetted on the palette. This color is neither overly red nor green, so it can readily be cooled or warmed.

- Sepia (Holbein): I like sepia as a neutral darkener with more warmth than black. It is noted for its granulation.

- Raw umber (Sennelier): This is perhaps my favorite earth color. It fits very well into landscapes. It tends slightly toward green or gold and works nicely in glazes.

- Lunar earth (Daniel Smith): This is a rust-colored paint which disperses into a fascinating granular pattern for a very textural look.

- Vermillion (Holbein): This intense red-orange is particularly lovely in glazes. I like it especially well for calligraphic marks and intense spots of color.

- Indian red (Holbein): A dense pigment with excellent covering power, this also thins to a rosy brown wash or glaze. It is very powerful when mixed wet with other colors. Used sparingly, it can be utilized to soften the intensity of some of the more vivid reds and also some of the blues.

- Cadmium red purple (Holbein): This, like the other cadmiums, is a powerful color with considerable opacity. However, it makes a nice glaze when thinned. I find its slightly neutralized color easier to work with than Cadmium red deep.

- Winsor red (Winsor & Newton): This red bleeds out quite freely, which can be quite exciting, but one should use it sparingly at times. It is the closest to a primary red of any on my palette.

- Permanent rose (Winsor & Newton): This is one of my favorites for glazes. It has a clear hue and interacts beautifully with other colors.

- Alizarin crimson (Winsor & Newton): Though this lovely cool red has come under fire for not being completely colorfast, this is true mostly of thin washes, so I use it generously. It can be substituted by Permanent Alizarin crimson.

- Cobalt violet light (Sennelier): This especially appealing color has opacity that brushes out into glazes very attractively.

- Thioindigo (Winsor & Newton or Da Vinci): This is a rich, deep red violet which is lovely in glazes. Painted onto a wet surface, it gives juicy darks.

- Mars violet (Holbein): I like the textural quality of this brownish, rich pigment when undiluted. Reminiscent of melted chocolate!

- Opera pink (Holbein): This intense hot pink can enliven almost any color mixture or as a glaze layer. Overly potent alone for most purposes, a small amount with other colors can be very satisfying.

- Mineral violet (Holbein): A deep, slightly neutralized hue, very rich and granular. It works well with other colors and thinned into a glaze.

- French ultramarine (Holbein): I like the way the pigment granulates on a wet surface in this particular brand. It is a lovely and very useful color in many glazes. In full strength, it is rich and velvety.

- Verditer Blue (Holbein): This is a beautiful, almost periwinkle, blue which is especially nice as a glaze color for sky and shadows. It is a "convenience" color, one which I use extensively enough to merit a place on the palette.

- Cobalt blue (Sennelier): Especially lovely in delicate glazes, used full strength this has a pleasing true-blue hue with a velvety edge. It loses strength quickly in mixtures and cannot be used for obtaining strong darks. Cobalt blue lifts off very easily.

- Titanium white (Holbein): This is often excluded by transparent watercolor purists, but I use it not to mask "mistakes" but mixed with other pigments to obtain more pastel shades. When combined with other pigments, it allows them to be lifted more readily. Or, for a less pastel influence (but still allowing for the lift-off benefit), it can be glazed on by itself, initially, to minimize the staining effects of following layers of color. Brushmarks of color over white will often develop a rimmed edge. I also like the manner in which Titanium white breaks apart when used as an overglaze, providing interesting texture.

- Winsor blue (Winsor & Newton): My favorite phthalocyanine blue, this has an explosive effect when painted undiluted on wet paper. I do not care for it thinned down considerably; the light tint, by itself, is a little dead-looking. Yet it can provide a good base for an enlivening overglaze color.

- Lunar black (Daniel Smith). This true black has the same intriguing granulation as Lunar earth.

- Horizon blue (Holbein): A great sky color with a good covering power for more intense color. It thins to lovely, even washes with enough body so that streaking tendencies are practically eliminated.

- Cerulean blue (Holbein): A favorite of mine, this blue imparts some warmth without becoming too green. It has a nice granular quality, without the streakiness of manganese.

- Manganese blue (Holbein): Though difficult to lay down evenly—and best laid onto unpainted, wet paper, and stroked out to smoothness—it is one of the most impressive granulating pigments. It works beautifully with other colors in glazes, particularly permanent rose, thioindigo, and aureolin yellow.

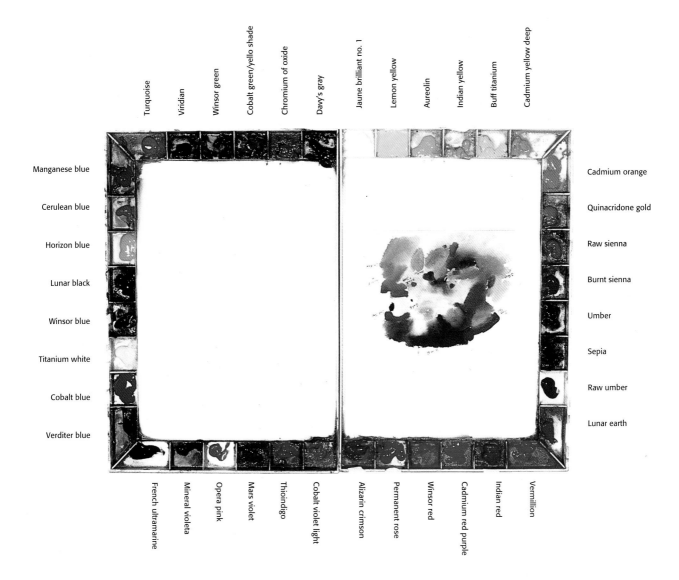

Turquoise · Viridian · Winsor green · Cobalt green/yello shade · Chromium of oxide · Davy's gray · Jaune brilliant no. 1 · Lemon yellow · Aureolin · Indian yellow · Buff titanium · Cadmium yellow deep

Manganese blue · Cerulean blue · Horizon blue · Lunar black · Winsor blue · Titanium white · Cobalt blue · Verditer blue

Cadmium orange · Quinacridone gold · Raw sienna · Burnt sienna · Umber · Sepia · Raw umber · Lunar earth

French ultramarine · Mineral violeta · Opera pink · Mars violet · Thioindigo · Cobalt violet light · Alizarin crimson · Permanent rose · Winsor red · Cadmium red purple · Indian red · Vermilion

My entire forty-color palette. In the center is a small color study. On the edges of the wells, I place masking-tape flags to alert me to the colors I have selected as the basis for my next painting.

- Turquoise (Holbein): This is a convenience color I like for its intensity and ability to mix with yellows to make lively greens.

- Viridian (Holbein): I like the consistency from this manufacturer. The cool green is powerful, and it mixes well with other colors in exciting ways. It can set up some interesting color vibrations when used in glazes.

- Winsor green (Winsor & Newton): Similar to viridian, but valued for its intense transparent green, this is very effective for obtaining clean, rich darks. I also like its spreading behavior on wet paper.

- Cobalt green/yellow shade (Holbein). This true green is almost the crayon color. It has a very nice, softly granular dispersion. It is a very rich green in the landscape and works well with other colors.

- Chromium of oxide (Winsor & Newton): A warmer, somewhat dull green, close in color to foliage and grass. It has opacity and a velvety edge and thins down nicely. It can also be used to reduce the intensity of other greens or to neutralize reds.

- Davy's gray (Grumbacher): This convenience color provides a deep, sooty, neutral green that I like for its handling quality and dark value. I sometimes use it to diminish the intensity of green pigments.

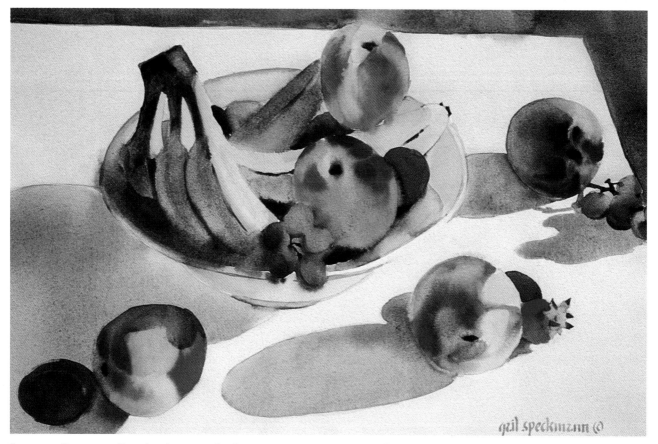

FRUIT AND BOWL
14 x 21"

I used rather neutral color to overglaze and darken the bananas. Still, they look like yellow fruit.

Values

Because of the different values of colors at their full intensity, you will achieve your most intense yellows in a high key. Blues and violets will be most intense in a low key, because of their naturally deeper values. (In a high key, they are tints, diluted by the white paper showing through.) Density and saturation can also carry a feeling of strength and power, which can be interchangeable with deep color for impact (note the power of intense colors like permanent rose, cadmium red, and turquoise).

As pigment expands on wet paper, you get a very natural display of some of its tonal value range. Because the deeper colors are the blues, reds, greens, and violets, you will see greater value range in these wet pigment marks on your wet paper. The value gradation as color thins out from most to least saturated is more difficult to see in the light values, unless they are laid over a previous dark wash that has been rewetted.

To obtain rich, juicy darks, you must have a good amount of saturated, soft pigment, preferably just squeezed from the tube. It is hard to rewet pigment adequately for larger passages, though certain pigments may rewet adequately for smaller passages.

You can only create darks by including the dark-valued colors within a mixture; several light or middle-value pigments will never create a strong dark, but will yield only a grayed tone and the loss of the reflective quality of the paper. It is more difficult for our eyes to distinguish the hue differences of very dark values (just as our ears have difficulty distinguishing among low notes on the piano), so a variety of deep colors can be placed side by side without being discordant. The same is true for tints—middle-value range is most visible in hue differences.

Color Intensity

A color is at its most intense when it is purest chromatically—used directly from the tube, not grayed down by its complement (or colors containing elements of its complement), not tinted with white, not thinned to reveal the white paper, and not shaded with black. It can be mixed with another tube color that does not dilute its chromatic purity as just described. Its power is enhanced by allowing it to spread out softly at its edges on a wet surface; the expansive look increases the appearance of its strength. Surrounding this area with a pale tint of its complementary color will further intensify its appearance.

For a slightly less vivid but still effective backdrop for intense color, surround it with a luminous gray which leans toward the complementary color.

Not all areas of a painting need should feature this kind of intensity, which is useful for achieving impact and creating a center of interest. You should effectively balance this with quieter areas that, by contrast, further focus attention on your area of greatest interest.

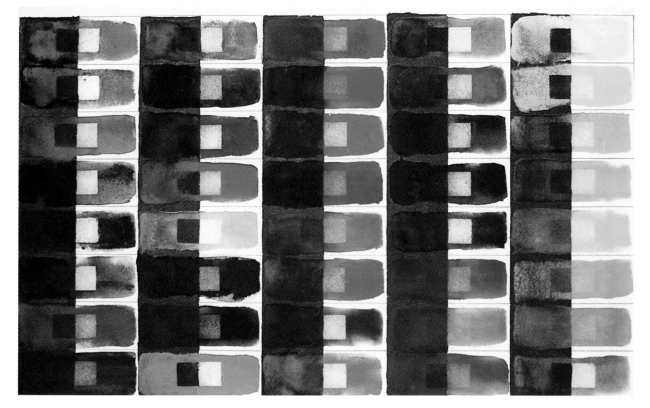

For this lifting-off test I drew rectangles and, using ink, made them half dark and half blank. I floated a brushstroke of water onto each rectangle. Then I "charged" my color in. After it dried, I made an acetate stencil cutout of a small rectangular shape and laid it over each swatch. Using a damp sponge I lifted the color off through the stencil opening.

SPRING REUNION
21 x 29"

The intense rose hues have a strength and power that makes them similar in impact to a dark-valued color.

Color Temperature

It is helpful to remember that every color has a cool or warm dominance. A painting usually holds our interest best if it has both warm and cool elements. Areas of contrasting temperature provide relief and interest (often the "center of interest") when they balance against the dominant color temperature. Within glazes, color vibrations are created between cool and warm colors.

HASTINGS DEPOT
(DETAIL)

Note the warm and cool elements in the shadows.

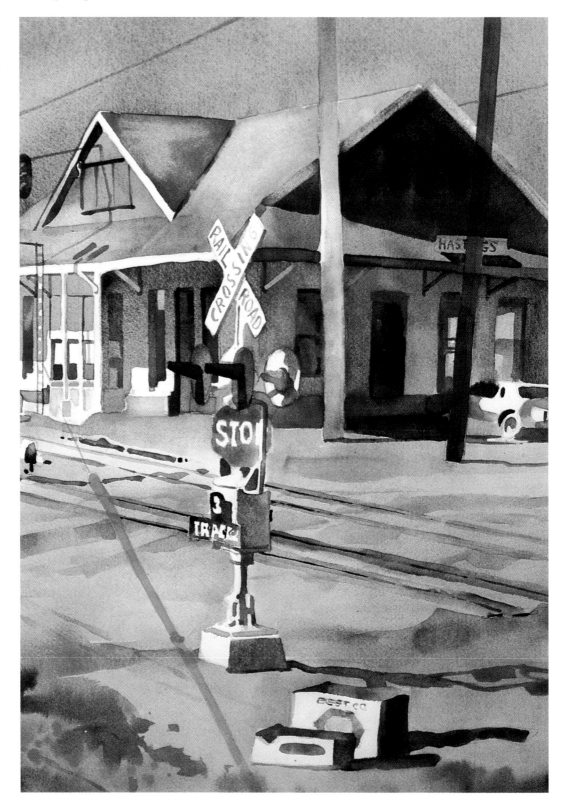

VARIOUS WATERCOLOR BRANDS

Pigments vary by their natural origin, but they also can vary considerably by brand. This is true among excellent manufacturers; they simply value certain different traits in their watercolor lines. The pigments themselves do not vary, although their density can. However, in the high-quality brands, more variation comes from their unique formulas. These often have to do with the balance of gum arabic, oxgall, or wetting agent, which affect the degree to which the paint flows out or holds its "shape" when applied on a wet surface. An awareness of these differences may help you select paint that suits your vision.

- Daler-Rowney: My experience with this line is somewhat limited, but it appears to be especially nice on just-wetted paper. The colors are rich and glowing. They are quite free-flowing on saturated paper.

- Daniel Smith: This company has recently created a new line of watercolors of very high quality. I find this paint to have a very expansive quality—lovely in appearance, but needing care to keep forms from dissipating into too much softness.

- Holbein: I am especially fond of Holbein's paint. Holbein is a Japanese company, and its paint is formulated to fit the desires of that society, in which the importance of the brushmark is great. This company's formula does not include oxgall or other wetting agents, so when their watercolor paint is stroked onto a wet surface, the paint does not really disperse, but expands only very slightly. The pigment is dense, so the colors can achieve greater opacity than most other lines'. The paint behavior is closer to gouache, which I find very appealing.

- Permalba: This brand has a very high percentage of pigment, very finely ground. I often see the evidence of the brushstroke (the textural "smack" of the mark as the brush touches the paper). It is very interesting to note how little the paint spreads out on the saturated paper. This can be very useful if you want greater control over this process. I also find that Permalba thins down to luminous glazes, among the loveliest I have seen.

- Rembrandt: This is a high-quality line. The paints are quite expansive, and particularly noticeable on saturated paper. This brand carries additional oxide earth colors, which are transparent (unlike other earth colors).

- Sennelier: Sennelier paints are made from very traditional formulas that have been the same since 1893. These formulas utilize honey instead of the more commonly used glycerin. (These are used to counteract the tendency of the watercolor binder, gum arabic, to crack.) They include an intriguing range of colors not always found in other lines. Most are permanent, but some are less permanent and are offered for their unique qualities. I find the wide range of behavior from the pigments to be part of Sennelier's traditional approach—not tampering with the natural tendencies unique to each pigment.

- Winsor & Newton: This is an outstanding, very popular line of watercolor paint whose formulas strive for a balance of the best characteristics suitable for each pigment. The colors are fairly expansive, and I appreciate the excitement they can engender on the wet paper surface.

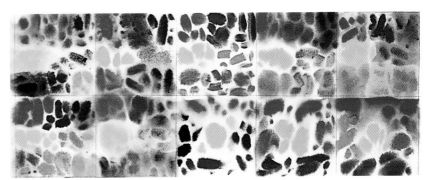

FULLY SATURATED PAPER

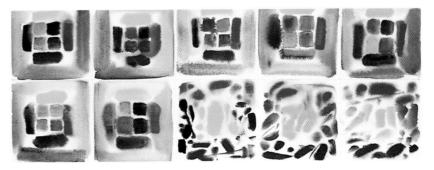

WETTED PAPER

These charts show the paint behavior of various brands of watercolor paint, including gouache. Top two rows, left to right: Daler-Rowney, Sennelier, Permalba, Daniel Smith, Rembrandt. Bottom two rows: Holbein, Winsor & Newton, Daler-Rowney Gouache, Holbein Gouache, Winsor & Newton Gouache

Gouache

The term "gouache" refers to an opaque watercolor, distinguishing it as a paint that has greater density and covering power than watercolor per se. It contains more inert substances which impart this greater opacity. The pigments are more finely ground than in watercolor, but the binder, gum arabic, is the same. It requires greater dilution to come to a transparent consistency; otherwise, it handles in essentially the same way as other watercolor paints.

In its solubility and general behavior, gouache closely resembles transparent watercolor. Its lifting-off capability and its use with salt and spray are very similar to those of transparent watercolor. With its greater body, gouache has somewhat less tendency to spread and run than does watercolor. Wet edges in gouache merge more gently when set side by side.

Gouache may be used to obscure an area that is not pleasing. Clear water can be laid over this passage and then gouache can be laid in. It will either softly diffuse at the edges (only partially filling the wet area) or completely expand to fill the wetted section.

Thinned with water, gouache has a translucent, rather than transparent, quality. These two light-revealing qualities are harmonious and can be used to enhance each other within a painting that utilizes both transparent and gouache passages. As always, contrast will bring out the best in differing visual elements. However, the principle of dominance also applies, so either the transparent or the translucent look should dominate, allotting a smaller role to the other.

In using gouache, remember that opacity and translucency can be used to keep the viewer's focus at the surface level of the paper; transparent passages, by contrast, send the viewer much deeper into the space in the painting.

Gouache lends weight and solidity to the painting surface. It is well utilized for expressing subject matter that calls for these qualities, such as buildings, still life objects, land, trees, and some floral images if used somewhat more transparently.

Gouache colors correspond closely to transparent watercolors. Dilutions of gouache, carried to the same degree of transparency, do tend to have less intensity than their counterparts in watercolor. Gouache is used attractively on color-toned paper, such as Bockingford, since the lights can be created with opaque whites and tints (rather than depending on the white of the paper, as with transparent watercolor).

Gouache is stroked onto a wet paper surface; note that the color is more dense and opaque than that of transparent watercolors.

USING ACRYLICS, INKS, AND PASTELS

Acrylics

Acrylic paints are made from pigment, water, and a polymer emulsion, which is the binder. For a wet-into-wet approach, acrylics can be thinned with water or with acrylic mediums (matte or gloss) to go from opacity to translucency to transparency. I prefer thinning with water, which causes the paint to disperse more readily and thus behave more like watercolor.

On a wet surface, paint mixtures of similar pigment type and dilution will show less dispersion in acrylic than in watercolor. In acrylic, pigment is less inclined to flow out very far. "Flow improver" added to the paint does increase this ability (and without altering its degree of translucency). However, the limited spread of the paint can often be a virtue, for a wet shape will better hold its form, and white areas are less likely to be invaded. The ability to work wet-into-wet on smaller images is improved with acrylic.

For washes, it is almost essential to have a layer of clear water laid down to float on a color layer, for acrylic dries too quickly to lay a wash directly on dry paper with ease. It is a little more difficult to lay down a smooth wash in one pass, because "striping" tends to occur at the overlaps. The wash layer often benefits from smoothing strokes brushed across randomly or perpendicularly to the wash strokes. For this reason, and also because you gain more distinct color layers, I prefer to allow acrylic wash layers to dry between glazings. Then I rewet (no chance of disturbing the acrylic underlayer) and float on and brush out the next layer. Acrylic has excellent adhesive properties, so the paint bonds to the previous layer.

For increased brilliance, you can thin the pigment with acrylic gloss medium. The acrylic binder suspension creates the effect of an internal glow within each layer.

On saturated paper, the acrylic paint sold in jars and also the Acryla Gouache (a product of Holbein not to be confused with traditional gouache) have a smoother consistency that works more attractively.

Because the acrylic pigment has less flow and spread, much of the work that I do in acrylic is done by wetting down a section and then immediately painting directly into it. The acrylic paint handles better than on a fully saturated surface, but the painting approach is similar in that the strokes are evident.

Acrylic paint works reasonably well using what I call the painterly approach (see page 65). Blending occurs between adjoining strokes, but color interchange is limited because of the limited flow. Colors charged in side-by-side retain their identity, instead of mixing freely.

A unifying overglaze is best done after the strokes are dry; although acrylic is fast-drying, it is difficult to stroke over immediately with clear water without losing the brushmarks. On the other hand, once it is dry, you cannot loosen the edges, as you can with watercolor. So it is difficult to catch the right moment to do this, for you can end up with too many hard-edged strokes that you might have otherwise adjusted.

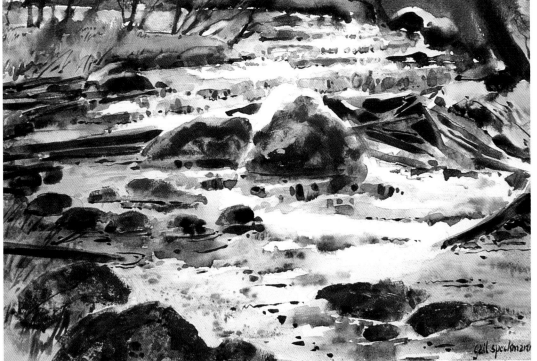

TUMBLING STREAM
14 x 21"

This wet-into-wet painting was done with acrylic and predominantly synthetic-bristle brushes. I never use expensive natural-bristle brushes with acrylics.

*I used black ink
first and then
worked in
watercolor over it.*

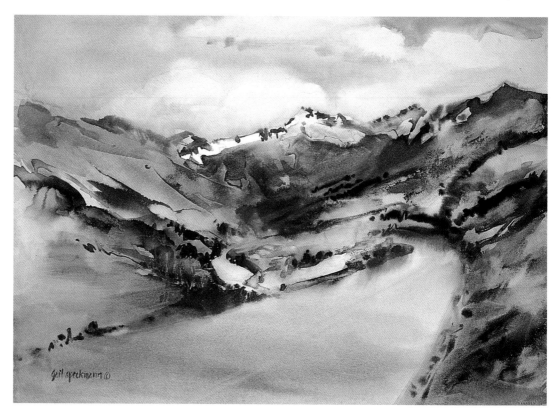

Watercolor/Acrylic Inks

Daler-Rowney's Luma ink is brilliant concentrated watercolor. I find it to be of intense transparent color and highly staining. The intense color absorbs evenly; there is no streakiness to contend with. Almost immediately after it touches the paper it cannot be lifted back. This is desirable if you want to create an area, perhaps an initial layer of color, which you do not want to disturb with successive layers. FW acrylic inks are the most effective medium I have found for salt texturing.

Water-Soluble Pastels

Holbein makes a water-soluble line of pastels which provide delightful variety when combined with watercolor. Sennelier also makes a velvety pastel which has a very high percentage of pure pigment. When working either of these onto a wet surface, you have the option of moving from a textured "broken" stroke to full, smooth passages, depending on how much pigment you lay down. You have the opportunity to apply very intense pigment without having it spread unless you choose to loosen it with a moist brush. The brush can be whisked over the entire surface, or simply at the edges.

This detail shows how I sometimes incorporate pastels into a watercolor painting.

BRUSHES

It is important to have brushes of good quality. The top of the line are the red sable brushes, and of these kolinsky is the finest. These are expensive, but it is worth having at least a few. Also among the natural-bristle brushes are those of ox hair (a less expensive alternative to sable), hog, squirrel, and goat hair. The latter two are very soft and can be used with a very light touch. Excellent synthetic and blend (part natural, part synthetic) brushes are part of my collection also.

Natural-Bristle Brushes

Natural hairs tend to be more subtle, delicate, and responsive in their handling. They retain water well and release it evenly onto the paper.

Sable hair has a natural taper which shapes the brush form. The thicker part forms the "belly" of the brush, and the thin end comes to a lovely, well-defined point. Sable has a wonderful, natural spring to it, snapping back to its original shape after performing various maneuvers. For a much stiffer brush for lifting in watercolor, hog bristle is often used. For this, I prefer very short-bristle brushes for strength and control; the longer bristles flop around a bit. I advise using natural-hair brushes only with media which can be rewetted and made soluble; because they cost more than synthetic brushes, you do not want to take the chance of pigment (such as acrylic) drying on them and ruining them.

Synthetic-Bristle Brushes

There are many fine synthetic brushes on the market today. The so-called white sable brushes are made of taklon. I like the firmness with which they lay down pigment—nothing indecisive about them! And I like them especially when I am stroking on clear water, "breaking" the surface tension of the paper. These brushes will fill the little hollows of the paper, whereas the softer-touch brushes, such as sable and squirrel, are more likely to "ride" across the surface of the paper (fine for a dry-brush effect). Taklon does not hold water as readily as natural hair, which is also one of the reasons it will fill the hollows. I find that in the white taklon brushes, a wash brush of slim depth (such as the Silver Brush Edgewater Wash) will prevent too much water from rushing out and will allow great flexibility of movement. They are also excellent for lifting color away again. Strong and priced economically, these brushes can be used for all mediums.

Blends

There are also various blends of natural and synthetic hair that attempt to capitalize on the best features of both. Typically, they carry water quite well, but also give some firmness to the brushstroke. A blend of natural hair and golden taklon (similar to nylon) is very popular. Because of their reasonable price and relative durability, I use this type of brush with all mediums.

Another blend that I find to be excellent, particularly for working on saturated paper, is a blend of natural squirrel-tail hair and black synthetic filament (the Silver Brush Black Velvet). The paint releases evenly and the touch to the paper is very soft, yet the brush holds its shape well. I use these brushes only with watercolor pigment. I always make sure to rinse these brushes well between color changes, for the black hair may hide some residual pigment.

Testing Brush Quality

The hair content alone does not tell the whole story. The care with which a brush is made greatly influences its quality. Brushes from companies that have established a fine reputation and who uphold quality are the ones I recommend.

To test the quality of a particular brush, first wet the brush and then cause its edge or tip to splay apart, either by pressing it against the back of your hand or on paper. As you lift the brush away, it should return to its original shape. Try making varied lines with the brush, thin to thick. Watch how the brush releases paint—it should do so evenly, not unload the paint all at once when pressure is applied. Try this particular test on saturated paper also.

Brush Shapes

There is a tremendous variety of brushes available to the watercolor artist. The use for the brush determines the shape you desire.

Pointed Brushes The *round*, perhaps the most basic and versatile shape, is the brush in which I am most willing to seek the best quality. It is very important to me to be able to get the fine line that it offers. Lower quality becomes very apparent in this shape.

Script, or *monogram* brushes are longer and thinner than the classic rounds. The brushes are of a uniform thickness throughout until they taper to a fine point at the end. Because of the hair length, they hold a good amount of paint and are great for creating long lines of uniform thickness or very free twig lines in trees. I can lay down many lines in succession, without having to stop to reload the brush. Rigger brushes have long thin hair bristles and are flat at the tip.

Spotters have a very short bristle length and allow maximum control, though they do not hold much paint. They can be used to deposit paint on a wet surface without having much additional water flowing from the brush, thus creating a line that will not dissipate readily.

Flat Brushes The flat brush is made up of a rectangularly shaped bristle bundle which ends with a chisel-like edge. It is a brush of great versatility.

The *bright* is like the flat, except that the bristle length is somewhat shorter. I am fond of this shape of brush; it does not carry as much water as the flat, and because of the shorter length it is easy to control.

The *one-stroke* is like the flat, except that the bristle length is longer. It is designed to carry more water and paint, which allows a stroke of considerable length to be laid down in one pass. It has traditionally been used by sign painters.

Brushes I repeatedly rely on for wet-into-wet work are shown, left to right, as follows: 1½" Silver Brush wash (squirrel/synthetic blend); 1½" Isabey wash (squirrel); 1" Silver Brush wash (squirrel/synthetic blend); ¾" no. 6 Isabey bright (sable); ½" Silver Brush bright (sable); ⅜" no. 10 Silver Brush flat (sable); ¼" no. 6 Dick Blick flat (sable); Silver Brush jumbo round (squirrel/synthetic blend); no. 5 Isabey quill (squirrel); no. 8 Isabey kolinsky round; no. 7 Silver Brush kolinsky round; no. 6 Silver Brush script (sable); no. 2 Winsor & Newton round (sable)

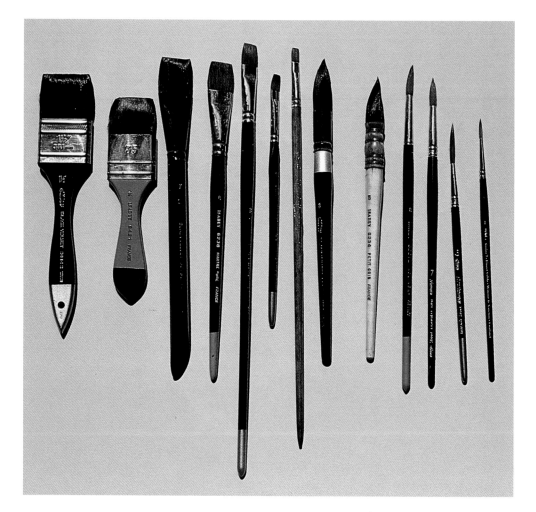

The *wash* brush is a soft, wide, flat brush which is instrumental in laying down evenly released, wide bands of paint.

Unusual Varieties The *pointed oval* wash brush is versatile, combining some of the features of the flat brush and the pointed brush. You can obtain quite a variety of interesting strokes with this brush, evoking images of fish, birds, or leaves.

The *oval* wash brush is flat, but its edge is oval, creating an oval stroke. Similar to it are the *filbert* and the *cat's tongue*, which also makes a pleasing oval mark, with a more rounded edge than the brush might at first appear to have (it looks very similar to the pointed oval wash).

The *striper* is an intriguing brush which comes straight to the point on one side and tapers gradually on the other. Very interesting thick to thin lines can be made with this brush. Good possible use might be found in landscape painting.

The *angular* brushes are like the flat brushes, but with the brush edge cut off at an angle rather than straight across. This feature allows you to paint handily into acute corners. This is a brush that could be of good use to those artists who paint architectural subjects; it is probably of less importance for painting organic shapes.

The *grass comb* and the *fan* both have bristles of uneven lengths. These are for creating a great variety of multiple-line motifs—rain, grass, fabric, feathers, and pine needles.

A *mop* is a full, rounded brush with a blunt rather than pointed end. I particularly like one made of goat hair, which is capable of painting generous, loose shapes that are different in character from those given by other brushes—especially for floral shapes. It is a brush I would be inclined to use most in a "painterly approach," using water or a pale tint and then charging pigment into the shape.

How many brushes do you need? Consider a basic requirement to be one round brush (perhaps a no. 8) or two (perhaps a no. 4 and a no. 10). I suggest you also get a broad range of flat brushes, so that you'll be able to create brushstrokes of various widths. Have at least one ½", ¾", 1" flat or bright, and a 2" wash brush. I always opt for having a limited number of quality brushes rather than many mediocre ones.

As you continue to paint, you will want a variety of shapes and sizes. If there is a brush that you particularly like, you may even want another just like it, so that you can switch from one to another without rinsing.

Brush Care

To prolong the life of your good brushes, always wet your brush in water before dipping it into paint. While painting, on the other hand, never leave your brushes standing in your rinse water. It is easy for them

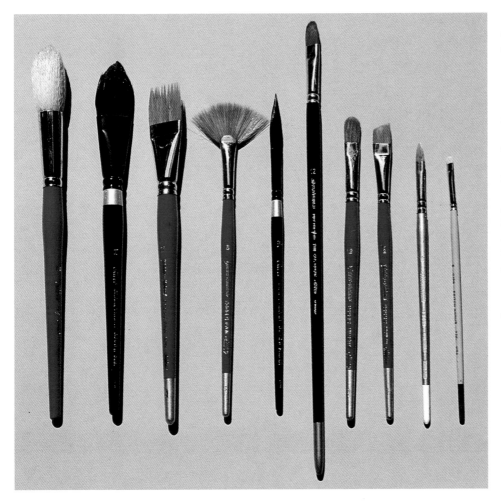

These more unusual brushes are useful (left to right): Silver Brush mop (goat hair); 1" Silver Brush oval (squirrel/synthetic blend); 1" Silver Brush grass comb (synthetic/natural blend); no. 6 Silver Brush fan (synthetic/natural blend); 3/8" Silver Brush striper (squirrel/synthetic blend); no. 12 Silver Brush cat's tongue (sable); no. 12 Silver Brush filbert (synthetic/ natural blend); 1/2" Silver Brush angler (synthetic/ natural blend); no. 8 Silver Brush filbert (synthetic); no. 6 Fritch scrub (hog bristle—good for lifting paint off small areas)

to become misshapen; this also can be hard on the wood handles.

Learn to stroke your brush on the palette pulling away from the paint, to protect your bristles. The same idea applies as you deposit paint onto the paper. Think of pulling the brush across the paper rather than pushing into it. If you seek a more aggressive, jabbing sort of motion (which can be quite exciting), be aware that this is very hard on brushes. You may want to consider using old, worn-out brushes or, at least, sturdy and inexpensive ones.

Fresh tube paint is much kinder to your brushes than resurrected hard, dry paint. If you are trying to resoften old paint, be sure to pre-soak it, and then use a bristle brush to coax it back to a workable stage.

After painting, clean your brushes with cool, clear water. Hot water tends to strip the natural oils out of the bristles. I use Winsor & Newton art gel to help in the clean-

ing process. It is nonabrasive and even has something of a conditioning effect. I often let it sit on the brush for a few minutes while I work on other brushes. I use an old toothbrush to stroke gently away from the ferrule, the area that seems to be most vulnerable to trapped, dried paint. Neglecting this area can result in a loss of spring in the brush action. Be particularly attentive to removing paint from dark-bristled brushes, for it is easy to overlook paint residue in the dark hair.

After the brushes have been rinsed thoroughly, shape them to a point or chisel edge. Then touch a paper towel near the ferrule to remove excess moisture.

Brushes should be stored upright in containers or, more ideally, suspended bristle-down (to allow any moisture to drain away). If a brush has become misshapen, reshape it by allowing it to dry with art gel or clothing starch on it.

WATERCOLOR PAPERS

I find paper to be the single most variable element involved in the results that wet-into-wet painting achieves. Watercolor papers present us with a number of options with which to work. Their various traits will have a direct effect on the results we obtain in each painting. Variables include the *weight* (thickness) of the paper, how it is made (handmade, moldmade, or machine-made), *sizing* (a coating that causes the paper to resist the liquid, to a degree, instead of acting as a blotter), and *format* (individual sheet, block, or board). These factors influence water absorption, and they vary considerably by brand.

I generally opt to paint on mould-made sheets, which simulate the look of handmade, but are more affordable and have greater consistency of surface quality. I use 140-lb. cold-pressed paper, a surface which offers both surface texture and clarity of linear work in a weight that resists buckling adequately, and has a reasonable degree of sizing (I adjust my techniques somewhat, based on the specific paper's sizing).

There is no single, perfect paper for every purpose. There are a number of high-quality watercolor papers, and I advise skimping in other areas before doing so on paper. It is vital to have quality paper to achieve quality results. I have found that the papers discussed on pages 29–32 work best for the wet-into-wet processes. I will begin by looking at some of the variables which differentiate painting surfaces.

Paper Content The best quality papers are labelled as having 100-percent rag content. These papers are pH neutral—that is, they do not have the acidity that would eventually cause discoloration. Today there are papers that are blends including some cellulose (the culprit in acidity); these have been neutralized successfully.

Weight The *weight* of a paper refers actually to the weight of 500 sheets of that paper, usually of the "imperial sheet" size, which is 22 x 30".

Papers are most commonly available in weights of 90 lbs., 140 lbs., 200 lbs., or 300 lbs. The weight that is perhaps the most popular with watercolor artists is 140-lb. paper, which is fairly heavy and yet reasonably priced.

When working wet-into-wet, it is quite helpful to stretch 140-lb. paper. Much of the time, I simply use large "bulldog" clips to attach my paper to the board. The paper can be stretched tighter by adjusting the clips as the wet paper expands. The 300-lb. paper has the advantage of staying quite flat on its own when wet and thus requires the least special handling.

Sheets, Boards, and Blocks Each of these options in paper has its advantages and drawbacks. I prefer using individual watercolor *sheets* (sold most economically in packages of 25 sheets or more). I like the flexibility of the individual sheet because I am able to lift up edges, thus having more control over the movement of the wet paint. Also, there is the advantage of being able to cut the paper easily to the size in which you want to work. The drawback to working with sheets is the need to resolve the buckling issue.

Watercolor *boards* are not going to ripple and buckle, but they sometimes develop an annoying warping or bowing. This can often be alleviated by wetting the back of the board and then clipping it to a nonporous support board. Watercolor boards tend to have much smoother surfaces than their counterpart in individual sheets or watercolor blocks. That is, a cold-pressed finish on a watercolor board more often resembles a hot-pressed finish on an individual sheet or block.

Watercolor boards can be a little limiting to work on, in that they cannot be saturated (due to the backing board), or manipulated by lifting edges and the like. It is also more difficult to cut them to a desired size.

Watercolor *blocks* are composed of many watercolor sheets bound together on the edges. This allows for the paper to expand when wet, but to pull tightly back to its original flatness as it dries. At that time, the sheet may be removed from the block by gently running a knife around the perimeter, beginning by sliding it under a small opening at the top of the sheet. Simplicity is the advantage here, and the watercolor block is often popular with students and works well for painting on location.

Finishes

Rough paper has the coarsest finish, with a lot of texture. It is particularly effective for large paintings. Brushstrokes should be bold; they will tend to have a rougher, more broken appearance. Washes are particularly successful on rough paper; the large areas of color are easy to execute well and evenly on this surface. The "pits" catch the color like little wells and hold it. More water and pigment may be needed than on a smoother paper, because of the increased amount of surface area.

Cold-pressed paper is the most popular with watercolor artists. It finds the middle ground between the other two finishes, maximizing the assets of both. There is enough "tooth" to the paper to hold washes nicely. However, the paper is also smooth enough to allow for quite a bit of detailed and calligraphic brushwork and for precise edges.

Hot-pressed paper is very smooth. Paint will flow quite freely on this surface, creating interesting, but less easily controlled, blending. With no little wells in which to settle, water tends to sit on the surface, though some brands wisely reduce the amount of sizing in their hot-pressed finish to assist absorption. Once the wetted surface has become only moist, the window of time in which it is easiest to work wet-into-wet on hot-pressed paper is rather small and work must be done somewhat quickly. The paper also tends to dry out with greater speed, because more of its surface area is

exposed. (You may want to use a little glycerin in the water to extend the drying time.)

When you are using hot-pressed paper it is crucial to wipe up collected beads of water because, with areas of unequal moisture, backcrawls occur very easily on this surface. I prefer to paint on hot-pressed paper when it is saturated, so that it stays workable and evenly moist longer. Color also disperses with greater texture on a saturated surface, especially if the paper is inclined vertically.

Hot-pressed paper is good for a painterly approach because it prompts you to limit the size of your wet strokes. Brushwork shows itself very clearly, with precise, unbroken edges. In general, one may want to use a somewhat drier brush than on the more textured finishes. (It helps to touch the brush ferrule to a thirsty sponge to wick away excess water in the brush.) A paint (Holbein works well) or pigment that holds its shape might be a good choice for work on hot-pressed paper.

Very clean color lift-off can be done on this surface. The negative side of this is that glazes can be difficult to create, for they also lift off readily. When working back into an area, it is advisable to keep the angle of the brush low, almost parallel to the paper. This way you will be less likely to "cut into" the previous pigment.

Several brands eliminate hot-pressed paper from their 300-lb. lines, but you can obtain a smooth-surfaced rigid surface in the form of watercolor boards.

BRANDS OF PAPER

Arches
Made in France, Arches comes in 90-, 140-, and 300-lb. weights, and in rough, cold-pressed, and hot-pressed finishes. It is made from 100-percent cotton fibers, is acid-free, and is a warm off-white. This is perhaps the most popular watercolor paper, and it has earned its favor by having a surface that is equally good for painting by sections or on saturated paper, as it is for applying pigment in a painterly manner. It is internally and externally sized (that is, both the fibers and the uniform surface are coated) with gelatin, so it possesses great resiliency. Even so, there is enough absorption in the paper that the paint is very workable on its surface.

Arches 140-lb. cold-pressed paper has a slightly finer-grained texture or mottling than some of the other papers of similar finish—subtle, but very much present. Arches allows for very pleasing wet edge joinings between different pigments. Very little dark edge outlining at the edges of wet sections occurs on Arches. This paper does not damage easily during color lift.

Crescent Watercolor Board
These watercolor boards are made by laminating rag paper to a sturdy backing. The finishes are all quite smooth, just varying by degree in texture. They are quite heavily sized and acid-free. Board sizes are 20 x 30" and 30 x 40".

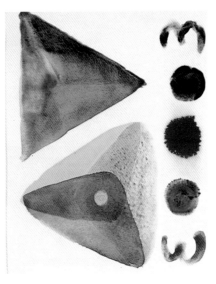

Arches 140-lb. hot-pressed paper

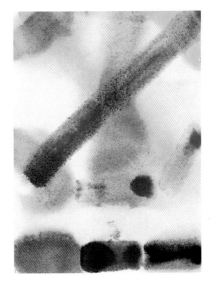

... On saturated paper

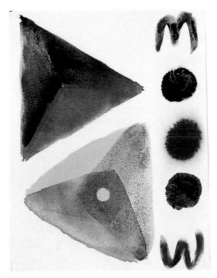

Arches 140-lb. cold-pressed paper

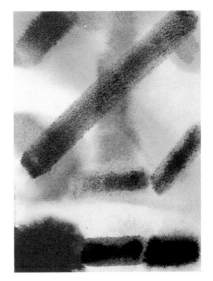

... On saturated paper

Fabriano

Artistico Mouldmade of 100-percent cotton and acid-free, Fabriano Artistico comes in the equivalent of 90-, 140-, and 300-lb. weights in rough, cold-pressed, and hot-pressed finishes. I find the surface texture very appealing; rather different from the other brands, it almost has the appearance of a fine fabric with its woven, finely screened look. It has quite a high absorbency, yet also a fairly strong surface. Dark values stay vibrant and juicy after they have dried. Paint has a very fresh appearance on this paper, which will take a little glazing and joining of side-by-side sections, but these are best not overworked. There is a tendency to develop crawlbacks.

The 140-lb. cold-pressed surface is smoother than most, and approaches that of a hot-pressed finish. Because of this, color edges join a bit unevenly, but there is a subtle richness to the blending. There is a very attractive pigment dispersal on painterly strokes, and edge line formation is uneven, so it adds interest rather than becoming unattractive (an even outline can be harsh and boring). The paper "pills" a little when lifting color, so scrubbing to any degree is not advised. (Papers that do this are not good candidates for maskoid.)

Fabriano 5 or Classico This mouldmade paper is 50-percent cotton rag and is acid-free. It has a very white surface, and a texture very similar to that of Fabriano Artistico.

Esportiazone This handmade Fabriano paper has a unique surface, particularly dramatic in the rough finish. It is 100-percent cotton, acid-free, and comes only in cold-pressed and rough surfaces. Esportiazone comes in 90-, 147-, and 300-lb. weights. It is very helpful to stretch the lighter two weights before painting. The surface of the rough Esportiazone has a very strong texture, which is made up of little kidney bean–shaped hollows, which take sedimenting pigments very strongly, but not other types. When working on just-wetted paper, the texturing is quite uneven between the pigment types. The paper pills a bit as you lift up paint.

The real beauty of this paper comes through when working on it saturated. Fascinating texture appears. Organic paint almost appears as if salt had been used. The sedimenting deposits seem more attractively irregular than when paint is applied to just-wetted paper. It is a good idea to put in some large wash areas, to make the most of the lovely texture of the paper.

Indian Village

Sheets of Indian Village vary quite greatly in surface and, to some extent, in size, and they are also not inclined to lie flat. The finish is rough. The paper comes in 140-, 200-, and 300-lb. weights, in a cool white and in gray and burlap colors in the 140-lb. only. Content is of 100-percent high-quality cotton rag, and the paper, acid-free, is strongly sized both internally and externally. The price is extremely reasonable for a quality handmade paper, making it enjoyable to experiment with, so long as one can get past its irregularities.

Lanaquarelle

Lanaquarelle, made in France, is a bright white mouldmade paper of 100-percent cotton. Acid-free, it is internally and externally sized, creating a surface which is very resilient for lifting techniques. It comes in 90-, 140-, and 300-lb. weights, in rough, cold-pressed, and hot-pressed surfaces.

My personal experience with Lanaquarelle is as follows. I find the hot-pressed finish to be very pleasing to work on. It is more absorbent than the other finishes—a helpful adjustment for painting on a smooth surface. It allows for very good lifting capabilities. (Sponge-off lifts are not as successful while the wash is still wet; the surrounding fluid tends to rush back in. But lifts after the pigment has dried are very effective.)

The cold-pressed and rough finishes are somewhat prone to leaving tiny "pinpricks" of white when water is stroked onto the dry paper, particularly in drier atmospheric conditions. This can be eliminated by prewetting the paper and allowing it to dry again before working on

it by sections or in a painterly manner, or by sponging quite firmly and working into the wet surface. I have also found that the sturdier brushes (synthetics) penetrate the surface more effectively, eliminating the pinprick look.

Using Lanaquarelle paper saturated is very successful. The resistance is somewhat broken by the saturating process, but there is enough present to help the color stay lively (not overpenetrating the paper and allowing the white glow of the paper below to shine through).

Lanaquarelle 140-lb. cold-pressed paper tends to form slightly ragged line edges, which could be used for particular effect. (See the rose-colored W in the illustration.)

Strathmore

Aquarius II is made of an acid-free, cotton and synthetic blend, which is very free of ripples when wet. It is a machine-made paper, available in 80-lb. cold-pressed sheets or in spiral-bound pads.

Gemini is an acid-free, mouldmade Strathmore paper created from 100-percent cotton fiber. Finishes are rough, cold-pressed, and hot-pressed, and come in 72- and 140-lb. weights. This paper's resilient surface handles easily, allowing colors to be worked wet-into-wet nicely in glazes and adjoining wet sections and maintaining color integrity and clarity. In the 140-lb. cold-pressed paper, the textural mottling is similar to Arches'—a little more subtle than other brands. There is very little formation of dark edges on the outside perimeter of wet sections. It is an attractive paper for use with painterly strokes.

T. H. Saunders

Bockingford This well-made, affordable paper offers some variety to the watercolorist. It is made of an acid-free, high-quality cellulose fiber. It is a mouldmade paper, internally sized only, and available in a cold-pressed finish in 72-, 90-, 140-, 200-, and 250-lb. weights in white, and 140-lb. in color-fast gray, cream, eggshell, green, and oatmeal. The latter are attractively used with more opaque applications.

The 140-lb. paper's texture is pronouncedly similar to a rough finish. Color lifts off very well and cleanly. Water tends to ride on the surface, which makes this paper prone to "blooms."

Waterford is an acid-free English paper moldmade by Saunders of 100-percent cotton fiber. It is tub-soaked in gelatin and internally and externally sized. A very durable paper that can withstand erasure and lifting with very little surface damage, it is available in 90-, 140-, 260-, and 300-lb. weights and in rough cold-pressed, and hot-pressed (in all but 300 lb.) finishes.

I enjoy using the 140-lb. cold-pressed finish. The texture is on the subtler end of the cold-pressed range and is good for a painterly approach. Because of its sizing, color is best laid onto the wet paper quite directly and not overmixed on the paper. This paper works successfully when saturated; it stays wet quite a long time. Yet shapes are vulnerable to dissipating and color to overblending if too much water is sitting on the surface. Color does not lift off very readily, but this is advantageous if you are rewetting and glazing over a dry wash.

Twinrocker

This lovely, handmade paper is made in Indiana. It is of 100-percent cotton, acid-free, and is gelatin-sized internally and externally. A beautiful deckled edge is available on this paper. Twinrocker has great strength and lifting capability. Absorbency is quite low, creating some challenges in preventing color overmixing on the surface. Puddles have a tendency to form hard-lined edges. I like this paper for saturated wet-into-wet work. The rough finish has a delightful, fibrous intertwining or webbing look, with the subtle variations of a handmade paper. This is most clearly seen when using sedimenting pigments. Organic color appears simply rather flat. When used saturated, the paper exhibits an especially nice subtlety and overall balance between the textural look of the varied pigment types. Color lifts from this paper outstandingly well; a clean white returns to the paper.

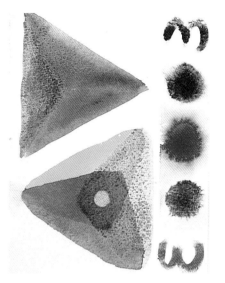
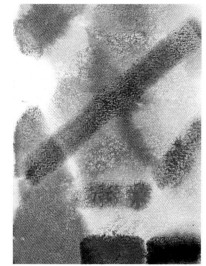

Fabriano Esportiazone rough paper

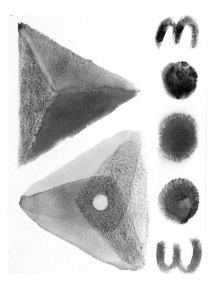
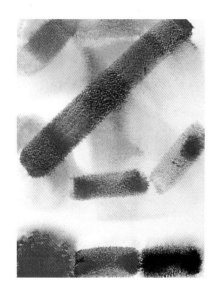

Lanaquarelle 140-lb. cold-pressed paper

Whatman

This acid-free English paper is bright white and made of 100-percent virgin cotton fiber. It is mouldmade and internally sized only, utilizing no animal by-products. The surface is soft and absorbent. It is available in 90-, 140-, and 200-lb. weights and in rough, cold-pressed, and hot-pressed (90 and 140 lb. only) surfaces. I am intrigued by its texture. The front side is typically mottled, but the back side, which can also be used, is an intriguing combination of mottling and a woven pattern.

Whatman yields delicate, soft tones nicely. I have to work a little harder to achieve deep, rich tones. The paper tends to pull the color in, so there is some danger of losing vibrancy. I add sizing or a thin coat of acrylic matte medium to the surface at times to encourage the color to sit more on the surface. (If this is done after an initial coat of paint has been absorbed, a nice feeling of surface depth can be established.) This also increases the capability to rework passages through lifting and overglazing. But there are certainly times when its absorbent nature is beneficial left as it is. Poured color arrests more quickly on this type of surface. Brushmarks soak in and hold their shape well even when immediately followed by a softly blurring wash.

As seen in the illustration of Whatman 140-lb. cold-pressed paper, the texture is fairly strong. Slightly ragged edges tend to form (notice the permanent magenta and cobalt rose areas). Color lifting by scrubbing is somewhat damaging to this minimally sized paper.

When Whatman paper is saturated, it behaves like more heavily sized papers. Its absorbent qualities are diminished because the paper fibers are already full of water, so there is nowhere for the paint to be absorbed.

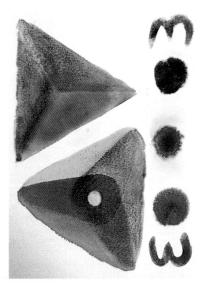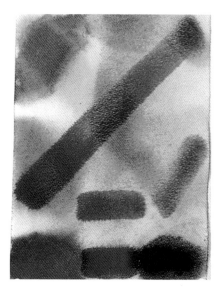

Whatman 140-lb. cold-pressed paper

Winsor & Newton

This mouldmade paper is heavily internally and externally gelatin-sized. Acid-free and buffered, it is made of 100-percent cotton. Rough, cold-pressed, and hot-pressed finishes are available in 90-, 140-, and 260-lb. weights. The color is quite a bright white, tending on the warm side.

I very much like the handling qualities of this paper. Colors maintain their integrity when worked in close relationship on a wetted surface. Pigment will maintain attractive, velvety edges when painted wet-into-wet. This paper takes wet glazing nicely. Backcrawls are not the significant problem that they can be on other papers. Irregular water content in areas on the surface do not wreak havoc. Sponged lift-offs of wet color leave a pleasing white shape. Color does not crawl back into the area as readily as on most papers. This paper seems to have resolved the challenge of having a good degree of sizing that still does not cause the paint and water to run too freely on the surface.

This illustration of Winsor & Newton 140-lb. cold-pressed paper shows the strongly textured surface—a fibrous webbing which I like very much. Wet-edge joinings are attractive here. It is also very pleasing for use with painterly strokes.

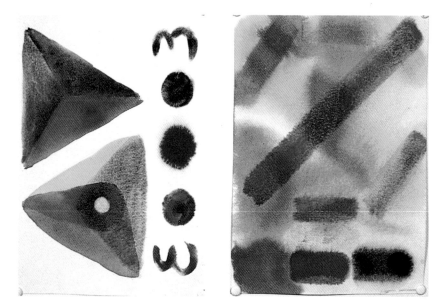

Winsor & Newton 140-lb. cold-pressed paper

SCALE

It almost seems to go without saying that when you choose to work on larger watercolor sheets than you normally do, you need to increase everything. It is easy to slip back into your regular habits and routine without realizing it, so plan ahead. Give yourself more space in which to work. This will help prevent frustration if you need to move your board around. Your brush must carry more paint to help you complete a stroke without going dry. You obviously need more paint to cover the surface of the paper. Mix or prepare generous quantities of the paints you need. Plan which colors you will want so that you are not squeezing out paint unnecessarily.

Consider going to a heavier paper. Whether you'll be working by sections or in a painterly style, the hills and valleys created by the uneven wetness of different areas of the paper can become an annoyance. Working on saturated paper, the heavier paper will retain moisture longer. If you use a nonporous support, Plexiglas or Sintra (see page 34), the paper will retain moisture longer, and it will take you longer to paint the larger surface.

I like using a pouring technique or working very wet on a large sheet. With such a large surface to cover, it helps to exploit the tendencies of wet pigment to flow outward.

The larger the piece, the easier it is to create an image that is overworked and to fuss with extraneous details simply because there is more surface area. If you can utilize the free, broad movement of the paint, it will help set the tone for the painting, and keep you from overdoing the more detailed sections to come. I also find it helpful to use texture to keep the surface active and interesting.

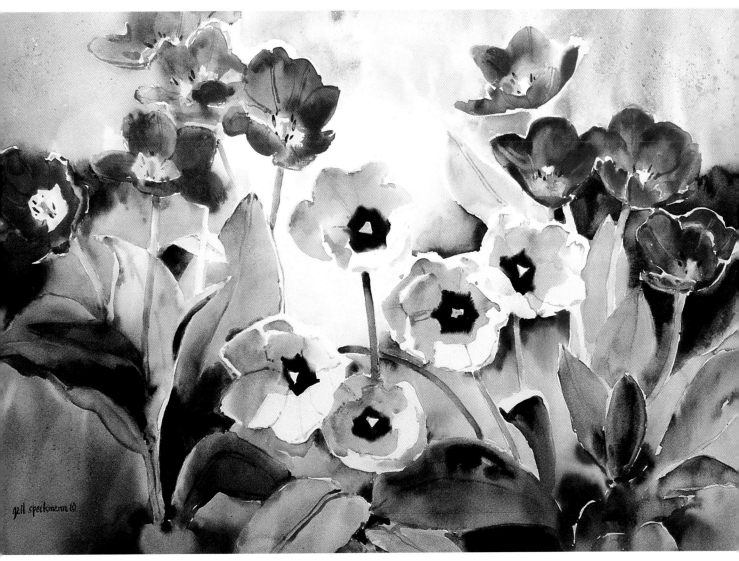

REIDEL TULIPS
29 x 40"

This is the largest size in which I have worked. I chose a subject I am familiar with and enjoy painting.

EQUIPPING YOUR STUDIO

Over the years, I have become a studio painter. I spend my outdoor time experiencing the location, taking notes and photographs, and doing quick paintings and studies. It is later that, in a more reflective mood, and carefully considering my creative options, I do my serious work in my studio. I like having all my supplies available to me and not having to deal with weather changes. I do not have to pick up everything each time my painting session ends. It does make it much simpler to jump back into my work the next time. I also find it helpful to have a special area that is mine in which to work, where there are not the other distractions of daily life. This is often not possible, and one can certainly work under much less ideal circumstances.

Currently, I am most fortunate to have a large room with a nearby bathroom, which provides me with running water and a shower stall in which I can soak paper or hose off paint. It is possible to paint very satisfactorily with simply a table, decent lighting, and a tub to soak paper. The following suggestions concerning equipment and setting up a studio are just a guide to using the best space available to you.

Boards and Attachments

For years I have used "gatorboard", a lightweight, rigid material, as the support for my watercolor paper. My support is cut 1" larger than both the length and the width of the paper I am using. It is about ¾" thick. Clipping the four corners of the sheet with large "bulldog" clips, I use paper that has not been prestretched. The board warps slightly from the wetness that occurs during the painting process, but then I use the other side on the next painting, and the bowing tends to even out. The front and back surface of the board has an almost paperlike finish allowing some water to soak in rather than crawl back onto your paper.

Another type of board, called Sin-tra, is available through framing supply stores. It is very rigid (no buckling), reasonably lightweight, and the matte plastic surface wipes totally clean; there is no danger of contaminating new work, even if it is only the back side that might be affected.

When I know that prestretching my paper will be important for a certain painting, I use Homosote, which I get at a local building supply store. This is a fairly porous, pressed material about ¾" thick. Cutting the board 1" longer and wider than my paper on each edge, I then coat it with a product called Bin (available at paint/hardware supply stores), which is waterproof and impervious. I attach the paper to the board with upholstery nails (long, spiked thumbtacks). I soak my watercolor paper in cool water for a minimum of 15 minutes. I drain off the excess water, carefully holding the paper vertically. Then I lay the paper on the Homosote board and tack all around the edges with thumbtacks at 4" intervals. I either proceed to work on the saturated paper, or I allow it to dry and stretch taut, and work on it by sections or in a direct, painterly manner.

Plexiglas can also be used as your board support. It provides a hard surface to which you can attach your painting, and since it is waterproof, it will slow down the drying time by reducing water evaporation from the back side.

Work Table

My "easel" is a heavy oak drafting table that was a castoff from someone else. Its height can be adjusted, and its tilt can go from horizontal to practically vertical.

A long aluminum table that folds down and has a carrying handle is useful if you want to carry it with you outdoors. I like to be able to spread out my materials, so I appreciate its length. I mostly work fairly flat, so I raise my board to a slight tilt with a fulcrum I constructed of Fomebord.

Taboret

I have most of my supplies in the drawers of a wooden taboret, a unit with drawers, which is on wheels. I use the flat top to hold my brushes, palette, and water containers. If I need additional space for materials, I pull the shallow top drawer partly out and set my palette(s) on that.

Lighting

I started out working by my studio window. Even though I was not getting direct sun on my work, I found that a strong green cast from nearby trees was distorting my color sense. So I reluctantly moved to working under color-balanced fluorescent lighting (available from lighting stores). Mounted at each end of the fixture, and angled toward my easel from each side, I have metal reflector lamps, each of which has a 500-watt tungsten bulb (available at camera-supply stores). I shoot slides of my work with the room illuminated by only the tungsten light.

Water Containers

I generally use two stainless-steel bowls as my water containers, one for clean water (to load my brush before adding pigment and painting) and the other for rinsing the brushes between color changes. The larger the containers, the longer you can go before needing to change your water. If you really plan to paint fast and furiously, you may also opt to have two larger pails available nearby on the floor—one for dumping out the "muddied" water and the other filled with fresh water into which you can quickly dip an empty container for a refill.

Paint Cups

Sometimes I need large mixtures of diluted pigment, either for a large wash or for a pouring technique. I have a variety of containers for these purposes, including Pyrex custard cups, plastic storage containers (be sure these are *very thoroughly cleaned* from food residue—particularly margarine tubs!), plastic cosmetic bottles, and a sectioned hors d'oeuvres tray made by Tupperware. The key issues are (1) having enough space to mix the pigmented wash, (2) having

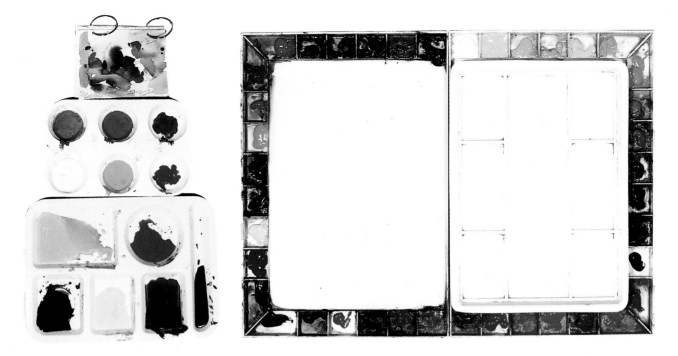

Any of a variety of divided containers can work for mixing up extra pigment.

a clean container, uncontaminated by other residue, and (3) having a lid for the container—all the better for saving leftover paint for short periods of time.

Pencils and Erasers

I prefer to use a 2H pencil on my painting surface for sketching in the key shapes and details. I like this light, hard pencil because it does not smudge and it gives me good clarity of detail. I use a gum eraser for changes. I try to use it as little as possible so as not to disturb the surface of the paper. When I do use it, I erase with a circular motion, so as not to create hard lines of roughened paper that could later be noticeable if a wash is applied over them. Roughened areas absorb paint more readily and appear darker than the surrounding areas.

Special Tools

There are a variety of special tools which are not necessities, but deserve consideration for the possibilities that they can create.

Gloves Sometimes I wear very thin surgical gloves, particularly if I am going to be working with cadmium or cobalt paints, which should not be absorbed into your skin. Wearing the gloves at this time will also keep you looking presentable in public later. These gloves are inexpensive and disposable; you can even reuse them to some extent. Though initially you may experience some loss of touch sensitivity while wearing them, you do get used to the feeling and adapt your sense of touch.

Plexiglas For many art shows, sheets of Plexiglas are required in the framing of your pictures. They invariably get scratched and can no longer be used on the painting. They find new usefulness in the following ways.

As noted earlier, they can be used as your board support. But also, saturated, not-yet-painted sheets can be sandwiched between two sheets of Plexiglas to be kept moist for a few hours if you no longer want to keep the paper moist in the tray or tub. If you are interrupted during painting on saturated paper, leave the wet sheet on the Plexiglas, lying flat. Lay an assembled metal frame (one that is slightly larger than the sheet of paper) surrounding the outer perimeter, and then lay one more sheet of Plexiglas on top of the frame. This will help hold the paper at a moist stage until you can return

to it (up to a few hours, depending on conditions).

Hand-held Shower Head I have attached a hand-held shower head to the shower unit in the bathroom by my studio. This has various controls for the type and force of the water spray. I use this for washing out passages (or entire paintings!).

Blow Dryer This appliance is helpful for speeding up drying time, but I prefer most of the time to allow the paint to dry naturally. There is a danger of pushing the pigment around with the force of the air. A low (but warm) setting may help you avoid this difficulty. Focusing the air flow (my dryer comes with an attachment, though simply directing through an object such as a paper cone or cup with an opening cut in it would also work) can facilitate uneven drying of areas. This can be useful when practicing washing out technique.

An alternative to blow drying is the use of a heat lamp or warm spotlight bulb. I stumbled across this while using my 500-watt tungsten light. If you hold the painting quite close below the lamp, the heat will arrest the stage and dry surprisingly

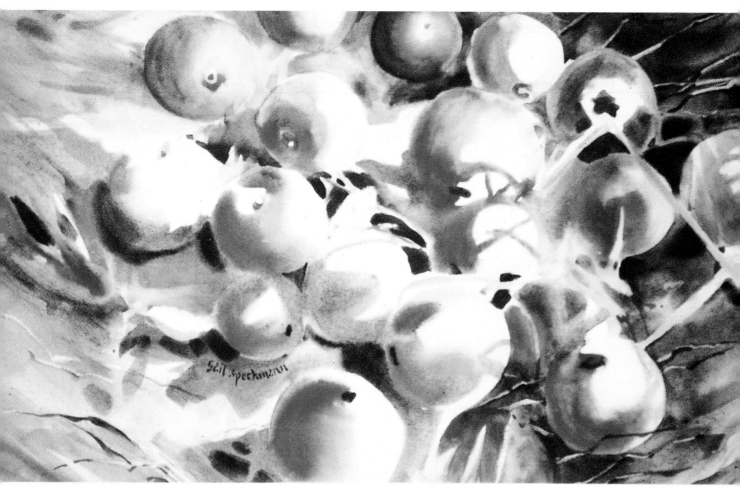

APPLES IN THE GRASS
18 x 28"

The scraper I used to lift off paint at the upper right was an old credit card.

quickly and with little disturbance of the paint you have applied.

Scraping Tools Various tools can be used for scraping or pushing the paint aside while the paint is wet. The beveled edge of a plastic-handled paintbrush, a credit card (which can be notched for special effects), a table knife, a spatula, or a palette knife are possible scraping devices.

The action is much like pushing the paint, as with a squeegee, as you press firmly across the wet surface. This works most effectively on paper that has just been wetted, rather than on saturated paper. Results will also differ on just-wetted paper, depending on how wet the paint is (very wet paint will tend to rush back into the scraped channel, thus leaving a darker mark, and slightly

moist paint will dam up at the edges of the scrape, leaving a lighter mark in the scraped channel). Brushing back over a lighter channel will deposit pigment into the scrape and darken the channel. You can brush over only a portion of the mark, thus creating a light/dark reversal along the length of the mark.

Paints with greater body are most effectively scraped; there is more substance to push aside. Paper with greater surface sizing enables this effect, for the pigment sits up on the paper surface rather than quickly sinking in.

Brayers, or even a rolling pin or other cylindrical object, can be used to push wet paint from one area on the wet paper to another. Brayers come in a variety of sizes; a small

one could be useful in confined areas.

Plastic Squeeze Bottles Plastic bottles with conical lids, such as a honey or glue bottle, are handy for pouring on paint solutions. Bottles with very tiny openings, such as empty "puffy" paint bottles are useful for creating very free linear passages. These can be filled with paint or with a resist, such as acrylic medium or masking fluid. (Beware of it drying out too quickly and ruining the bottle. Keep it covered when not in use.) Brushing over with a wet brush before the poured-on mark is totally dry can leave an intriguing image; the edges of the mark will have dried and will remain, but the interior of the mark will wash away, leaving a lighter value.

Food Baster This kitchen gadget is helpful for directing a stream of water at the paper, if you wish to create rivulets or remove a section of color. It can also be used with diluted paint to direct a stream of paint onto the painting. This has the added feature of allowing the artist to apply the liquid with greater force than is possible with pouring.

Spray Bottles An atomizer or trigger spray bottle helps you apply water or color to the painting surface without disturbing the paint that is already dry. Or it can be used to delicately "interrupt" a wet surface, creating texture. There are a host of different spray bottles which can be used to deliver spatter or spray to the painting surface. They range from very fine misters to coarse trigger sprayers. An artists' fixative sprayer can also be used to direct paint, rather like a simple airbrush. Sometimes I use an airbrush with clean water to lift the paint. After the paint has dried you can blow off the water to create white shapes.

Soaking Tray A wallpaper-paste tray (obtainable at a paint or hardware store) is useful if you are doing any spraying. My tray is 30" long, 6" wide, and 6" deep. Rest your board in the tray, keeping it raised slightly off the bottom by attaching large "bulldog" clips to the lower edge of the board. When it is inclined even to a shallow degree, the excess liquid can run off into the tray.

I purchased a large darkroom tray which holds paper close to the often-used full sheet (22 x 30") size, and I set this in the bottom of the shower stall. If I have larger paper (including full sheet size), I take large plastic sheeting (large plastic bags slit open and laid flat) and line the bottom of the shower and up the sides for a few inches. Then I simply soak the paper in there. The sheeting protects the paper from any oily residue that could be on the floor of the shower.

Electric Eraser The electric eraser can be used to lift spots of lines off a painting, re-creating light areas. It is most effectively used to lift a non-staining watercolor pigment off an acrylic-coated surface.

Oiler Boilers Cheap Joe's Art Stuff carries plastic bottles with two sizes of fine gage needles. These can be very helpful in a number of ways. The larger (18 gage) needle can be used to create fine lines with maskoid. Either size can be used with thinned-down paint. An additional use is creating a fine line lift-off by forcefully spraying clear water onto your painted paper just as it is beginning to dry. Then blot lightly and remove excess water.

I loaded creamy paint into an oiler boiler bottle with a tiny opening and proceeded to draw with it. Before the paint was dry, I whisked over the surface with a moist brush.

3 Basic Approaches

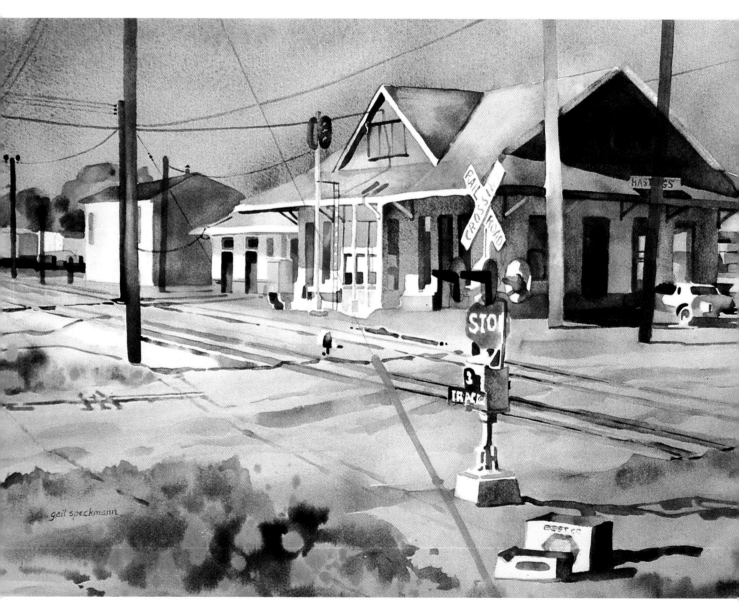

HASTINGS DEPOT
21 x 29"

What are the advantages of laying wet paint onto a wet surface? Paint disperses in lovely and unique ways on the paper. When you stroke paint directly onto a dry paper, the results are fairly uniform, even if the pigment types and the papers vary. However, when you paint onto a wet surface, the paint floats and then settles naturally onto the paper. The results will vary considerably depending on pigment and paper type. Once you learn to work with the variability of this type of painting, your work will take on a richness and depth of color and texture that are impossible to achieve in any other manner. And it is a joy to have the materials participate in the creative process. This dialogue between the media is what engages me. If painting were simply my idea totally transferred in a controlled manner to the paper, I would soon become bored. But my idea combined with the natural behavior of the medium creates endless possibilities. This is the essence of watercolor—the delicate balance between control and the natural flow of the medium.

HOW WET IS WET?

"Wet" is a term which needs to be defined in order to communicate clearly about this process of painting. The three variables in this process are the paper, the paint, and the brushes.

Paper

When you paint on dry paper, it stays right where you put it, but once you lay paint on a wet surface, it comes to life. The degree of wetness of the surface onto which you paint is a key factor in visual results. There are two ways in which the paper can be wet: (1) saturated throughout, or (2) wet on the surface only. Within those two main categories are variations as to the degree of surface wetness.

1. Saturated and pooled: water actually has some very slight depth on the surface. This condition is quite difficult to work with, for the paint runs uncontrollably. Interesting things may occur, but then they dissipate.

2. Saturated and shiny: no standing water, but enough wetness on the surface to have some shine. This is an interesting stage in which the paint can do some very free and exciting things. Keep the paper perfectly horizontal once you have the image you want. You can wick away some moisture by touching the point of a paper towel in places where the paint will not be disturbed. Wipe away excess moisture from the edges.

3. Saturated and quite damp: the watery shine is gone. At this stage you can work very well with quite undiluted or slightly diluted paint. Your images will stay fairly defined. Do not lay in a very watery wash at this point, for it may cause "blooms," or a creeping of the color.

4. Saturated and barely damp: a dangerous time in which the paint is often wetter than the paper surface. Unwanted "blooms" are likely to occur. If you must paint at this time, use only undiluted paint.

5. Surface only/pooled: water standing on the surface, but the underside of the paper is dry and will start to absorb the standing water. The paper may swell. This condition can be used in fairly large but contained sections for some paint "explosions." Quickly wick away the excess water with a thirsty (moist) paper towel.

6. Surface only/shiny: no water standing, but there is some shine to the surface. A nice, workable stage, but one which passes quickly as the water absorbs into the paper. This surface condition works best for contained sections.

7. Surface only/damp: because this stage passes very quickly as the moisture wicks into the paper, it is a troublesome stage that causes "blooms."

8. Dry: once the paper is dry again, it is safe to paint on it directly or lightly rewet it and work on it.

Staying Wet Some variables affect how long the paper stays at a stage of wetness:

1. The weight of the paper. Particularly with saturated paper, the heavier it is, the longer the paper will stay wet. The paper passes through the wetness stages naturally over time, from pooled—or at least shiny—to damp and then dry.

It is clear which portions of the paper had the pooled water on them, judging by the free flow of pigment in those areas.

2. The finish of the paper. The more "tooth" the paper has, the more moisture it can hold without actually pooling. Hot-pressed papers have a higher percentage of their surface area directly exposed to the air, so the surface wetness is more subject to evaporation and run-off.

3. The amount of sizing in and on the surface of the paper. Without sizing, the paper would behave like a blotter, immediately absorbing the water placed on it.

4. The humidity of the surrounding air, which can cause the paper to dry out more or less quickly.

To test if a paper has returned to a dry stage, touch the surface with the *backs* of your fingers to detect any moisture (a feeling of coolness) that might be left in it. Finger*tips* can deposit oils and other contaminants on the paper.

Paint

Another important factor in achieving your desired results is the degree of dilution of the paint (in other words, the ratio of paint to water):

1. Undiluted: Paint straight from the tube has a stiff, toothpaste-like consistency. To be usable in this state, the paint must be moved around a bit with the brush. Stiff paint will hold its shape quite well on paper in its various stages of wetness. Undiluted paint can even be used in a drybrush manner on rough-surfaced wet papers, catching only the tops of

the bumps and not penetrating into the hollows.

2. Barely diluted: In this state, the paint has been diluted only very slightly so that it has a little flow to it. This consistency will give you quite dense coverage, but it will expand outward to a greater degree than will the stiff paint and will fill prewetted sections nicely.

3. Creamy: This consistency is as it sounds, similar to that of dairy cream. This solution will flow nicely as a wash.

4. Milky/watery: In this dilution, the paint is thinned to the degree that it basically behaves like clear water. I typically use this consistency for painting directly on dry paper and then charging in less diluted paint.

To check on the appropriate paint consistency for dispersion, I often touch a small spot down into a discrete area (perhaps one which will later be darker in value) to see if I have my paint consistency correct for the wetness of the paper.

Often I use a more watery paint solution for background areas and a denser paint for the more defined motifs. I also find that I can successfully work with wetter paint and on a wetter surface in sectioned paintings because I know there is nowhere for the color to run. If the paint is "puddled," I allow it to sit undisturbed to dry. I may get interesting

edges as the color separates out into rings. Tapping or rocking gently can encourage the puddles to break apart into interesting textures.

Brushes

I generally prefer to have my brush fully "loaded" when I am painting directly onto dry paper, or, if I am laying a wash into a shiny surface, either saturated or just wetted. The amount of liquid that your brush is holding greatly affects the stroke of the paint being laid down. Brushes should be (1) loaded—that is, saturated—either with water or a milky or creamy dilution of paint, or (2) damp—wet, but drained or blotted. This blotting can be achieved by touching the brush (near its ferrule) to a sponge or towel, either before loading in the paint or after. The paint can be loaded on the tip or the flat face of the brush (blotting the other). Less water is needed in your brush when paint is deposited on a wet surface.

From Wet to Damp

Between two areas of uneven wetness, osmosis occurs. It is nature's way of trying to even out the moisture balance. This should tell you which way the water is going to flow when your wet brush contacts your wet paper; moisture will travel to a wet area that is less saturated.

Damp pulls water to it, whereas *dry* tends to resist water. Notice how a truly dry brush could not really be described as a "thirsty" brush. It does not pick up water from paper like a damp one does. Water laid on dry paper (if there is sizing on it) will initially sit there as the paper resists the water. Water laid on damp paper soaks in quickly.

Another factor in water movement is the type of brush used. Natural brushes tend to retain the water they hold. There is less rushing out of water onto damp paper. Also, a damp natural-bristle brush will pick up water readily from wet paper. Synthetic brushes are less likely to drink up water from wet paper and are quicker to release their water load onto damp paper. For this reason, when I use synthetic brushes, I prefer them to be of almost no thickness, with short bristles, so that they hold less water.

Common Pitfalls

There are several problems to be avoided in working wet-into-wet. First, having your image dissipate after you lay it down occurs when the paper surface is *too* wet, either from plain water or a runny wash. If you attempt to paint a form into this, it will run too freely and lose its shape. Avoiding this usually means allowing the paper to dry a bit before painting into it. Also, the stiffer the paint and the less saturated the brush, the firmer your image will remain on very wet paper.

After an initial wash layer on the paper has lost its shine, laying down an even wetter wash or brushstroke can bring about a bloom. Water rushes out onto the paper surface and carries some of the paint from the earlier wash with it. The place where the water rush finally stops is dense with the paint it has carried and forms an irregular edge.

Blooms can be deliberately created for special effects, of course. You can create an interesting effect by laying a wet wash next to a drying one, to form a bloom-type edge which will extend into the drier section. (This could, for example, suggest the upper edge of tree foliage or a flower edge).

But when blooms are unwanted, just make sure that you do not deposit a creamy or milky paint solution into a damp wash. To correct a bloom, allow it to dry and later gently loosen the edges with a bristle brush. Then lift the paint. Alternately you can, while it is still wet, go in and cover that bloom shape with stiff paint.

You cannot really ascertain what you have accomplished in your work until it is completely dry. It is easy to become enchanted with the process, enjoying what is happening at the moment, but you ultimately have to concern yourself with the end result. Learn to pay attention to the changes that occur. It will give you the clues you need to repeat successes and minimize errors.

In my own experience, there are three basic approaches to creating wet-into-wet watercolor paintings. The first that I will explore is painting on saturated paper.

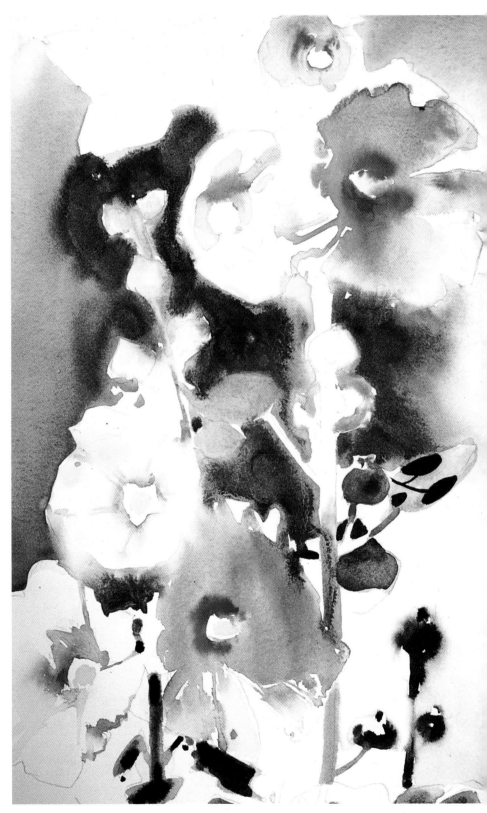

In this painting in progress, the paint dilutions range from undiluted, in the background, to the watery and creamy consistencies on the flowers.

WORKING ON SATURATED PAPER

This particular approach to painting wet-into-wet is particularly well suited for landscapes and soft, loose floral paintings. Once you have developed an understanding of the following methods, which have proven successful, you can go on to cultivate your own style of working on saturated paper.

Preparation

Often I begin by sketching my design on the paper and tinting all areas except for those I will leave white. I use a staining color, such as Winsor blue in a pale tint, so that the color is not washed off in the wet-into-wet process. I also choose a color harmonious to the overall color scheme.

Other times I begin freely, with no specific plan, and see what develops. Or I may have a general idea (for example, tulips) and an approach,

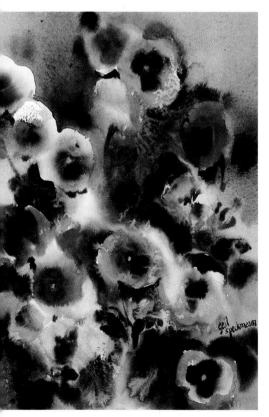

BETH'S PANSIES
10 x 14"

Working on saturated paper is a good approach for paintings in which you seek to create full, lush shapes.

with no specific design; then I just lay in colors and shapes that will suggest the subject I have in mind.

I may or may not choose to stretch my paper when painting on a saturated paper. If I do, the process is fairly straightforward (I have done my best to simplify it). I cut a Homosote panel to be 1" larger than my paper on all sides (in other words, for a 22 x 30" sheet, I have a 24 x 32" board). I paint it with Bin, an impervious white paint. I soak my paper for a minimum of 15 minutes in cool water (at times I have left it in for several hours and no harm was done). When it is ready, I pick the paper up and hold it vertically to drain excess water from a bottom corner. Then I lay it, centered, on my board and attach the outer edges with upholstery nails (these look just like thumbtacks with long spikes; get them at your hardware store). Spacing them at about 4" intervals should suffice. The paper swells to a slightly larger size when wet, and when tacked down at this stage, the paper will dry taut and flat. I have discovered the hard way that the larger and heavier the weight, the greater the pull created when the paper shrinks. In other words, you cannot attach a 300 lb paper with only a tack in each corner. The paper will tear away from the tacks. I like these tacks because they are easily removed from the panel when the painting is done. I usually keep the head of the tack away from the surface of the board by about ¼". This prevents water and paint from pooling under the head of the tack. It also assists in removal (I usually pluck them off with a pliers, though I can do it by hand, if needed.)

If I choose not to stretch the paper, it is most likely because I do not have a convenient basin to soak the paper, or I prefer to keep the paper free, so that I can lift corners or edges to help manipulate the flow of the paint. For this method, I simply wet the back of the paper with a sponge or a wash brush, stroking clean water down the sheet. I turn the paper over and wet the other side

in a similar manner, repeating again on both sides. Soon the paper is limp (in 10 minutes or so). If there are any buckles in the surface, I lift a corner to expose the back of the paper and stroke on more water where an area may have dried too quickly. When the shine has left the front surface, I am ready to begin painting. My support is a Sintra board, which is waterproof and will help retain moisture for a longer working time. The paper will not require clipping at the corners until the paper shows signs of drying (a slight curling of the edges). The paper dries gradually and fairly evenly, so there is minimal danger of its buckling while you are working.

To extend drying time, you can add a teaspoon of glycerin to the saturated 22 x 30" sheet, (or proportionately less for a smaller size) and brush or sponge it smoothly across the surface of the paper before you begin to paint. Too much glycerin can damage the paper, but in small quantities, it can be useful particularly if you are working in conditions drier than usual—painting outdoors on a hot, windy day, for instance.

The Painting Process

Because my board is tilted at a 10- to 20-degree angle, I often decide to begin at the top of the sheet and allow color to flow down. I frequently lay in the background area first, with strokes of color of a creamy consistency. I have frequently taken care to prepare small containers with separate colors, mixed to a greater or lesser dilution, so that I have plenty of paint at a workable stage of thickness ready for use.

As I start to paint, I think about the color, temperature, values, and shapes I am introducing. (Do they express my idea for the painting?) Simple reminder notes can help keep you on track.

Laying in shapes, I find that I can develop forms in which the top edges will hold their shapes fairly well. As the color washes down the paper, I use a clean, moist brush to wash away excess paint at the bottom edge of the shape to give it definition.

Fairly early, I will drop undiluted or strong paint into the darker, more intense areas. This helps define my value range for the painting, and is often a vital part of the center of interest. I try to lay in strong, stimulating color, knowing that this will energize me. The rest of the painting will seem to circulate around this "heart" and support the theme.

A key to painting on saturated paper is to put down brushstrokes with a light but decisive touch. I allow paint to spread completely before determining whether or not it works well. I try not to jump in too quickly to try to "fix" things as they occur. There are other parts of the painting to be brought along, so it is usually fairly easy to allow an area just worked upon to spread out to its completion, undisturbed. This process engages me in moving around in the painting and developing it as a whole.

As I paint, I am always judging relationships. "If I strengthen or alter this area, what will it do to the balance of the whole? Can I balance a strong section of intense red if I add one?" I also maintain an awareness of drying time on different areas of the painting. If I notice that very little or no shine remains on parts, I will gently mist or stroke on water unless it has gotten too dry and I think blooms would be created. In that case, I'm better off leaving that area alone until it is completely dry, at which time that portion can be gently rewetted and worked upon.

I like to take my greatest chances towards the beginning of a painting. At that point I have less time invested in the piece, so consciously choosing to take risks seems more natural. It may also set the tone for the piece because I often get the most exciting results by being daring, and it helps me continue with an attitude of adventure. I do sometimes take some pretty big risks later on while working on a piece, particularly if some part really is not working well. At that point a risk seems worthwhile, for the piece is already not succeeding. I may or may not pull it off; I just may learn something from trying. Sometimes I have a painting going well, but I may

feel that taking a particular risk might make it stronger. Most likely, I will take the risk. Fortunately, the process of painting on saturated paper is so engaging that if I feel moved to try something, I am not calculating how much time I have already invested.

I paint as long as I can—up to a few hours on full-sheet paintings—in the initial effort. I paint as long as my enthusiasm is there and the paper moisture is workable. When either is gone, I stop, knowing that needlessly reworking passages or picking at unimportant details is the quickest way to kill a painting. Later I can go back into the painting and work with a fresh eye.

Pointers

When first learning to work on saturated paper, start small. A quarter sheet (11 x 15") is a good beginning. Work up in size as your ability to handle the procedure increases. Generally, as your paper size increases, so should your brush size.

The top of your watercolor paper will dry the most quickly because of the tilt of the board. Work that area first or remoisten it occasionally with a mist of water if you are not ready for it to dry. You can also lift the paper partially off the board (if not stretched) by picking up the top two corners and gently brush clear water onto the backside of the paper.

For better control and less running, keep the board more horizontal. The wetter the paper, the less incline you can afford, for the paint will run down the paper all the more quickly. I generally prefer some tilt, but for the most control, flat is best.

Basics of Form Remember to give form; connect shapes; give edge. Always seek to link and define as the process moves along. Start out with large shapes which will eventually evidence themselves as separate but connected or overlapping objects, as further definition is worked in. (For example, a group of houses begins as one shape, but with further definition individual houses can be discerned within the larger shape.)

Also, work by creating separate forms next to each other and link these by overglazing or superimpos-

ing connecting shapes. (This is more difficult on saturated paper since it is likely to disrupt underlayers. You might want to wait until the separate forms are dry and rewet and overglaze them later.)

Soft edges are lovely, but be sure to give enough form and definition so the image is not just "mush." Make color deeper and more intense than you think you should; paint dries lighter and with less intensity than it appears when wet. Be sparing in adding line to strengthen forms. The fewer strokes you use to "say it," the better. Avoid obvious, harsh, and unbroken outlining. I prefer to use edging subtly as I increase definition. This can often be achieved by painting edging that is close in value (though not necessarily in color) to the shape you are defining or to the background surrounding the shape. If you create a more obvious line, vary it in width and value along its length. You can even have it briefly disappear and restart; the viewer will mentally connect it for you.

Seeking to show too much detail in a subject is detrimental, too, if it clouds the overall impression. Know your subject well, but be willing to sacrifice details for the larger feeling or idea of a piece. Trust your instincts; you will generally know when something "rings true," and this will help you depart from your sketch or the scene or photo in front of you. All parts should feel correct or in balance but not be equally defined. If you are feeling uncertain or are experimenting in adding something, use a paint that will lift off easily.

The larger the painting, the more important is a path or movement of interest, rather than just a "center of interest." As in music, a simple tune is fine for something brief, but you would want more richness for a larger piece. Occasional reflection on where the painting is heading is important. Anything that causes you to look at the piece differently (upside down, on its side, in a mirror, at a distance, or through a reducing lens) will help you see it more objectively.

Reserving White Areas A special challenge when working on saturated paper is to prevent the loss of

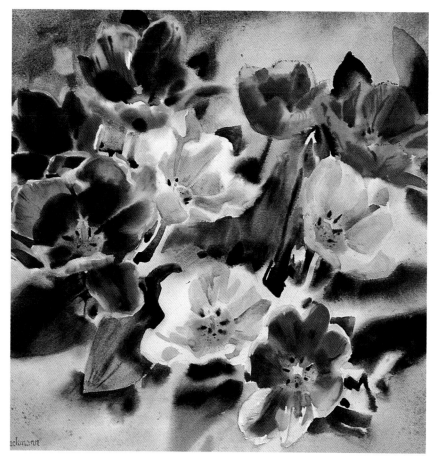

SUE'S TULIPS
15 x 16"

The white tulip edges had a protective perimeter of white painted at their edges.

- Sometimes I use retarder medium or white paint (slightly tinted to match the paper color) and paint it around the perimeter of the white area. This paint will bleed out slightly into the adjoining sections for a soft blending, but it will help act as a wall to protect your white area(s).

Handling the Paint Create your dark areas as directly as possible. Stroke them in once, rather than putting on layers of paint to increase value depth. These areas with the most concentrated paint are the most liable to be unattractively disturbed by working over. Once you have laid in your darkest or most painted areas, try to keep other areas from washing into them. Brush thinner paint and excess water away from these areas.

Use short-bristled brushes with thicker paint on wet paper. (When the paint is thicker, reload the brush more often, for it will not flow out of the brush in the same way that diluted paint will.) These can hold enough paint, but not so much that you waste it by having to rinse away excess paint.

Be reluctant to add opaque paint, particularly of very high (toward white) or low value (toward black). These tend to sit unharmoniously on the surface. This can be minimized if edges are blended gradually.

all white areas because of the drift of the paint as it spreads. You can reserve white areas by these methods:

- Carefully tilt the board in different directions as you paint, so as to keep the flow of the paint away from the main (often fairly central) white area. This is not always easy, but it will help preserve some white without using a masking agent.

- Use paints that lift easily and completely in the area(s) surrounding your whites. This way, you can readily remove (perhaps with a damp, natural sponge for a soft-edged lift) stray paint that otherwise would contaminate your whites.

- Use masking fluid or other blockout before saturating the paper. Once the paper is saturated, you can paint freely over the entire paper. When the painting is dry and the masking fluid has been removed, you will have to make a

conscious effort to soften the crisp white edges at some points to integrate these shapes into the piece. A damp hog-bristle brush can be used to loosen the edges as you blot up loosened paint with a tissue. Glazes of light tones can later be washed over the white areas or parts of them and into adjoining sections to help unify the piece.

- After the initial wetting of your paper with clear water, you can stroke or drop masking fluid into the area(s) where you wish to preserve whites. This will give you looser, softer edges than if it were applied to dry paper. You need to allow it to set somewhat (test this by touching with your fingertips). Your paper does not have to dry again; the masking fluid dries more quickly than the paper. Proceed with painting if you prefer a damp paper. Or let the paper dry and then rewet and begin to paint.

Here, diluted paint has been poured onto a saturated surface.

EXPLORATIONS ON SATURATED PAPER

You can do small "explorations" into the process of painting on saturated paper to improve your technique. Working indoors is probably simplest. The fewer variables you take on at one time, the more you are able to discern what is happening as you paint on the paper and why. For this reason, it is helpful to pick a particular theme or challenge, as suggested in the explorations, and always ask yourself, "What am I learning from this particular experience, and how could I later apply this in a painting?"

I suggest keeping a file of the explorations you do. Perhaps most could be done on a quarter sheet (11 x 15"). The book's explorations increase your knowledge and can be fun projects to work on when you feel low on ideas, or when you have too little time to undertake a whole painting. They can also help when you have a particular challenge you want to work through in preparation for doing a painting. I also allow myself the option, if an exploration is looking especially intriguing, to develop it into a small painting.

Exploration 1
Diluting Paint
Try out various dilutions (straight-from-the-tube intensity all the way to quite thin) of a specific paint, to see the results as you stroke it onto saturated paper.

Exploration 2
Relating Two or More Paints
Stroke two paints side by side. Then charge (touch down with your paint-loaded brush) your thicker paint into another color on your paper. Layer one stroke of color over another.

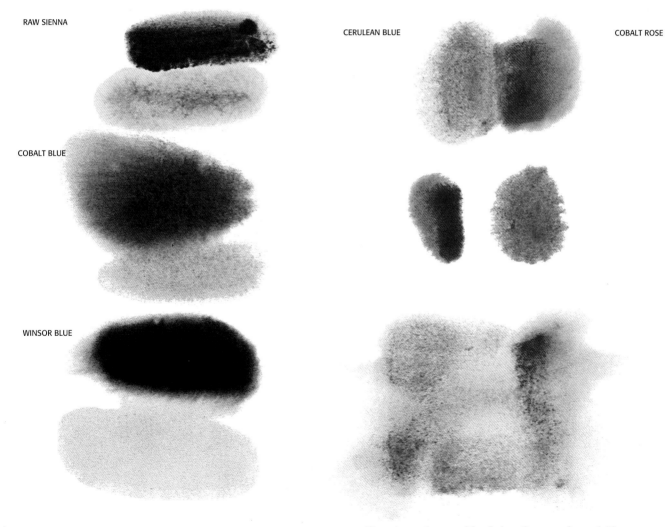

RAW SIENNA

COBALT BLUE

WINSOR BLUE

CERULEAN BLUE

COBALT ROSE

Diluted paint on thoroughly wet paper

Here, two colors are blended as they are charged (the paint on the brush makes contact with the wet surface, which draws the color into the paper).

Exploration 3
Softening Lines

Stroke in a line, then brush it into the surrounding area on one side.

Note that as you soften the line in one direction, the other side remains more distinct.

RAW SIENNA

COBALT BLUE

WINSOR BLUE

Exploration 4
Varying the Tilt of Your Board

Explore the effect of the incline of your board upon your work, ranging from flat to a more vertical incline.

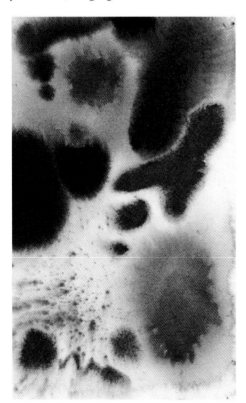

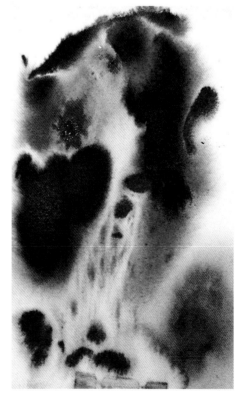

Paints on a saturated flat surface (left) and a vertically inclined surface (right)

Exploration 5
Blurring an Intense Area

Stroke in an image or shape with undiluted paint. Then whisk over this lightly with a sponge or moist, soft brush to soften the image. Or use the brush to soften part of the shape or even just the edges, pulling some color out into the surrounding area.

Exploration 6
Observing How Angles Soften

Try laying down angular brushmarks. Observe how the saturated paper softens the angularity.

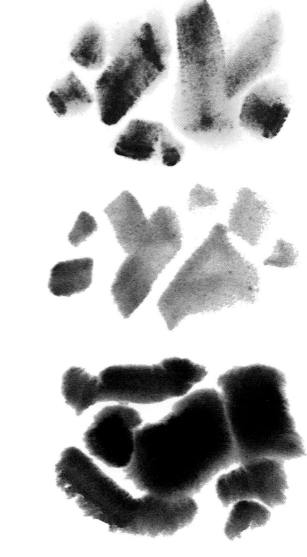

Sharp edges are dulled by blurring into the wet paper.

The paint-rich areas are softened by being brushed over.

Exploration 7
Spattering and Blotting

Try spattering paint of different dilutions and types onto your saturated paper. Blots squeezed from a paint-loaded brush or simply dripped on can also be interesting.

Paint can be spattered to give you accidental effects.

Exploration 8
Creating Abstract Three-Color Studies

Limit yourself to three paints, perhaps triads (ones that are fairly equidistant on the color wheel, page 80). Certain proven triadic combinations include (1) rose madder, cobalt blue, and aureolin yellow, (2) Winsor blue, Winsor red, and Winsor yellow, and (3) yellow ochre, cerulean blue, and Indian red.

Play with these three paints in as many ways as you can (use Explorations 1–7), observing the varied results on saturated paper, as it goes gradually from wetter to drier stages.

A triad of Winsor blue, Winsor red, and Indian yellow were charged into saturated paper and intermingled.

CREATING A COMPLETE PAINTING ON SATURATED PAPER

I felt that a painting of fish underwater would be an excellent subject for a painting on saturated paper. The imagery is soft and fluid, and I decided to keep the fish fanciful—you will never see fish quite like these!

Step 1 I work with my board quite horizontal to help maintain the shapes as I paint them in. (There is a slight vertical influence during the brief time I photograph the painting in progress.) For this painting I do not want to get too locked into a preconceived plan, so I begin with a bare sketch, outlining the shapes of the fish. I have overlapped some of them for more interesting shapes. I pull out a paint color, Holbein's Compose green no. 1, which I do not have on my palette regularly, but which seems just right for the light green water. With this color and cerulean blue, I use wash brushes to stroke in the water background. I use the paint in a creamy consistency, and it dilutes on the saturated surface. The paper is at its wettest during this step (it will dry gradually as I work, though the addition of paint does put moisture back in). I also use Winsor blue, for some deeper value, with a slightly thicker consistency, and I make sure that my brush is not too wet before I load on the paint. If Winsor blue goes on too wet, it will flow out more than I want. I paint around some of the fish shapes as I begin to define their shapes. This is called *negative painting*.

Step 2 I paint the rocky background at the bottom with raw umber, sepia, cobalt rose, and mineral violet— loosely stroking side by side, with some overlapping. Then I paint in some of the fish colors. I consciously leave flowing openings between the fish shapes and the background—I don't want the fish to look pasted on. This suggests fluidity and the iridescence of the fish, which seem to be at one with the watery surroundings. Fanciful color and markings are chosen for the fish. Some detail is painted in with thick, rather undiluted paint, using a round brush.

Step 1

Step 2

Step 3 I spatter some water into the upper third of the painting because it is beginning to get a little drier than it should and I have work to do there. The paper is moist enough that most of the spatter dissipates and blends into the paint. The textural marks that occur suggest water bubbles, a happy occurrence. Outlines of the fish are made with thick paint and then brushed inward on the fish bodies with a quick, whisking motion, using a flat sable brush. My striper brush is used for the markings on the lower right fish. More distant upper fish are allowed to remain less defined.

Step 4 I intensify the value of the wash areas, especially around the outer edges; I want to keep the brightest areas within the more central part of the painting. Additional detail is painted in to further define the fish. I use restraint, however, because I do not want to overburden this painting with detail. Some overglazes are used on the fish, some deepened so that they are now darker than the surrounding water.

I strive to create dark/light reversals between the fish value and the water value. This often alternates even within individual fish. At the end I stroked in deeper blue with an oval brush in the lower left. Nothing specific, but I felt like some darker value was needed, and I didn't want to darken the whole area. The shapes are in keeping with the watery feel. Since this painting is a fantasy, I felt especially free to add them. I try to bring this playful attitude at times to more structured paintings—it helps keep them from getting too stiff.

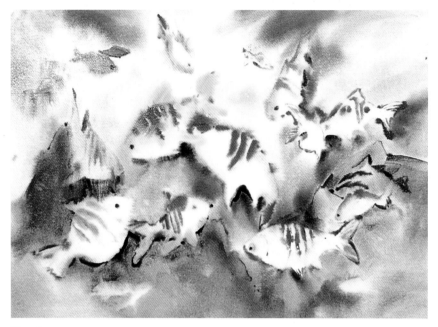

Step 3

Step 4

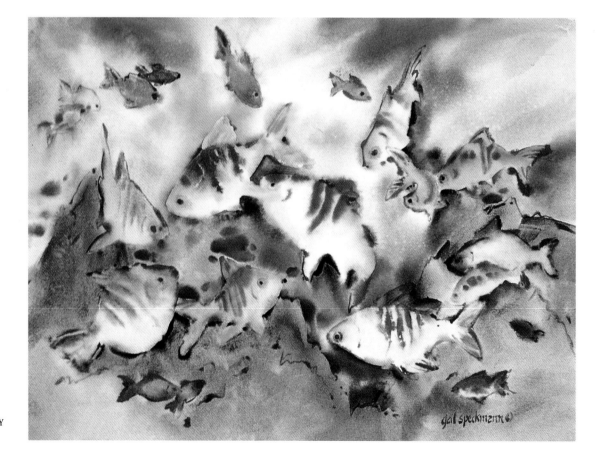

FISH FANTASY
21 x 29"

PAINTING BY SECTIONS

Painting wet-into-wet does not mean that your entire paper must be saturated, although that is the approach that comes immediately to mind. It simply means that you are laying wet paint onto a wet surface, whatever the size of the area being worked on or even the degree of saturation.

Strong light and shadow often play a predominant role in my work. In paintings with these as a strong element, I sketch, tint, and work by sections. Buildings, boats, still-lifes, and certain florals are typical subject matter for this approach.

I am able to exercise control over the boundaries of the areas being painted while retaining fluidity of expression. I have the vitality of wet glazes of paint within a confined area. This is achieved by outlining a specific area with clear water and then filling it with water. Then paint is dropped or lightly brushed into the wet area. Increasing detail is

added into the area as it is drying (the time span is much briefer than on saturated paper) or put in at a later time.

Another advantage of working in this method is that it is easy to retain crisply defined white areas simply by avoiding working in those sections.

Sections are worked separately and then linked together either by (1) pulling some paint out of one section into an adjoining one and then developing that new section, (2) working wet sections side-by-side and allowing some of the edges to meet, or (3) rewetting sections after they are dry and joining them together with an overglaze. I view these as important steps in the "weaving" of paint on the paper, for the challenge is to create a painting that feels interconnected. Pathways to lead the eye smoothly through the painting—shapes, color, textures

repeated throughout—support a main theme or center of interest. "Threads" of hue and value are woven in and out of the sections to help unify the painting.

Planning the Picture

On tracing paper, I begin by working out my design on a small scale. I may go through several generations of the design, drawing on tracing paper laid over a previous design until I arrive at a design that fulfills my goals. It should have economy and describe the important forms.

The shapes should be interesting and interlocking and be as few as required to address the subject. There should be a good distribution of values. I need to make sure that the plan reads clearly: light against dark and the strongest contrast in the area where I want my center of interest. Using an opaque projector I then transfer my plan to the water-

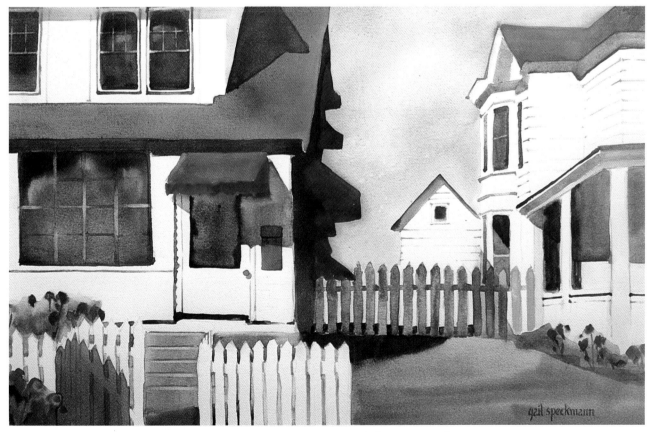

A NEIGHBORLY SPACE
19 x 29"

A clear example of how painting by sections helps you control the boundaries of color areas.

KALEIDOSCOPE QUILT
19 x 29"

Working on an abstract design allows you to concentrate on weaving the painting together for unity, on edge control, and on pigment qualities.

color paper. Important decisions have already been made at this point, and I can put in my sketch decisively. This way I will not damage the paper with erasure marks or excessive pencil lines.

The next step is to tint in the sections based on the values I have planned for them. In the simplest of plans, I might choose only to indicate three values: light, midtone, and dark. (This is often sufficient since I like to leave myself some latitude. If the pronounced differences read well, then the finer points usually work out). The tints are made of paint so diluted by water that they have very little influence on the finished piece.

In a three-value plan I might choose white for my light tone, yellow ochre or permanent rose for my midtone, and cerulean blue for my dark tone. The more values included in the plan, the harder they become to distinguish from one another. For ease in reading the tinted areas, I equate the warmer hues with the lighter tones and the cooler hues with the deeper tones. From light to dark could be as follows: yellow, orange, red, green, blue, violet, indigo.

The Painting Process

Once I've determined my color scheme and squeezed out fresh paint onto my palette, I begin by wetting a section toward the top of the painting; usually this is a background area. (Perhaps I will create a neutral that still retains a color dominance simply by glazing on the triad colors I have chosen.) At the bottom of this section I may take my brush and pull some of the paint into the next section, thus linking the two sections. Careful not to drain off too much of the upper section's wash, I keep the wash from being too runny.

I work the sections by painting in clear water and then charging in paint, often creating two wet sections side by side with only a thin line of dry paper between them. When I feel that the degree of moisture in each has lessened, I test the possibility of connecting the two: touching a point here and there, I can see if one side wants to rush into

the other. The degree of wetness and the expansiveness of the particular paints used should be fairly equal, unless I want one color to flow more deeply into the other.

If I fill a section with water and it starts drying before I can charge paint into it, I just drop water off my brush to rewet it. The water will quickly refill the area I had defined. This gives me the luxury of being exacting about the shape, while still taking time to consider my choices.

I proceed with the sections, linking them to each other as described above. I usually try to develop my area of darkest value early in the process so that I can gauge my other values against it. I try not to work back into the darkest areas for fear of disturbing the concentrated paint, particularly if earth or mineral pig-

ments have been laid down in these sections. If only staining (organic, or carbon) colors have been laid down and have dried, they can be over-glazed because their color sinks into the paper and is not disturbed by new layers.

As I link various sections, I spend a lot of time tilting the board in different directions to help control the flow of paint. This is partly to develop interesting patterns of color glazing. It is also important in helping control the flow of paint when edges of sections meet. The directional flow of specific paints as they meet is a key issue for fusing edges together. When two paints meet, it is less crucial that they stay politely within their borders if they are of approximately the same value because they will read as one shape anyway.

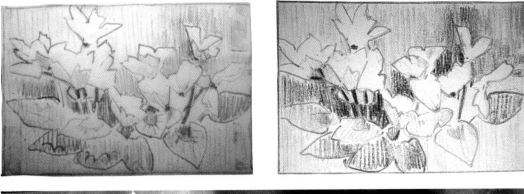

I developed this value study for Airy Cyclamen *first with a graphite pencil, with which value changes could be easily made. I then retraced it and indicated values in colored pencil.*

I begin the painting with the dark-valued upper section.

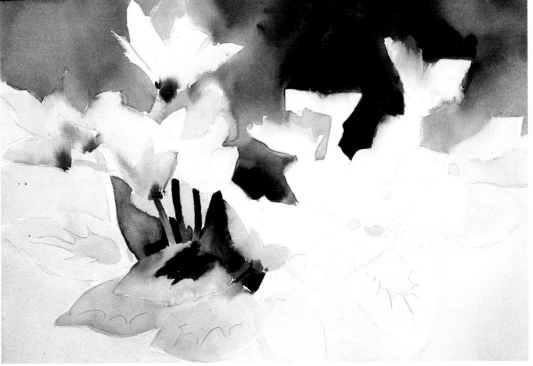

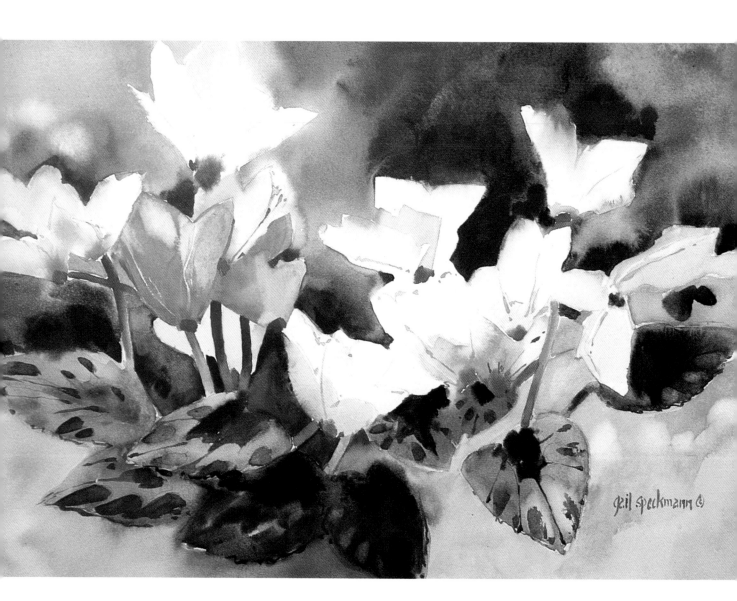

AIRY CYCLAMEN
15 x 21"

*Note the pink overglaze used to unify
several of the flowers on the left.*

Finishing Touches Once I have the
sections painted in, I let the painting
dry. Next I flow clear water where I
wish to alter color or value. I can also
flow water over adjoining section
edges and glaze in color to unite
them. In rewetted areas I can work in
more detail or reinforce edges by
flowing in contrasting value or color.
Calligraphic-type strokes will be
somewhat blurred, but the drier the
section when the strokes are applied,
the sharper the resulting image will
appear. Using paint that is undiluted
or only slightly diluted will help
maintain the shape of the strokes.

There are two other methods I use for finishing details. In one approach, I let the section dry, then stroke on clear water in lines and spots and then charge in paint. I might even vary the color or value charged in within this area. Because I am using the same process of wetting the paper and then charging in color, the calligraphic finishing details have the same quality as the large shapes of the painting.

Another approach, best done with earth and mineral pigments, reverses this procedure but also creates a compatible wet look. This entails painting the finishing details directly on the painting, allowing them to dry, and then whisking lightly over the surface with a moist, soft brush. A few light passes can be made, depending on the desired result. This causes the edges of the strokes to bleed a little, giving a wetter look and making them harmonious with the total painting.

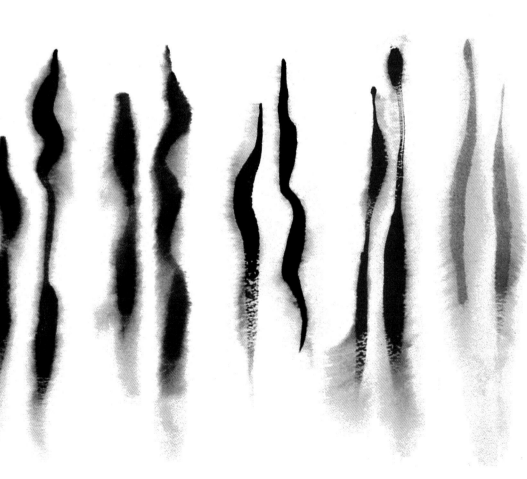

Here the lines have been laid down with clear water and color charged in. In the two lines on the far left, I charged in additional color.

I painted these lines directly onto dry paper. After they dried, I gently stroked over them with a wet brush once or twice, causing the colors to bleed.

EXPLORATIONS OF PAINTING BY SECTIONS

The following explores isolated techniques of working in sections; doing these, it is easier to learn a particular aspect and speed your understanding of the process.

The first step in learning to work in this sectional method is to explore the various ways in which you can apply paint to a confined wet area. There are some interesting edge effects that can be achieved through this method because of contrasts you can make between wet and dry looks.

In doing these explorations, use freshly squeezed paint from the tube. Use two water containers—one for rinsing paint from your brush and one to load your brush with clear, fresh water. Keep your board level or at a slight angle of about 15 degrees.

Remember as you work to pick up the puddle of water or paint at the base of a section or you will get a water "bleedback" or bloom.

I find it helpful to use a flat watercolor brush with somewhat shorter and stiffer bristles. It is easier to mix the paints with water using a brush that has sturdy bristles, and you will waste less paint if the bristles are not long. When you use the paint fairly undiluted, it is mostly coming off the end of the brush only. The rest often gets rinsed away and wasted.

Exploration 1
Charging the Paint

Brush water into a confined shape on the paper. Tint your water ever so slightly or control your lighting so you can see the sheen of the water on the paper. Prepare the fresh paint by diluting, more or less, with water.

Now charge in paint to spread and fill the shape. You may do this in two ways:

1. Start at the top of the shape and allow gravity to spread the color downward. Increasing the tilt of the board will encourage this.

2. Start at the center of the shape and allow the paint to spread to the perimeter. A rocking, circular tilting of the board will encourage this, though it is not necessary much of the time. If the paint is quite stiff (undiluted) or if it is a heavier, sedimenting type, you may need to touch the brush lightly down at various spots within the wet area to fill it. The size of the section is also a factor. You will need to charge paint in at more spots in a larger space.

Do this exploration in chart form, if you wish, as a study of how the various paints behave on a wet surface.

SILVER PITCHER AND NAPKIN
10 x 14"

The cyclamen shape on the left had permanent magenta charged in from the top, and it is running down to fill the shape. The flower on the right had color charged in from the middle; this expanded outward.

Charging in color from the middle of the form helps create backlit objects. Charge in only a little so that it does not run all the way to the edges of the water-filled space.

Exploration 2
Overglazing a Wet Section

This is the same procedure as in Exploration 1, except that now you will charge another paint over a (still wet) section such as you have just completed. With a light touch of the brush, touch in some new paint (diluted to some degree for flowability) over the initial one. The touch has to be somewhat more delicate than in Exploration 1. You can push the paint around a little with your brush, but in this second or even third glaze, you have to be careful not to disturb the earlier layer(s).

This procedure of glazing while the underlying layer(s) are still wet can create exciting paint reactions that you cannot replicate when the layers have been allowed to dry between applications.

Blue-gray is charged in over the still-wet permanent magenta in the shape on the left.

Exploration 3
Pulling Down Paint to Create a New Shape

Begin with a confined area of clear water on the paper and charge in paint. You can even glaze in extra colors in layers.

With your brush, "pull" some of the color from the first section into a new section below. Now charge in a different color over this, while it is still wet, to differentiate the new section. Continue on down (or even to the side) in this same manner, creating new linked sections, each with its own particular hue and value.

Here I have pulled paint from the top shape into two more shapes below. I added aureolin yellow to the middle one and permanent magenta and then Chinese white to the bottom one, which connects with its neighbor as the wet edges meet.

Exploration 4
Painting an Edge of Clear Water

Lay down a strip of water. Charge paint into it. Then lay down another strip of clear water next to the painted strip. Observe how the flow of clear water into the painted strip develops. Experiment with these variables:

l. Try a variety of paints.

2. Vary the degree of wetness of the painted strip by either controlling the amount of water in the paint solution or timing the degree to which the solution has dried.

3. Try directing the flow by blowing through a funnel or a straw or by tilting the paper.

4. Try doing the following variation using a color square (see below) on a tilted board.

I paint a 4" square of water and charge in Mars violet. My board is slightly tilted.

I pick up the wet bead line at the base with a tissue.

I extend the left edge by a half-inch, with paint applied directly to the paper.

With a 1" flat brush, I run a clear band of water all around the outside of the wet square, leaving a thin line of dry paper between band and square. I move a moist, small round brush along this dry space, joining the wet edges of the square and band of water.

Exploration 5
Connecting Two Wet, Paint-Charged Sections

Lay down two strips of water next to each other, but divided by a narrow band of dry paper. Choose two paints and charge them in, one into each strip of water. Now attempt to connect them with a moist brush running between them.

Repeat the experiment until you are pleased with the balance of paint flow between the two paints as you join them. Perhaps one of the paints will need to be more concentrated than the other. There is no one "right" way. It just depends on the result you are best satisfied with. You can try tilting the board to direct the flow.

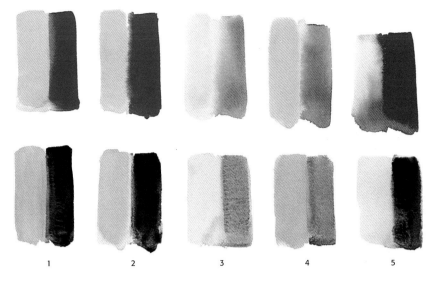

These test strips, of Naples yellow, Winsor red, and Winsor green, have a thin line of dry paper between them and, while still wet, are joined by a moist pointed brush. From left to right, the strips are tested as follows:

1. Strips of equally dense color are painted on dry paper, then joined.

2. Strips of water are laid on the paper, then full-strength paint is charged in and the strips are joined by a thin line of water.

3. Dilutions of both colors are floated into the water-charged sections, then joined.

4. Two strips are filled with clear water. Full-strength yellow is floated onto the left strip and diluted red and green are floated onto the right strip. Then they are joined.

5. A diluted yellow is floated onto the left water-charged strip, and full-strength red and green are floated onto the right strip. Then they are joined.

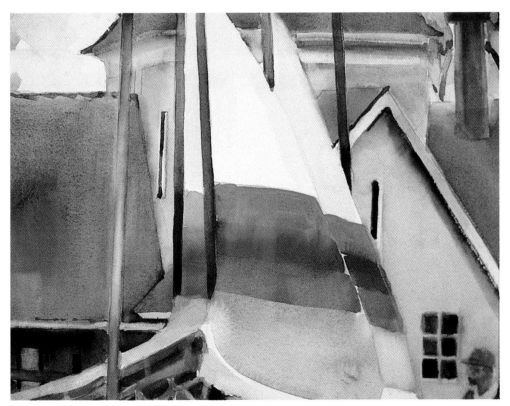

This detail of a marine scene shows how I allowed the stripes in the sails to join freely.

Exploration 6
Rewetting Areas and Unifying with a Glaze

Paint several side-by-side sections of different hues and/or values. Allow them to dry.

Select a paint for your overglaze. It is best to avoid the staining colors, which tend to overpower anything below them. Mix an adequate supply of the paint with water for flowability. Rewet all the adjoining sections with clear water, using a light touch with your brush.

Charge in the overglaze color, touching down at several points to allow the paint to fill the areas.

Exploration 7
Overglazing with Differentiating Paints

This is actually just the reverse of the previous exploration. Define a large section (one in which you will later wish to have some differentiation) by filling with water and then charging in a single color. Allow this to dry.

Rewet this large area with clear water and then drop in differentiating paints of varied hue and value to create sections or shapes within the larger one.

The results of Exploration 7 may be fairly similar to those of Exploration 6, but there will be subtle differences as to the strengths of the paints below or above them. The advantage to knowing both approaches is that these two opposite needs may arise in one painting. At times you may need to unify a piece that has become too fragmented. At other times you may need to develop greater detail and richness in a larger, massed shape.

I painted the top row of tulips with clear water and charged in different colors. Then I did the bottom row with clear water and charged in French ultramarine. After allowing this to dry, I rewetted it and began charging in other colors.

I then rewetted the shapes and overglazed the top row, shown here, with a blue that subdues and unifies the tulip shapes.

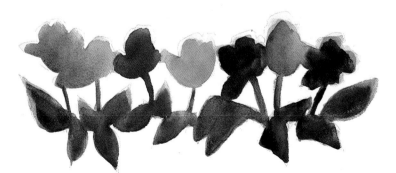

I finished the bottom row, shown here, by overglazing with various hues.

Exploration 8
Painting a Simple Abstract

I suggest doing an abstract so you won't need to concern yourself with creating likenesses of real things. Sketch a plan using a simple four-value abstract design with ten or fewer basic, interlocking shapes. Limit the size of your paper to 11 x 15". Tint in the values with very diluted washes of the colors you have chosen to represent them. For instance: White (as itself), yellow ochre (light tones), light red (midtones), and French ultramarine (dark tones). Paint using the methods described in Explorations 1–7. When the painting is complete, see how close you came to reaching the values you set out to achieve.

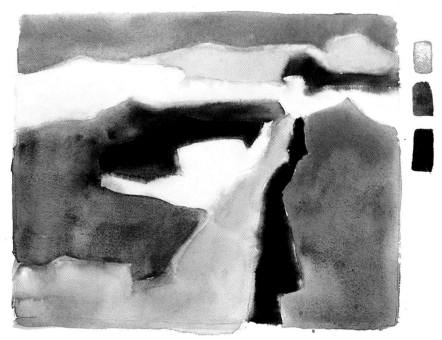

This design employs four values and ten shapes. Yellow ochre, Mars violet, and light red oxide were charged in. Chromium green oxide was charged in over the light red oxide. Using a hog-bristle brush, I cleaned up unwanted ragged edges.

Exploration 9
Adding "Interrupting Shapes"

Expand on the previous exploration by including some smaller, "interrupting" shapes within the larger shapes. Also try creating a large shape formed by two shapes and joined visually by a series of smaller shapes that are all of the same value.

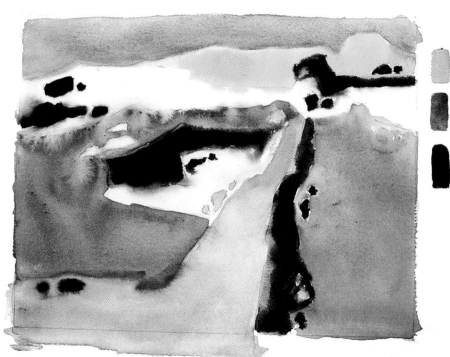

Using a new set of colors but maintaining the same values, I work in glazes and touch colors into wetted areas to interrupt existing areas. For joining, I use an overglaze of blue-gray.

CREATING A COMPLETE PAINTING IN SECTIONS

Now we shall find out how all the techniques put forth in the explorations really work together in a painting. I come to the beginning of a painting with a general idea of how I will approach the process, but mostly I come armed with a knowledge of my options. Once the painting has begun, I respond intuitively with the method that best suits the need as it arises.

Step 1 The large shapes have been defined, and the values have been tinted in with this key (from light to dark): white, yellow, orange, red, green, blue, violet.

Key decisions have been made. The painting will have a diagonal emphasis. However, I chose to play down the pattern created by the road, sidewalk, and driveway, because it seemed to be the most demanding shape in the picture. I played down the value contrast between it and surrounding areas, so as not to allow it to dominate the painting. Mood is the dominant theme of the painting, so I wanted to capture the contrast between the backdrop of dark clouds and the row of houses illuminated by strong sunlight during a time of fast-changing weather.

Step 2 I went back and added more detail within the large value shapes. Small darks in the light areas and small lights in the dark areas help weave the piece together. I chose not to tint in the sky, which I planned to be a mid-dark value, because washing in a larger area can cause some buckling of the paper. That can make laying in a smooth wash difficult.

Step 3 I turned the painting upside down and carefully painted with clear water around the edges of the roofs. I then brushed in more water to fill the sky area. I lightly brushed in successive washes of Naples yellow, Indian red, cerulean blue, and indigo using my 2" flat brush. I tilted my board to get pleasing sky washes.

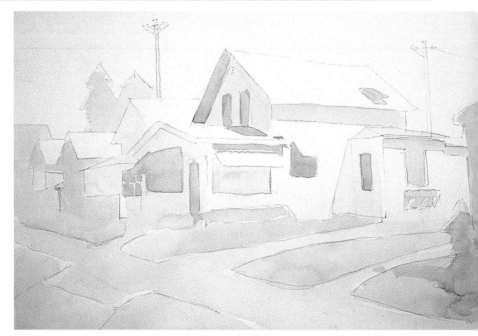

Step 1

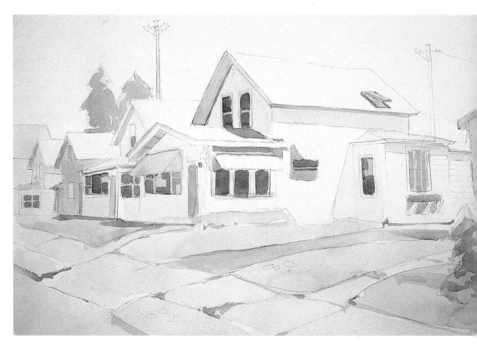

Step 2

Turning the paper top side up, I pulled an edge of the sky wash down and carried it into the shadow under the eaves of the large house, using a little lemon yellow. This paint wanted to expand into the sky, and that helped counteract the movement of gravity, which wanted to drain the sky wash downward.

I painted the evergreens behind the houses into the wet sky with burnt sienna and chromium oxide green. This created soft shapes that recede into the background.

I washed in the shape created by the shadowed upper-story face of the large house and the shadow area under the eaves on the broad side of the house with Naples yellow, permanent rose, and cerulean blue. I charged some additional warm color under the eaves with some raw sienna. Then I pulled some of this wash into the roof of the attached wing of the house. On top of this roof area, I glazed in a little light-red oxide and allowed some of this warm orange tone to push back into the eave shadow, creating the feeling of warm, bouncing light.

The windows under the gable of the front face of the large house were painted with indigo and manganese blue. This was applied fairly dry to keep the indigo from spreading too much. Then I pulled a little of the window paint into the shadow on the roof, but quickly changed the hue to Indian red and Mars violet, to create a deep reddish tone.

I charged a thin wash of turquoise paint into the sunlit porch's awning. While it was still wet, I painted the darker shapes of the windows underneath. To my regret, gravity didn't prevent the indigo from bleeding upward. I quickly picked up what excess I could with a moist tissue, but I would have to wait until it dried to lift more of the dark color out of the awning. I later loosened the excess indigo with a hog-bristle brush and blotted it with tissue.

Meanwhile, I had brushed burnt sienna into the wet indigo to get some warmth into the windows, to avoid a dark, blank look.

When the awning had dried, I laid in its shadow with water and charged in a more dense turquoise.

The turquoise brings an exciting color note into the painting. It is the cool summertime blue of swimming pools, and it heightens the dramatic mood of the sun-drenched house against the foreboding sky.

I laid in a warm undertone of Naples yellow on the sidewalks and the driveway. I glazed over this, still wet, with cobalt violet. Most of this paint is concentrated in the driveway area. I touched in a little clear water at the upper edge of the driveway and allowed it to bleed upward into the grassy area, still damp with a fresh wash. The furry edge which formed hints at grass, and I later enhanced this with a jumpy, broken line of chromium oxide green. Grassy lines cut into the sidewalk, touched in while it was still damp. In the grassy foreground, I dropped in some lemon yellow and Naples yellow mixture to hint at dandelions.

The red door of the large house is floated on, first in Naples yellow, then in Winsor red. Some of the red is pulled into the flowers alongside the house and bled into the green of the foliage.

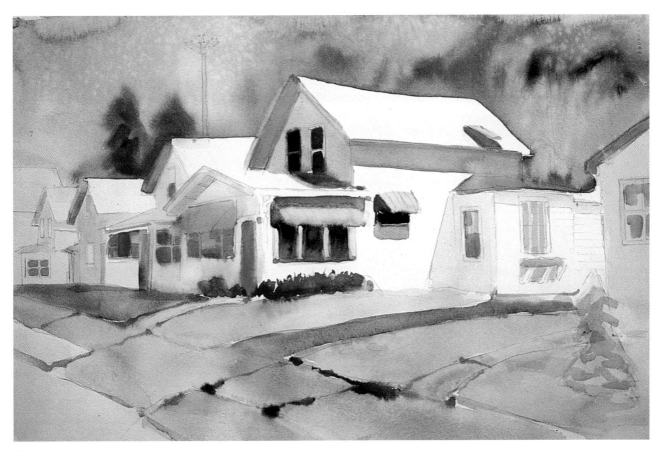

Step 3

Step 4 In the far right, I painted in the shadowed edge of the house and the evergreen tree in one wash. These take on differentiation through the overglazes and descriptive but subdued linear work. The darks of the windowpanes have less contrast, both in hue and value, than do the windows of the main house.

On the houses in the distance I washed in the shadow areas with manganese blue, having united them into as large and simple a shape as possible. I then glazed over individual roofs and house frames with different hues to softly differentiate them. I pulled some of the paint from the distant houses into the lawns in front of them. This helped to unify, and it also muted the green of the yards, so causing this area to recede into the distance.

Most of the linear finishing work was done to help define the windows, doors, eaves, and siding. The detail gives a crisper quality to sunlight and shadow, but I used it with economy.

I rarely redo an area so large toward the end of a painting, but I felt the sky was not deep enough in tone to give the painting the punch it needed. So I delicately rewet the sky, painting once again around the edges of the roofs and lightly brushing in water to fill the sky. Then I floated in indigo and some touches of Naples yellow, tilting the board, spraying water, and tilting some more. I hinted at more evergreens in the background. I eventually arrived at a sky that brought the painting to life.

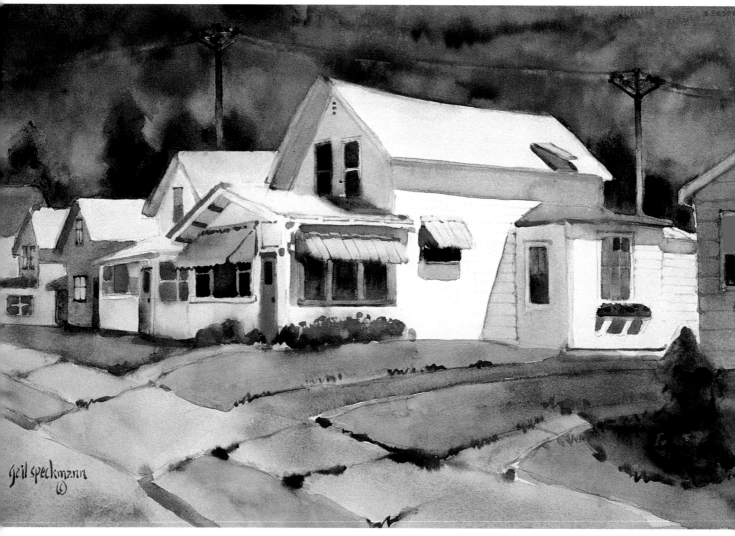

Step 4

NEIGHBORHOOD
21 x 24"

THE PAINTERLY APPROACH

This approach emphasizes the value of the *brushmark* as it is laid down onto the paper. It is a good approach to encourage loosening up an artist's style. Painters whose work is too tight and contained can derive great benefit from learning how to express themselves in as direct a manner as possible, utilizing the brushmark for expression. For this wet-into-wet approach—and of the three, this is the one that which comes closest to direct painting on dry paper—you apply light tints (so that you can see the brushmark), and then charge paint into the strokes. The advantage that this approach has over direct painting is that you can see if you like your brushmark before committing color to it. Blot it off with tissue if you do not. You can also develop the juicy look by floating the color in. The paint disperses naturally, rather than unevenly, as in the raspy deposit that sometimes occurs when painting directly.

While I can paint for hours on saturated paper or in sections, I find that the painterly approach is best executed rapidly. The painterly approach is my favorite for working outdoors. It has the advantages of speed and spontaneity. It is a good approach for getting at the heart of what attracts you about a scene.

I use this approach with a relaxed, casual attitude. I often think of the picture as a study, and if it happens to develop into a successful painting,

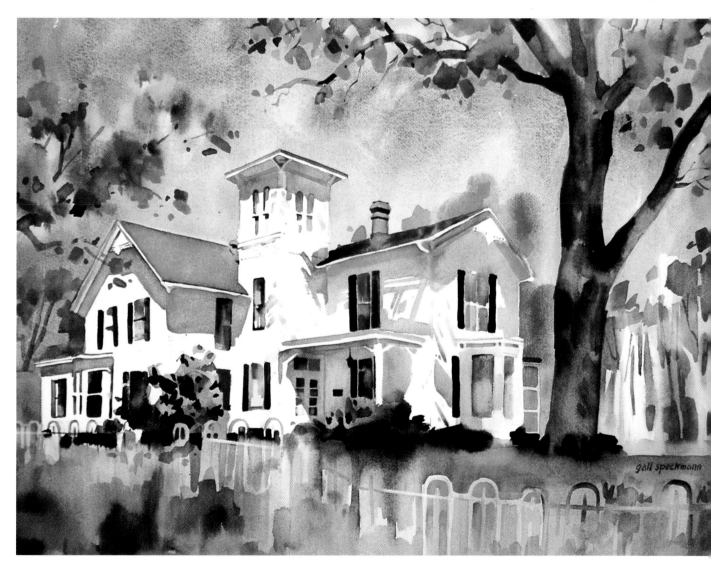

HASTINGS HOUSE
21 x 29"

The larger, quieter areas balance the active central area. The negative painting around the fence subtly enlivens the ground area.

all the better. The approach is looser in its appearance and perhaps even a little messy-looking. Although the painterly approach shares many of the same techniques with painting by sections (charging in paints, edge joinings, etc.), the loose, brushy style is the antithesis of the sectioned approach with its more formal, coolly calculated structure and clean lines. The strengths of the painterly approach are its liveliness and staccato energy.

Brushstrokes take on a tremendous importance, and it is best to accept what you put down on the paper, without fussing too much and attempting to correct. Because of the proliferation of strokes and the variety of color, it can easily become too busy. If too much is layered on, the evidence of brushwork becomes muddled and disappears. Lively areas need to be balanced with some calmer areas.

The Planning Stage

With the painterly approach, you will want to go into the painting with confidence and a clear idea of where you intend to go. A working knowledge of your subject is also very valuable. You have more courage to dive in if you clearly understand the forms, appropriate color, and values.

For these reasons, making quick thumbnail sketches is helpful. I sketch in the larger masses only and think of the basic value pattern; detail is minimal. If I can get these aspects right, then I can leave myself some latitude for changes in this more spontaneous style of working.

Without this structural base, it would be easy to make the painting dappled and mushy.

Because this type of painting is tough to rework, also test out your brushstrokes and color scheme. This approach is direct and fast-paced; it helps to limit your color scheme, at least until you develop a comfort level working this way. Small color studies are kept abstract so that I can focus my attention on the color balance. I keep such studies for future reference, so I use good paper for them, something I'd have trouble doing if I were going to throw them away.

Paints you will be using should be squeezed out fresh from the tubes; I often "flag" the outer edge of the wells of those colors with a bit of masking tape as a quick visual reminder of my color choices.

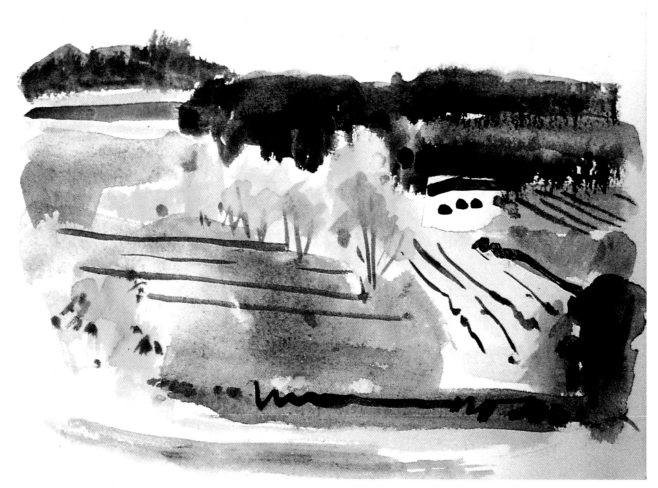

This quick study for a landscape establishes basic values—darks, midtones, lights—the broad, basic shapes, and the color scheme.

The Painting Process

Lay in your largest areas of color first. This will help set the color scheme and also give you an anchor from which to work. The white paper will seem less overwhelming, and you can judge your colors and values more accurately. The painting is less likely to get overly fussy.

To get comfortable with the painterly approach, you can proceed by tinting in your value areas with *direct* brushstrokes, using thin color tints to represent the values you want. Allow this to dry. Now mimic the original brushmarks with clear water, and then charge in your paints. Do not worry about precision in recreating the underlying brushmarks. If they are slightly out of register, this will be in keeping with the loose approach, and can even give some pleasing color edging.

It is helpful to have brushes already loaded with paint and ready for use. If you have laid down your brushwork in a light tint but you are unhappy with it, you can quickly towel off the surface. I prefer to lay down a grouping of strokes that, together, create an object or passage. Then I charge in color at various points. This, of course, means that I must be prepared with paint-loaded brushes, so that I can move rapidly before my tinted strokes dry. If you need to keep the tinted strokes wet, you can continue to charge in water, which will quickly refill the shapes. This will help secure some additional working time.

When filling a clear stroke it is best to have just enough water to allow the paint to flow. Too much water in a limited area can cause difficulties with runs and slow drying time.

If you do not like a segment of the passage that you have laid down, it is dangerous to wipe off that segment only and continue to charge in paint adjacent to it. The color will tend to spread out into the still-damp areas you wiped off. It is best to pat dry the whole area and try it again. Allow the good part of your passage to dry without blotting up the tint, then re-create it.

You also may find it helpful to work in nonstaining paints, because you can come back to an area even after it has dried, rewet part or all of it, and attempt to blot it back to white paper.

In developing general areas, try moving around a bit, so as to work the painting as a whole. Brushmarks may be linked side by side with different paints, or color can be pulled down from upper areas. Your stroke of paint can traverse some areas of dry paper as it links areas; such a passage from wet to dry to wet can create interesting contrast. A shape directly painted into a wet area will create an atmospheric blending of color. Or, after charging color into a prewetted shape, move this color with no further dilution of intensity down onto the dry paper. This also creates a softly differentiated blending.

A fully defined shape can be segmented into the brushstrokes that

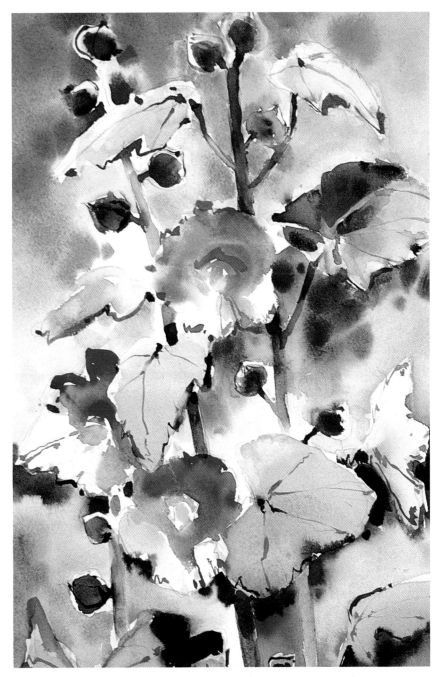

When you work in the painterly approach, try to express each element with as few strokes as possible. Often I make my strokes larger than I think they should be, for too many timid strokes can destroy the image.

wholly form it. You can then join these strokes with water at strategic points and charge in color to fill the whole shape. This approach is good for subjects made up of compound parts—lilac blossom, clusters of grapes, masses of foliage, windowpanes, and so on. Larger shapes can be composed yet will remain true to the importance of the brushstroke. It allows you to put in some definition through shapes rather than lines.

It is easiest to work on a small scale in the painterly approach. If you wish to work larger, move up in scale gradually. (And remember to move up to correspondingly larger brushes and more paint on larger paper.)

Values and brushstrokes are tinted in for Maroon Tulips.

Maroon Tulips
20 x 24"

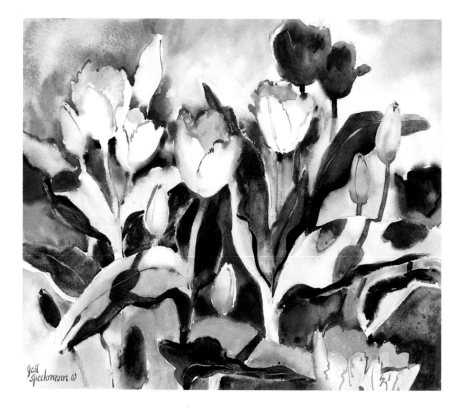

Finishing Touches Calligraphic-type brushmarks are often vital to the completion of painterly work. It brings accents and focus to the loose structure of shapes. Given the importance of brushwork in this approach, these finishing details tie in harmoniously with the work that has gone before. By the nature of watercolor these last strokes tend to be deeper and more intense than your shapes, because you are laying them on top. The darker lines are somewhat balanced by the light spaces left between larger brushstrokes.

These little spaces, looking like white "cracks," can be distracting at times. Sometimes they are pleasing but call for a little toning down. This can be achieved in a variety of ways. The first is to start out by washing a light tone over the entire surface of your paper (except for your whitest whites) before you begin. The disadvantage of this is that if you do not stretch your paper, you will be painting onto an already bumpy surface.

A second way to deal with the white spaces is to rewet and glaze over much of these areas after they have been painted. Both of these methods, underglazing or overglazing, have the beneficial effect of giving a unifying color harmony to your work. A third method is to "fill in the cracks" with a subduing tint of color. The idea is not to obliterate these spaces (we want to see the beauty of the brushstrokes) but to tone them down a bit in order to let the viewer focus attention at the center of interest.

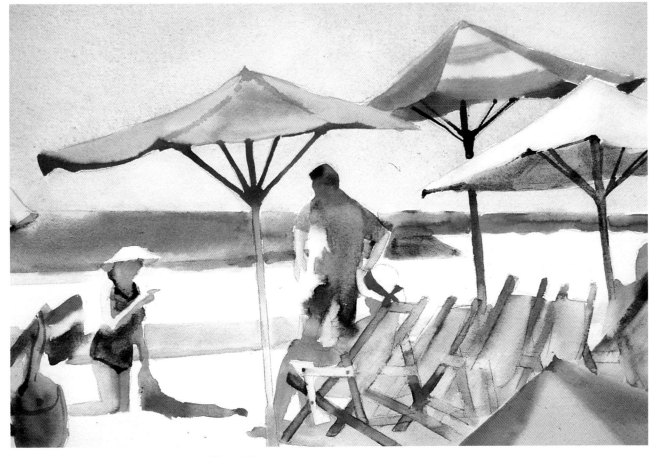

In this detail of a beach scene, strong calligraphic-type strokes give accent and punch.

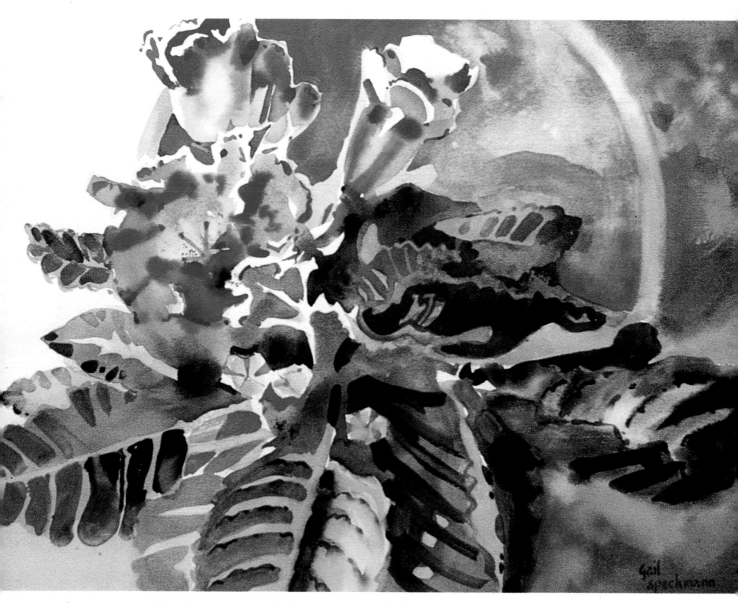

GLOXINIAS
14 x 21"

The yellow overglaze on the leaves tones down the bare-paper "cracks" left between the leaf segments.

EXPLORATIONS IN THE PAINTERLY APPROACH

Many of the techniques used in a painting by sections approach apply to the handling of paint in the painterly approach also. But in the painterly approach we are involved with points touching (joining and intermingling shapes), rather than with joining complete edges.

I recommend that you use freshly squeezed paint from the tube; use two water containers, one for rinsing paint from your brush and one for loading your brush with clear, fresh water; keep your board level. Your brushstrokes are going to fill quite readily with paint, so you are less likely to need gravity to work with you. If you tilt your board, you greatly increase the danger of runs.

To get to know your brush capa-bilities, take each one and try to make as many types of marks as possible. Paint directly with paint on your paper or with clear water. Try as many ways of applying the paint with each brush as possible—held at varied angles, stroking directly, twisting the brush, and so on. Jot notes alongside the strokes as needed for recall.

Exploration 1
Charging Paint into Wet Brushmarks

Prepare the fresh paint by diluting, more or less, with water. Put brushstrokes of very lightly tinted water directly onto your paper. Develop a feel for how much water you want to fill the shape. If it is quite loaded, it will take much longer to dry and runs the risk of flowing out too freely into other wet brushmarks that could touch it. If there is not enough water, it will dry too quickly, before you have had a chance to charge color in.

Charge in paint to fill the shape. You may wish to touch your brush ferrule to a thirsty sponge or towel before charging in color, for you do not want to add more water to the already water-filled shape. Note how different paints expand to fill the shape. (Some-times you may like to have paints that only partially fill in the tinted shape; other times you may like a thorough expansion.) Now charge in additional color. Color should be applied with a light touch. It is better if the first layer of wet color is not bulging with water, as you need a little more liquid in the overglaze color to help it flow on.

Color is charged into another color and then pulled down to create a new shape.

Exploration 2
Touching a Light-Tinted Brushmark to a Paint-Charged Brushmark

Try placing a very lightly tinted brushmark just touching a paint-charged brushmark. Vary the position—above, and at vari-ous angles, side by side. Vary the paints. Try tilting your board.

Here, a light-tinted brushmark was touched down into a paint-charged brushmark.

Exploration 3
Connecting Direct and Charged-In Strokes

Create a directly stroked (onto dry paper) shape and carry the color down into wet strokes below; this will dilute the color. You may charge in or overglaze additional color, if you wish.

Charge in paint. Then create directly painted strokes on to the dry paper to connect to this shape.

The connecting of direct and charged-in strokes

Exploration 4
Connecting Wet, Paint-Charged Brushmarks

Lay down two or more lightly tinted brushmarks, very close together but not quite touching. Charge different colors into them. Touch a moist brush just between them, causing them to join or lay down several lightly tinted strokes, just barely touching. Proceed to charge in vaired colorls into the strokes.

Connecting wet, paint-charged brushmarks: Observe the variations that may occur by slightly tilting the board, to cause more or less paint flow between the two brushmarks.

Exploration 5
Developing a Simple Abstract

Sketch a simple four-value abstract design using ten or fewer interlocking shapes. Be sure to include one or more large background shapes. Limit the size of the paper to an 11 x 15" sheet.

Use lightly tinted paint to designate your areas by value. Consider the types of brushmarks that you make. Vary the types of approaches for charging in pigment, using the methods in Explorations 1–4. Finish with calligraphic strokes and glazes for filling in white "cracks." When finished, evaluate your choice of brushstrokes, your methods of relating them, your adherence to your value plan.

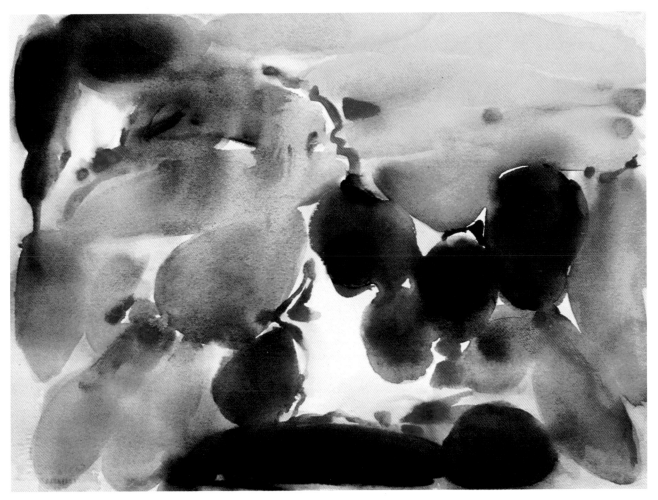

Try an abstract design, such as this one of ten interlocking shapes, by charging your colors into clear-water areas. I also pulled some color from one area to the next and overglazed parts of the design. I connected some strokes and put in calligraphic details, then did a final overglaze to fill in the white "cracks."

CREATING A COMPLETE PAINTING WITH THE PAINTERLY APPROACH

In selecting a subject for this demonstration, I tried to work in a variety of images, so I could utilize a number of different brushes effectively. I also wanted to include some quiet background (sky) and ground areas and calligraphic strokes.

Step 1 I begin by tinting in my sketch with chromium oxide green. This will provide a warm, slightly neutral green undertone for the painting. I start by using my mop brush, jabbing it down vertically to create the upper row of logs, and I use my cat's-tongue brush, spun around, to create the round and oval shapes for the lower logs. The tree trunks are painted in with a one-stroke brush, as are the distant trees on the right. The brush is put quite flat on the paper as I pull the trunks upward. This same brush is used differently as I lightly use the corner of the brush to drop in the foliage masses. The larger branches on the right are made with a script brush using a jogging motion. For the textural linear strokes along the bottom left, I used a grass brush, pulling it along almost parallel to the painting surface. Compound (connected) strokes were used to make up the shadow under the eaves and the shaded side of the house. Small flat brushes were used to lay in the windows and door. The angular brush was useful in stroking in the roof.

Step 2 Before I begin painting, I flag the colors I plan to use with a little strip of masking tape along the edge of each well. I will move quickly once I am painting, and I appreciate this quick visual cue.

I begin by stroking in clear water with my wash brush in the sky area. Then I glaze in jaune brilliant no. 1, followed by gray of gray and cerulean blue. I soften edges at the bottom here and there. The house area is stroked in with my angler brush, using diluted cadmium red purple, and a little diluted Indian red is floated in. Quite undiluted amounts of these same colors, plus

some French ultramarine, are later stroked in for the shadow under the eave and on the side of the house. The roof area is begun with lighter tints of red, and then cerulean blue is charged in. This is pulled down into the shadow side of the house and beyond into the tree area on the right; this helps unite these two areas, so they do not remain isolated. I proceed to charge in thicker paint

(raw sienna, Davy's gray, and Indian red) loosely, side by side, into the foliage. Little, loose, dash-like dots are added on the edges of the foliage.

Step 3 I stroke water along the trunks of the larger trees on the left and then charge in varied color. I then blend with an overglaze layer. The logs are painted with raw umber and sepia, and darker blues are over-

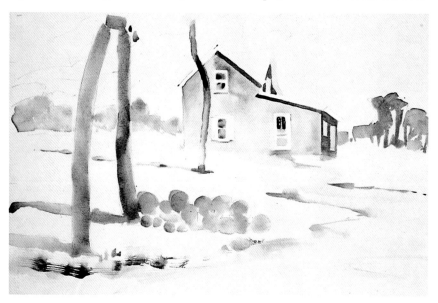

Step 1

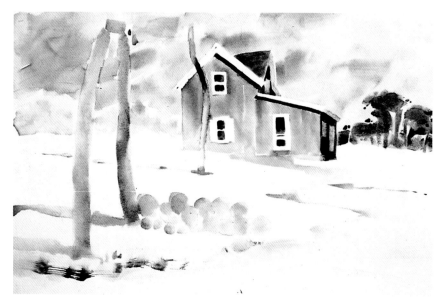

Step 2

glazed into the bottom row. A loose stroke of water is carried across the base to indicate shadow. Some calligraphic detail describes the cut end of the logs. Long horizontal shadows are pulled out from the still-wet tree trunks. Distant trees on the left are made by pulling a round brush horizontally across the paper, with varied clean and ragged edges left as the brushmark. Color is charged in. Some linear detail is added on the house.

Step 4 A unifying glaze is carried across the ground with my wash brush. As a result, calligraphic details that had already been painted loosen up at their edges. Loose, brushy strokes in a light tint are made with a round brush along the foreground area of the path. More detail brushmarks are added along the path.

I subdued the grass-brush stroke on the far left with a middle-value overglaze in the same color. I felt it was too demanding a stroke for that unimportant location. A new, similar stroke is made in the angle of grass that projects into the path. I felt I could afford that kind of detail in the more central area.

Further finishing strokes are kept rather spare, to avoid fussy detail.

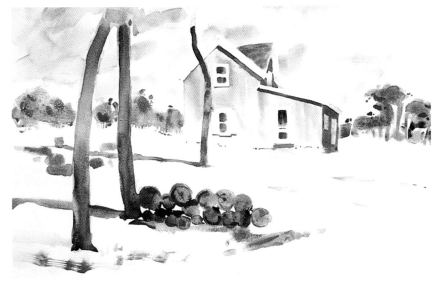

Step 3

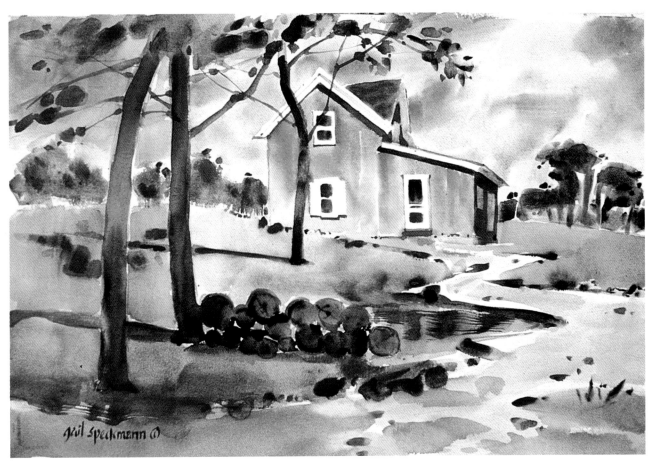

Step 4

UP NORTH
14 x 21"

4 Wet-into-Wet Techniques

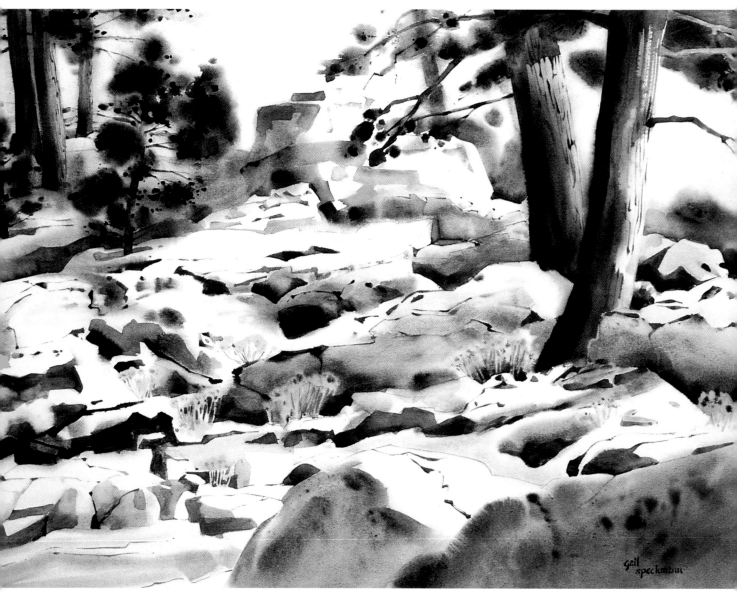

LEAVING THE PATH
14 x 21"

There are a multitude of things going on when you are involved in the painting process. I take time before I begin in order to explore areas in which I feel uncertainty. This allows me to test the results without endangering the outcome of the painting. Rather than killing my enthusiasm for proceeding with the painting, it usually has the effect of whetting my enthusiasm, having increased my confidence. The key is not to create the entire painting in miniature, but to isolate the elements that are part of it. Often, for me, this involves trying out particular color glazes, or trying out a new texture, or seeing if a specific process actually does express my subject well. I recommend that you sometimes try a process just to acquaint yourself with it, in case its application is called for at a later date. Also, consciously plan to use a certain technique within a painting, so that you actually do learn to incorporate it into your work. You can try the techniques in the following pages when you are limited in time or having a hard time getting started on a painting. They can also be a lead-in for the inspiration to begin a painting.

WET GLAZING

Direct Wet Glazing

Often artists will say that you should only glaze additional layers of color after the preceding one is completely dry. It is true that the color layers remain purer, but there are also many advantages to a process I call "direct" wet glazing. While the first layer is still wet, I will often lightly stroke on one or more additional layers of color.

You do not want to lay paint into a nearly damp layer—otherwise you will find that you get blooms. Rather, in this case, a wet shine should be visible on the surface, but not pooled.

My fondness for this technique was probably born of my impatience to go on once I have begun, working from the energy and purpose of the moment. Another advantage of direct wet glazing is that the underlying layer cannot suffer the unpleasant lift-offs of color which sometimes occur as an additional layer of color is stroked onto a previously dry one. In direct wet glazing, all the color is still in the process of settling. The danger of this direct approach is in losing the individual color and character of the lower layer(s).

Direct wet glazing allows the pigments to react to each other, often sedimenting into a beautiful surface. Direct wet glazing involves using a light touch or even pouring so as not to overly mingle with the previous layer. A soft brush, one that allows color to flow out well and evenly, is beneficial (Black Velvet, Isabey squirrel-hair, or sable brushes are favorites of mine for this).

But direct wet glazing does tend to push aside or overwhelm the lower layer to some extent. An alternative method is to rewet the initial wash before you apply additional layers of color. To distinguish this from direct wet glazing, I call this *rewet glazing*.

Rewet Glazing

In this process, the goal is to lightly rewet the surface by spraying or gently stroking on clear water with a soft brush, so as not to activate or loosen the pigment from the initial wash. (If your underlying paint is of acrylic, the rewetting can be done comfortably without concern for lifting up the previous color layer.) The next color is then floated on the water surface, and it settles naturally into the paper.

Rewet glazing allows each layer to maintain its integrity, while also allowing the natural settling that occurs when paint is laid onto a wet surface. A more even and balanced layering of color can occur.

This method is particularly helpful when you wish to unify a painting if your color relationships are not harmonizing well. The painting may benefit from a unifying rewet glazing. Glazing establishes mood and atmosphere. Bear in mind, however, that the hues below will be altered, and this may or may not work well with your original colors.

When you are tempted to glaze back into an area that is partially dry—the paper has dried to the point where a misting of water would cause textural watermarks—you may want to restrain yourself and allow the area to dry. Then proceed by rewetting and glazing.

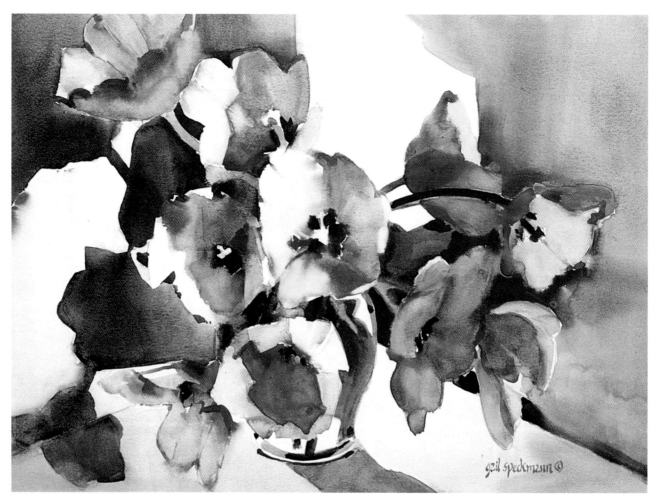

THOMPSON'S TULIPS
21 x 29"

Rewet glazing is used in the shadow on the wall to the left of the tulips.

FACTORS IN WET GLAZING

Direct wet glazing can be applied to large wash areas or to smaller strokes. The key difference between this process and that of simply charging in color is that in wet glazing the integrity of color for each layer should be distinctly preserved and allowed to "vibrate" optically against the other pigment layers. When you charge in color that is either dense enough or potent enough to obliterate the color below, you are not achieving a wet glazing technique. For an even wash, it is easier to use paint with some opacity or body to it for the overglaze (for example, Holbein paints do not spread wildly but control nicely), though sometimes a pigment that creates starbursts of color is good for an effect (Winsor violet or indigo will simulate rain-pouring clouds).

Values

Be aware of how glazing alters the value of an area. Does it become only as dark as the darkest pigment used? There is a progressive graying or dulling that can occur, but does the area become darker?

The thinner the layers, the less the dulling or darkening; much of the paper still glows through. In the very dark glaze layers, you will not see a lot of value change either (dark is dark already), but the area could become heavier and duller. It will be in the middle-value range that addi-tional layers will most obviously have a darkening effect, as you begin to lose the look of the white paper shining through.

Angle of Board

Wet glazing effects are aided by uti-lizing gravity to help the flow of the additional layer(s) of paint. This is particularly true if you are covering larger areas. I often raise my board to a 15- to 20-degree angle. The tilt of your board will vary, depending on the type of paper, medium, and pig-ments used. Paper with greater tooth can handle greater tilt. Pigments with some opacity do not tend to spread quite as freely. Staining colors need very little encouragement and

tend to spread rapidly. The painting can be tilted in various directions, or corners and edges can be lifted in order to promote directional flow of the paint.

Type of Paper

Rough paper surfaces take wet glazing particularly well. It especially enhances the settling qualities of granular pigments. Because of its texture, it is the easiest surface on which to lay smooth washes of color. However, remember that you will need more paint solution (and also with greater water content) than would be needed for what appears to be the same area on a hot-pressed finish. On rough paper, you actually are covering more surface because the liquid paint goes over the hills and valleys of its textured surface. Rough paper handles thinned-down solutions of color much better than a smooth surface, from which the watery pigment runs off easily. You are less likely to disturb previous layers of paint on the toothed surface of rough as you lightly stroke across the top of the "hills." You can glaze a number of layers on this surface, especially if the layers are thin.

Hot-pressed paper is a challenge to work with in wet glazing; however, some lovely effects can be achieved if the surface water content is held to a minimum. Paint that has more body and sedimenting particles works better than the thinner dyes. Acrylics have some advantages with their greater body quality and their reduced tendencies to spread. Stroking over the glazed areas with a wash brush or even using a squeegee-type action with a flat rigid surface (such as a strip of mat board) can help even out moisture discrepancies and smooth out the glazed layers. When you do this, the excess liquid must go somewhere, so plan to bring it out to the edges of the paper and then wipe it away.

I also use Holbein's water-soluble pastels in the underglaze layer on hot-pressed paper. This pigment (containing no additional moisture) then can be moved around through the stroking action, without being in danger of washing away. Finishing details can also be added with the pastels since they add no water content, which could cause uneven drying and crawlbacks.

Cold-pressed paper represents a compromise between rough and hot-pressed surfaces. It is my favorite surface to work on for wet glazing. It wet-glazes nicely, without having to add as much water (as for rough) to make it flow. Thus, somewhat more intense color layers can be laid down. For larger areas, especially, remember to mix more pigment than you think you will need. To keep color clean and luminous, make your color layers strong enough to create your desired look in as few layers as possible.

Papers with more sizing will enhance wet glazing (which is, after all, about color riding lightly on the paper surface). When the color absorbs too fully into the paper surface (as in less-sized papers), there is no opportunity for the color layers to remain distinct and vibrate against each other.

Paint and Pigment

I almost always use pure color from the tube, diluted down. The idea behind glazing is to mix the colors optically on the paper surface, rather than through a physical combining on your palette. I usually reserve my staining (organic) colors for the underglaze, which is then allowed to dry before working in the rewet method. Staining pigments carry a great deal of strength and influence over layers to come. If painted as the top layers, the stain colors will overwhelm any other color and destroy the optical color mixing, which is the hallmark of glazing.

Pigments with body (earth or mineral) settle out distinctly, for a lovely glaze effect in which one color layer appears simultaneously with another. This is often achieved by the broken color flecks (either as one color settles into the wells or rides on the "hills," or as pigment breaks apart on the paper surface). Paints with more body, especially ones that separate, work well thinned down for the overglazes. The undercolor shows through. Other colors may have less body, but do not stain or overwhelm the other colors. Among my favorite pigments for both direct and rewet glazing are lemon yellow hue, aureolin, raw and burnt siennas, raw and burnt umbers, permanent rose, cobalt rose, permanent magenta, gray-violet, mineral violet, ultramarine blue, gray of gray, blue-gray, cerulean blue, manganese blue, and viridian green.

For glazed passages there needs to be sufficient contrast to be able to see the separate layers of pigment. The top layer has the power of being on the surface and not hidden by other pigment. But the layer that dominates often depends on the intensity of the colors (for instance, using orange and light gray for your layers, the orange will almost invariably dominate). The saturation level of the washes (their pigment to water ratio) is another important factor. The most pleasing balance tends to be one in which one hue dominates, but the others challenge its power. Bringing some balance to the domination, the underlayer is usually strong and transparent, though often light in value. The successive layer(s) are deeper in value and with more body, though often weaker in intensity. However, I also like a rich, dark underglaze with a translucent, light-yellow or white "broken" overglaze. Intriguing color and textural vibrations may be set up, but do not count on lightening the value of areas this way.

Paint consistency is important. The color will most likely dry lighter than you expect, so you may need to compensate for that. Also, you do not want the paint so runny that it flows right off the paper. At the other extreme, you do not want your pigment too thick. It has to be able to flow and gently intermix with the other layers. Because there is already moisture on the paper from the underglaze layer, the next layer can be less watery. Often, you will need to touch down color at several points and allow the flow of color to spread and join. This gentle dropping-in of color and allowing it to meld naturally often works more successfully than stroking color across the paper. In stroking, you run a greater risk of disturbing previous wash layers.

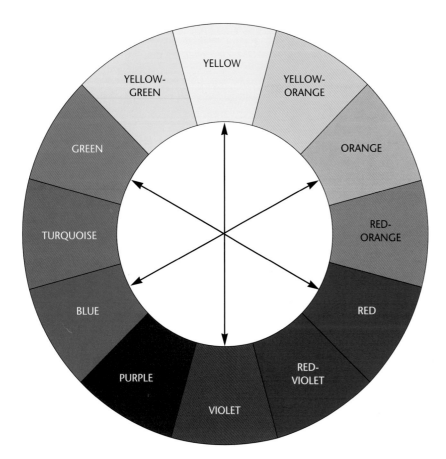

A color wheel, showing primary and secondary colors

Triadic pure color glazes made up this detail of oak leaves.

Layering Colors Glazes can impart a richness that is nearly impossible to achieve with a single pigment. Some suggestions follow.

1. Triadic glazes, which involve three colors approximately equidistant on the color wheel (such as yellow/red/blue or orange/green/violet), create particularly luminous glazes, giving the feeling of the presence of the full spectrum. Color harmonies occur, rather than the solo voice of an individual hue. It is advisable to give one color the strongest voice in the glazing, for dominance. The traditional color build-up, which is a very successful approach, usually moves from the warmest and lightest color to progressively cooler and darker (yellow/red/blue).

2. The duality of complementary colors (opposites on the color wheel) is also pleasing for wet glazing. Once again, giving dominance to one of the colors is most effective.

3. Temperature contrast also creates interest. This does not necessarily involve complementary colors, but ones that do have a definite warm and a definite cool direction. The color underneath imparts the temperature of the object or motif, and it carries much power because of this. The upper color relays the surface temperature of the object or motif; it carries a more tactile quality.

4. Even for a strong color direction, sometimes richness can be added by glazing variations of that hue. The most intense color glazes result from layering two related colors which do not contain complements of one another. Red-orange/orange-yellow, yellow-green/blue-green, and red-violet/blue-violet are the most potent of these combinations. You can see that red-violet and red-orange contain complementary elements (the blue in the violet and the orange are complements). Glazed one onto the other, the colors' purity loses a little. Still, the richness of tone achieved often has a pleasing power. Calligraphic brushwork or edging in the pure tone provides the intensity you may need.

5. Lively neutral shades can be created by wet glazing of pure hues.

SHEILA'S PANSIES
16 x 22"

Note the complementary wet glazes in the background on the right.

Color temperatures contrast in the detail below, as warm light filters through the paper bag into the cool shadow.

The purer your hues, and the closer they are to the triadic primary colors, the brighter will be the results— grayed down versions of the primaries (or secondaries) will yield lovely, subdued glazes. The individual colors should have a definite color or temperature opposition. The more equally matched the colors in terms of dominance, the more neutral will be the look. It is still a good idea to give some color dominance.

6. Rewetting and glazing a color over itself will deepen its value and intensity. This can be an important tool if you have misjudged your value in an area and wish to strengthen it.

7. A lovely, opalescent quality is created if you allow one color, then another, to dominate here and there very subtly within a direct wet glazed area.

8. Consider the value of layering translucent over transparent paint to create color vibration.

9. Patches of color can be glazed over an underlayer. In order to keep their shapes, lay the paper fairly flat.

Pure Color Edging I often find it pleasing to see the edge on the color glazes left slightly "out of register," particularly if they are strokes or shapes. That is, if the glazes overlap imperfectly, you can see the original pure colors in them at the edges. If you have lost those pure edges, sometimes you can rim the area with the colors, perhaps in a rainbow-like sequence, moving from dark to light.

SMITH'S TOYS
10 x 14"

Lively neutral color is created by wet glazing in the body of the toys.

In this detail, various glazes over a blue underlayer differentiate the house colors.

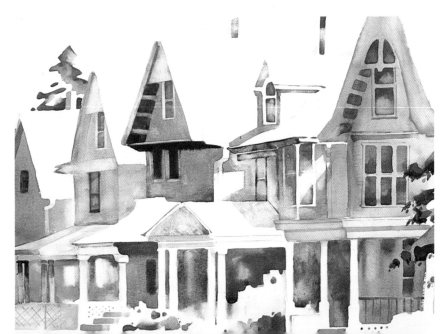

EXPLORATIONS OF WET GLAZING

Exploration 1
Wet Glaze *vs.* Charge-In
Experiment with laying one or more glazes into an area, balancing the consistency of paint so that the individual layers of color keep some distinction. Compare this with color charge-in, which overwhelms the color below.

Exploration 2
Varying the Dominance
Shift the dominance from under- to overlayer by varying the saturation of two colors glazed one over the other.

Exploration 3
Direct Wet Glazing
Try lightly stroking one wash over another while the first is still wet, methodically stroking horizontally across the paper, catching the bottom of each previous stroke. Use board tilt to facilitate movement.

Now touch down a brush loaded with the overglaze color at several points into the first wash, allowing the paint to spread and join. Shift the board angle as needed.

Compare the results and think of potential uses. Stroking in paint tends to push it around; touching in allows a more natural settling of pigment.

Exploration 4
Color Shifts Within a Glaze
First, select colors for glazes built upon complementary and triadic color relationships. In successive layerings of these colors, allow the hue dominance to shift from one to the other subtly within each layering. (This is most readily established by working in direct wet glazing.)

Exploration 5
Unifying Overglaze
Create a jarring array of colored brushstrokes. Allow this to dry. Rewet with clear water and glaze over a harmonizing color. Try the same approach to a painting that lacks coherence. You may find that a unifying glaze improves it.

Exploration 6
Overglaze Patches of Color
Lay in a color as an underglaze. While it is still wet, lay in patches of different overglaze colors, side by side. Do the same again, but allow the initial layer to dry. Rewet it with clear water and lay in your color patches.

Experiment with board tilting to let the patches of color flow down.

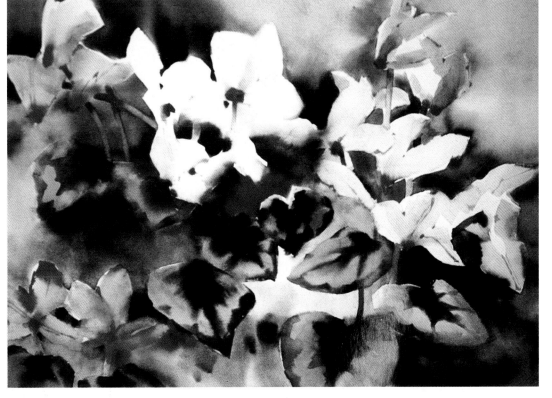

CYCLAMEN
MELODY
21 x 29"

Note the subduing rose-colored overglaze, particularly on the upper right, and the blue overglaze at center right.

MANIPULATING THE PAPER

The way in which the paper is handled can have a pronounced effect on the wet-into-wet painting results.

Of course, the tilt of the paper surface is the most frequently exploited paper manipulation. As we've seen, a perfectly level paper allows for the greatest control. However, it does not assist us in handling the excess of liquid that can occur in the wet-into-wet process. Moisture may need to be carefully wicked away by brush, tissue, or towel.

Inks are wildly affected by paper tilt, even a modest degree. Likewise, the staining watercolor pigments, which are of a thinner consistency, will handle more easily on a level surface. The more body a paint has to it, the more easily it can be managed with some tilt. Many of the thicker watercolor pigments benefit greatly from a tilt of at least 15 degrees to facilitate flow. Tube acrylic paint, though of a thick consistency, has a tendency to break apart when applied to a wet paper surface at a highly pitched angle. This tendency can be further exaggerated by dropping additional water into the paint. However, fascinating granular textures can be created. Liquid acrylics and finely ground, more opaque watercolors or gouache are the most consistent in their even, gentle bleed-down of color.

When various paints, possibly even of different mediums, are wet-glazed and then subjected to a steep incline, their flow behavior variations become more pronounced, for they separate from each other. This can result in interesting surface effects. Adding water to any of these paints will create runs peculiar to each type.

Lifting a Corner or an Edge

One of the advantages of using watercolor paper instead of watercolor board is that an edge or corner can be easily released from your "bulldog" clips and lifted to encourage paint flow to alter direction in a limited area. These minor adjustments can be made without causing the whole wet paint surface to shift.

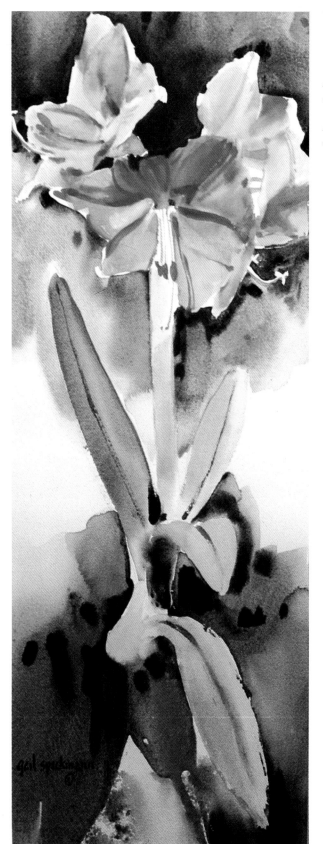

NOREEN'S AMARYLLIS
10 x 29"

The lower background was painted and then given a vertical incline, causing the paint to drift and granulate.

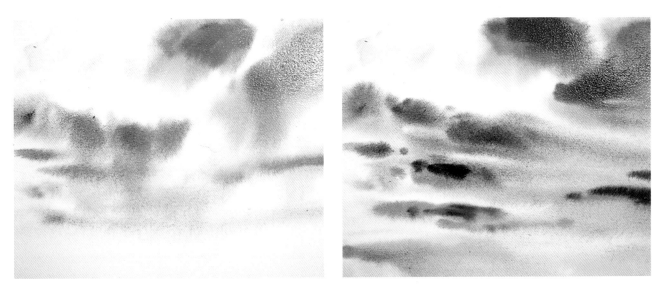

Two sky studies in which I lifted an edge to control color flow. Left: The top edge was tilted up for rain clouds. Right: The left side edge was tilted for windswept clouds.

Rocking the Paper

Particularly with finishes that have some tooth, and when you are using granulating pigments, rocking the paper will encourage a greater precipitating of the pigment particles into the wells of the paper. The paper should be wetted first and then pigment applied. The settling motion can be in the form of a rapid shaking back and forth or side to side, while the paper is kept horizontal. Or it could involve a seesaw action, actually tilting the board on one side and then the opposite in rapid succession. If there is a lot of liquid on the paper, you may wish to keep it more level. To encourage greater movement, use the more dramatic motion. Also, you can try raising up the board and pounding it down. This forceful action also encourages precipitation of the heavier pigments. Try this with the board at various angles.

Suspending the Paper

I have not utilized this to any degree, but suspending the wet-into-wet painting surface face down in the air as it dries can create unique results. The paint is forced out of the paper's wells and up onto the surface. The paper needs to be perfectly level—consider using the carpenter's tool—in order to prevent run-off.

The earth pigments and inks used here break apart through a rocking action.

MASKING

There are various methods of masking to protect white areas on the watercolor paper while freely applying wet-into-wet technique in the open areas. While masking techniques are very effective in keeping some clean white areas, the challenge often lies in being able to blend these areas at the edges or within the shapes, so as to integrate them with the wet-into-wet look.

Masking Fluid

Perhaps the most common method of masking is the use of masking fluid, a liquid with a rubber-cement base. There are various brands available. I am most familiar with Winsor & Newton's, which comes in a clear-drying white and a pale yellow version. The tinted version allows you to be able to see where you have applied the masking agent, as it contrasts with the white of the paper. For detailed linear work, this fluid can be diluted half and half with water.

Masking fluid is very hard on brushes, if any residue at all is allowed to dry on them. Precautions can be taken by first wetting your brush and then dipping it in a gentle soap or detergent. Then the brush can be dipped into the fluid, taking care not to get it into the ferrule area. Even with precautions taken, it is advisable to use masking fluids only with inexpensive brushes or other tools. I like using a wooden dowel the thickness of a standard pencil, which I sharpen to a fresh point as needed. Then I slit the tip down its center with a razor. This allows me to pick up enough masking fluid for drawing twigs or other linear elements.

Masking fluid can be applied in many ways other than by brush or dowel. It can be poured, rocked, and tilted; squeezed out of a bottle with a fine tip (empty "puffy paint" containers work for this); blown through a screen or spattered by a toothbrush; stamped in with a sponge; or applied raggedly with a bristle brush. The harshness of a masked edge could be softened by a line of spattered masking fluid along its length.

For a soft dispersion of shape, the fluid can be dropped onto a wet paper surface and allowed to dry. The edges will still be hard, but the shapes will appear more expansive because of their being laid down wet-into-wet. If it is dropped into a wash of color whose paint lifts readily, some of the color may bond with the masking fluid and lift off with it at the time it is removed.

Masking fluid can also be freely spattered onto a paper surface that is part wet and part dry (either abruptly alternating or with damp transitional areas between them). Interesting contrast results between the reactions of masking fluid in these different areas.

The fluid needs to dry thoroughly before you apply water and paint to the paper. Once it has dried, the areas covered are completely protected, and wet passages can be applied with great freedom—through brushing, pouring, or simply spattering into the open areas.

Masking fluid is usually lifted for removal with a rubber cement pick-up square. Sometimes if you can get an edge to lift up and catch hold of it, you can peel away all the masking from that area. The advantage to doing this is that there will be less disturbance to the paper surface than is caused by stroking it a lot with the pick-up square.

Indeed, my greatest concern in using this masking agent is the slight roughening of the paper that occurs. It causes the paper to take subsequent color layers unevenly. I attempt to deal with this problem in the following ways:

- I restrict my use of masking fluid to small areas or areas with intricate or notched edges, preferring other means, such as the use of acetate paper, to block out larger areas.

- I slightly "burnish" the area to be masked, gently flattening down the paper fibers with the bowl of a spoon; this protects them from being roughened by the masking removal later.

- I try to use it only on areas which will receive no other paint layers, either because they will remain white or because I have applied my light- to middle-value colors first.

- Or I may lay in a dark wash, mask only the dark areas, and use a sponge to lift the dark colors to create the lighter middle-value and delicate-value areas. This yields value nuances with a great degree of control.

Using the last two methods next to each other within a painting sets up a pleasing positive–negative alternation.

Papers should have an external sizing for this process. Naturally, different papers produce different results with masking fluid. Hard-sized papers take the rough treatment of masking fluid better than soft-sized papers do. Rough paper may be more vulnerable to damage, for the raised fibers tend to lift and break during the removal of the masking. The less time that elapses before removal, the better. The longer the masking remains on the paper, the more difficult the removal becomes. Tempting though it is to speed the drying process, *never* use heat on paper with masking fluid. The heat sets it more deeply into the paper fibers.

Some intriguing effects can occur when you combine staining color with the masking fluid and allow it to settle into the paper surface for a few days. Also, you can use a masking fluid on clean white paper and, when it is dry, soak the paper in a colored bath of water with staining paint in it. A delicate hue distributes itself evenly on the masked areas, similar to the surface of a dyed Easter egg.

The hard edges left by the masking fluid can be softened before or after its removal, or through a combination of the two. While it is still on the paper, a soft sponge can be used to lift color, particularly around the masked area, if you wish to reduce the contrast at that point. Once the paint has dried, a damp

THREE BASKETS
14 x 21"

Here, masking fluid was used to "save" the small white details.

In this detail, highlights on the iris achieved by masking have been softened a bit by gently scrubbing edges with a bristle brush.

bristle brush is also effective for lifting defined specific areas of paint along the masked edge. For larger areas a vigorous scrubbing with a damp toothbrush or sponge is helpful. After the masking has been removed, you can soften the edge within the white shape using a bristle brush or a swab such as a Q-tip. One of the most natural ways to do this is to continue to coax paint in from the edge, moving a thin tint into the white area. If you also brush toward this edge from inside the white shape with clear water, you will avoid a hard edge where your wet line of softened edge ends.

Waterproof Sheeting

When I have large areas of paper I wish to protect, particularly when I am using pouring techniques, I use a waterproof sheeting which is attached to the perimeter of these areas with a mildly adhesive strip. This is easily removed afterwards, with the paper surface preserved. The adhesive causes only the slightest disturbance.

The procedure I use is as follows:

1. I first determine the edges of the area that I wish to protect. Following the edge, I draw a line onto a piece of tracing paper laid over my sketch for the painting. I then cut along this line.

2. The next step is to trace along this line onto a mildly ("low-tack") adhesive paper (available through art supply stores), the as-yet unexposed sticky side down. Once this line has been drawn, I draw another line approximately one inch beyond it (deeper into the space that represents the white, protected area—this is important). Then I cut out the strip created by these two lines.

3. Next I lay the original tracing paper onto a sheet of acetate, craft paper, or plastic, and draw the initial line (representing the contour edge of the whites) onto that. Cut along this line.

4. Turn the adhesive strip over and remove the protective covering.

5. Turn the protective sheeting over and lay it onto the adhesive, over-lapping by about ½" and leaving about ½" of it exposed.

6. Turn right side up again, and attach it to the watercolor paper, with the adhesive running along the protective line and the sheeting covering the areas to remain white. If I use plastic (I cut up the large, flat plastic bags my mat board is delivered in) I may wrap the plastic around to the back of the painting and seal it with tape to prevent paint leakage back onto the paper from the outer edges.

Frisket film or transparent shelf paper (more economical) could be used to simplify this process, by combining the roles of the low-tack adhesive paper and the waterproof sheeting. However, I suggest only bonding it to the paper at the perimeter of the white protected edges and at the outer edge of the sheet of paper. On shelf paper, stencil-type openings can be cut within the block-out areas, allowing for painted sections to be poured on within the protected portion.

I advise you to try this on something simple first, to make sure you have the sequence down correctly. It may seem like quite a bit of work, but it is worthwhile for protecting the large white areas without the danger of having a damaged surface.

I sometimes experience a little leakage or paint crawl underneath the low-tack adhesive strip. If the area is to remain white at that spot, I can easily use a razor to scrape and lift the color. If the area is to receive additional color at that spot I can often scrub at that area with a moist bristle brush, loosening that dried errant paint and blending it into the surroundings, or blotting, rewetting, and blotting again.

Masking Tape

Masking tape can be used to establish some linear blockouts, but you are severely limited to linear shapes. It is also subject to the possibility of paint crawling underneath if it has not been pressed down very firmly. Remove it as soon as possible after the paint has dried, so the tape does not bond too permanently to the paper; it can leave a tacky residue.

Waxed Paper

Waxed paper can be laid over the watercolor paper and linear elements drawn in, or a broken surface of wax can be "scribble-transferred" onto the paper surface. Waxed paper laid onto a wet paper surface and allowed to dry will transfer irregular, blocky areas of wax to the paper. With either approach, color can then be applied freely wet-into-wet over these wax-protected areas.

Starch

Liquid starch can also be used as a masking agent. Try using it poured or stroked onto a wet paper surface, then allow it to dry. For removal, it needs to be soaked out. Thus, it is best utilized with acrylic, so that the paint does not lift off along with the starch.

Acrylic Mediums

Acrylic mediums can be utilized as masking agents, ones which can remain permanently on the paper. The degree of color-lift from the masked area is in the artist's control. The light areas are painted in with an acrylic medium or even in a light acrylic color. Then deeper-value watercolor is painted over the entire area. This layer is allowed to dry. This color can be blasted off with a spray of water, lifting off mainly from the acrylic-blocked areas, or the color can be lifted more carefully with a damp sponge, exposing more or less of the acrylic-protected passages. I enjoy this technique for its defined edges and the subtle shade nuances it allows me to create. (Sometimes when I work with masking fluid, I am reluctant to remove it after I have painted over it—enjoying the subtle shades that have been created. Using acrylic medium allows me to have that effect and be able to preserve it.) Applying the acrylic very thinly will create a more broken look. Applied with greater density, it will allow you to lift color away more cleanly.

AUTUMN APPLES
21 x 29"

For Autumn Apples, *I used clear acetate to block the white areas before pouring paint into the lower corners.*

EXPLORATIONS OF MASKING

Exploration 1
Masking Fluid

Try applying masking fluid in different ways on dry paper: by brush, spraying or spattering, drawing (with sharpened dowel or squeeze bottle with a tiny opening), and so on. Then try the same approaches, but this time try them on wet paper, painting after the masking fluid is dry, or directly into a moist wash. For further variation, try the above techniques on different papers. Vary your paints also.

Using a stiff-bristled brush or a Q-tip, try softening hard masked edges after the masking has been removed.

Exploration 2
Acrylic Mediums

Try acrylic mediums (matte or glossy) as a masking agent, stroking or spattering it onto the paper surface, and allow it to dry before paint is applied. Then allow this also to dry. Achieve removal of paint on the masked areas by blasting with water or lifting color by lightly brushing or sponging over the paint surface. The watercolor paint should lift readily off the protected surface, but hold quite well to the untreated watercolor paper surrounding it. Try only a partial lift of color from the protected area. Paint can be allowed to remain on as much of this area as you desire, allowing you to create subtle gradations of lift-off.

KRIS'S LILIES
16 x 17"

Acrylic medium was used to mask the area around the foliage and allowed to dry. When the color was poured on, I lifted it off the acrylic-protected areas.

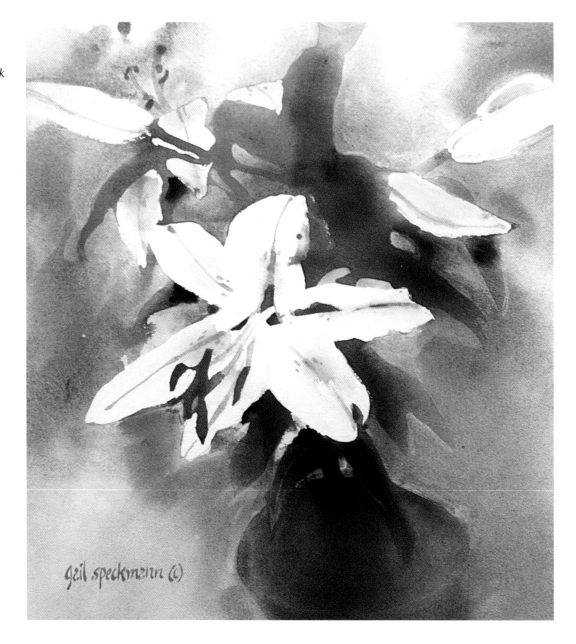

POURING

Pouring is a technique that offers the advantage of creating very smooth layers of color, which expand and dry without the intrusion of a brush. It is a technique which is respectful of the natural dispersion of water and paint on the paper surface.

I often use pouring in conjunction with masking. Pouring is such a free, expansive technique that I frequently need to mask certain areas, especially to save white areas. I prepare the paint mixtures for pouring in various containers—cups, saucers, small plastic bottles (with lids, which allow me to keep the excess for a period of time), or catsup-type plastic dispensers. It is important that the paint be mixed evenly. I start by diluting it with only a tiny amount of water; that way it is easier to break up the paint evenly. Continue to add water and mix gradually. The paint dilution should be more concentrated than the end result that you desire, because it will be poured onto a wet surface which will further dilute it. Be sure to mix plenty of paint solution, for it interrupts the process when you have to stop and mix more color.

It is important to remember that the more water there is on the surface, the more freely the paint will flow out and dissipate. Paper that is barely moist will allow a more limited spread. Somewhere between the extremes may lie the most effective surface, but the options are available as suits your needs. The paint can be poured on in dramatically different ways—carefully and parsimoniously very near the paper surface, energetically from farther above or from the side. Pouring can either begin freely and move to greater control, or begin with greater control and then explode into expressive overglaze pourings. As always in watercolor, it is effective to have both the elements of spontaneity and control present within a painting.

If paint needs to be urged outward, misting from farther away into its edges will cause the paint to advance in a natural flow. (Sometimes misting or a light brushing can be helpful to urge paint to flow over masking fluid, which can cause paint to pool at its edge.) On the other hand, if too much liquid is on the paper, some of it can be wicked gently away by touching a tissue to it. If color has not yet been poured in, some of the water can simply be drained (holding the paper vertically) or sponged off. If you wish to apply thin, transparent layers of color, but you want the fluid to have more body to it so that it will not run too freely, consider thinning the paint with matte or gloss acrylic medium.

Color Choices

It is a good idea to use colors of enough contrast that each will retain some of its uniqueness in the pouring. Triads of color can be very lovely in this application. Color can be allowed to dry between pourings or applied directly in the same time period. When allowed to dry between layers (sometimes rewetting with clear water before each subsequent application), colors will better maintain their integrity, and the application can be a little freer, adding and removing paint of one color at a time, without concern for contamination. If colors are applied while they are all still wet, caution needs to be taken to apply them in smaller, more concentrated amounts and with less liquid on the paper, so that there is not too much overmixing and runoff. Colors of similar paint types will mix more predictably with each other. Staining colors should not be allowed to overmix. Opaque colors should be poured in a limited number of layers or muddiness will occur. Masking tape around the edges of the paper will prevent color from flowing underneath the edges and onto the backside of the paper.

Achieving Values

Color is often applied from lighter to darker, but I particularly find a reversal of this order to be attractive. If the darker color layer is applied initially and allowed to dry, then a thinner, translucent layer of lighter colored paint can be poured on. This can be rocked and tilted to allow a breakup of the light paint, creating a lovely textural surface glaze. This can be allowed to dry and further transparent glazing can be laid over to variegate the granular light paint pouring.

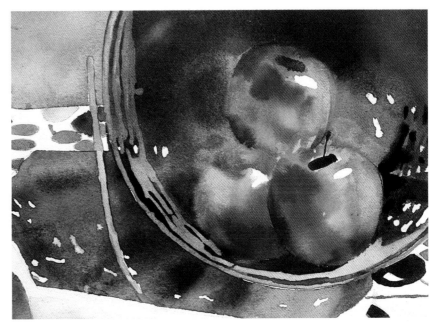

As this detail of Autumn Apples *shows, lighter paint can be poured on over deeper color for a rich effect.*

If you work with masking fluid blocking out the light areas, the darkest areas could be painted in directly, and then, when they are dry (or at least dry enough to hold their shape), a middle-value transparent pouring can occur. Or the middle values can be poured in first and the darkest accents applied, thickly, into the moist pouring. It is more difficult to create poured areas of truly deep value and retain transparency to any degree; pouring for the middle values gives better results.

Paper Effects

The type of paper is, naturally, a factor in this process. The minimally sized papers (and those with no external sizing) will be more absorbent, allowing for a more controlled result, since the movement you create will more quickly cease. This is, perhaps, a good choice for multiple pourings done while the surface remains wet (no drying between colors).

On harder-sized paper, the paint expansion will be freer. You will need less water on the surface to allow for flow. It may be best to allow drying time between color pourings.

The paper finish is an important variable also. Hot-pressed papers will allow pourings to flow quite freely, so water content will, once again, need to be limited. Rough paper can hold quite a bit of liquid, so more will be required for the free flow of the paint. Cold-pressed paper results lie in between these two extremes.

Controlling the Paint

Poured paint can be guided by controlling the tilt of the board. Initially the pour should be made onto a level surface. It will usually take a modest degree of incline to cause the paint to run. It may be helpful to consider applying your color to the innermost point where you wish it to be and then guide it out to the paper's perimeter, either by misting a path or by tilting the board. Or you may wish to pour color into the area where you want it in its greatest intensity, then mist it out from the edge of the pour into surrounding areas, where it will appear in reduced concentration. (If you accidentally dissipate your color intensity too much, some thicker paint could be dropped in where desired.)

Small areas in which you wish to have the appearance of poured color can be applied by the more controlled amount of a squeezed blot, perhaps from a syringe. Drips, runs, and spatters are also in harmony with the nonbrushed, poured look. They can evoke images of tree branches or stems. Drips or spatters of complementary color or of different value can be exciting on a poured passage that has dried.

Arresting the Flow

The movement of the pour can be arrested by heat applied *carefully* with a blow dryer or heat lamp. (Guard against using heat in the areas of masking fluid.) It can also be controlled by wicking away excess liquid. Limiting the liquid used to begin with can be a key to success in this regard. Keeping the board perfectly level during drying is also important.

PAT'S TULIPS
21 x 29"

The upper right side received a pink-colored pour and then a darker paint was poured into that.

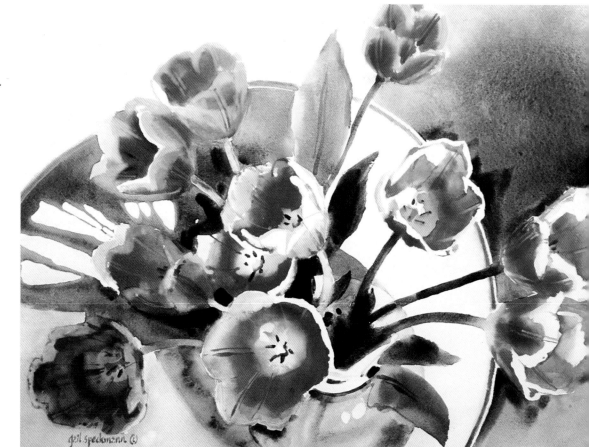

EXPLORATIONS OF POURING

Exploration 1
Pouring and Its Variables

Prepare a paint solution to an even, reasonably saturated consistency. Pour onto a moistened paper surface by various means: from a dish, a squirt bottle, a baster, a medicine dropper. Develop a feel for the degree of paint flow and the amount of paint deposit you need. Vary the degree of liquid in the paint and the degree of moisture on the paper surface, until you arrive at a balance which pleases you. Experiment with different paints and papers.

Exploration 2
Multiple Color Pours

Try pouring a triad (or other variety) of colors sequentially, allowing drying time between pours. Rewet the paper surface lightly before continuing with each pour. Allow some pure color of each to remain at the edges.

Next, try pouring a triad of colors while each is still moist. Note the change in the blending as compared to when layers were dried between pourings.

Try pouring a light color over a (dry) darker color pouring, and pouring a dark color over a (dry) lighter color pouring. (The darker color will need to be thinned so that the light undercolor is allowed to shine through.)

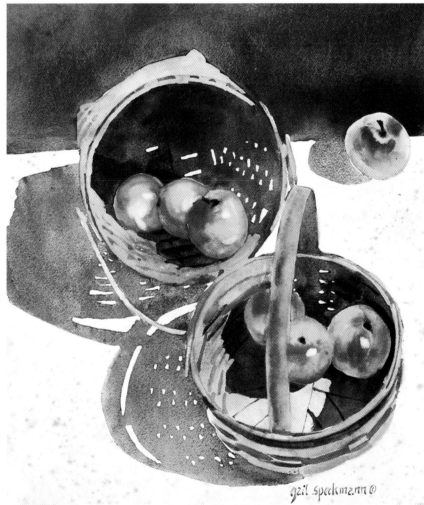

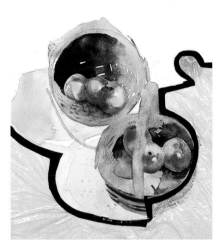

For Two Baskets of Fruit, *I began by painting the center of interest. I taped plastic down to mask areas that I wanted to protect while pouring.*

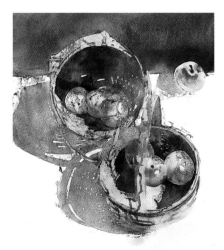

After pouring in the background colors, I removed the masking and added the finishing touches.

TWO BASKETS OF FRUIT
15 x 18"

I used a razor to clean up the paint crawls into my white details.

LIFTING COLOR

Watercolor paint can be lifted back off the surface of the paper in various ways and with a variety of tools. There are a number of reasons for utilizing color lift in a painting.

1. Color can be lifted to define shapes and edges. This bears some similarity to the work of a sculptor, as an image is "carved" out of a raw material (in this case, the raw material may be washes or loosely defined shapes or color areas). The advantage is that you can add and subtract color, moving back and forth between the positive and the negative, as definition is gained.

2. Color can be lifted back off to correct an area. Perhaps the shape or color seems wrong. Perhaps the area became too muddy. Lifting color off is a valuable option.

3. Color can be scrubbed or blasted off with water (after the paint has initially dried and set to some degree) to create a lightened, atmospheric, dream-like effect (see pages 95 and 96.)

4. Paint can be removed to add texture to the surface.

5. Paint can be lifted to regain some light areas if the painting has become too dark and heavy, or if greater value contrast is needed within or next to a dark passage. You can increase the illusion of having a strong, dark value in an area (without risk of muddying it with more paint) by lifting a lighter image from within it or alongside it.

Papers

The degree of sizing which a paper has will affect the degree of lift that is possible, particularly once the paint has dried. In papers with less sizing, the paint soaks more deeply into the paper fiber and is almost impossible to remove. Soft papers are also more vulnerable to surface damage in the more vigorous removal methods.

While the Paint Is Still Wet

During the wet-into-wet painting process, lifts are generally made from the wet painting surface by utilizing a thirsty (moist) brush or natural sponge to pick up color. The lift is usually very soft-edged, because the area is wet. Sometimes when I lift color with a sponge (creating a drier spot), I quickly squeeze a little water from a clean sponge back into that area, to equalize the moisture. I prefer not to use dry tissue for lifts, for they tend to create a dry-looking shape that does not harmonize well with the wet-into-wet look.

Blotter paper can also be used to lift color. This works better with some paints than others. It is best done when the wash is not too wet. The blotter paper can even be cut into specific shapes that you wish to lift. Press firmly onto the paper to remove the paint. This technique is especially effective for architectural shapes.

Push and Scrape Lifts Color can be forced off the paper surface by use of the beveled end of a brush handle, a credit card, a knife, or other similar devices. Paint is pushed aside squeegee-style, leaving an open area with an outline of dammed-up paint at the edges. This is done most effectively with paints that have some body to them (earth and mineral paints work well).

OUR TULIPS
17 x 24"

I used a sponge to lift color and create soft-edged light areas throughout this floral design.

The more sizing a paper has, the more successfully this type of lift works. The paint needs to be at a stage when it is no longer too wet, or the paint will rush back into the lift area. A lift mark also needs to be generous enough that if some paint pushes back into it, it will not become too small or even disappear. (Stingy shapes are inharmonious with the wet-into-wet techniques.) If the paint approaches being too dry when a scrape lift is made, lifting may be less successful.

After the Paint Has Dried

Lifts from painted areas that have dried often occur late in the painting process, as definition or corrections are sought. It is important to utilize them in ways that are harmonious with the wet-into-wet approaches.

Paint will lift more or less readily depending on the type of paint used. Staining paints, especially, are difficult to remove once they have dried. While wet, they will lift more readily than one might suppose.

To lift the paint, it is generally best to remoisten it first. This can be done by soaking the entire paper, an area, or even just a specific line or spot. If you are soaking a large area, the paint softens, but it will basically stay in place unless coaxed off with a brush or sponge. The firmer the brush or the more vigorously the sponge is applied, the more the color will lift. Hog bristle brushes work well, but synthetics are also very effective and can lift a very clean line. If you do not choose to rewet an area but simply wish to lift a line or small shape, simply stroke that line or shape with your damp brush or sponge. Rinse and remove excess water from brush or sponge between each approach and blot with tissue, until the lift is complete.

If you need to remove color vigorously from an area, try using a toothbrush to scrub the remoistened area in a random circular motion, one which approaches the paper from all angles. This is especially helpful on rough-finished paper.

Using Acetate Stencils Stencils of shapes that you desire to lift can be cut out of clear or frosted acetate using an X-acto blade. Lay the stencil onto the dry painted paper and then use a damp, squeezed-out sponge to lift off the paint. The lift can be made with more or less pressure within the stencil, to vary the degree of paint removed. For a softer look, lift vigorously in the center and more lightly at the edges.

Water Blasting The paper is remoistened before blasting it with water. The focal point of the blast will lighten significantly, with the outer areas releasing less paint. A sharp, focused stream of water can remove lines of color, particularly when the paint is one which lifts readily. After blasting an area, quickly hold the paper vertically (before more paint loosens) to remove excess water from the surface. Let the painting dry horizontally, undisturbed, or speed the arrest of paint loosening by holding it near a heat lamp or blow-drying it.

Using a Razor Blade A single-edged razor blade that comes to an acute point on both ends seems to be the easiest and most effective type for paint removal. I use the blade to clean up unwanted dots or rough edges that have extended into white areas. The razor tip is used at a very low angle (almost parallel) to the paper, so as to scrape only the very surface of the paper.

If you use it to lift marks in painted areas, you must expect any paint you apply to tone down the newly exposed white to dry much darker on this scarred surface. However, you may choose to lift a broken line out of the wash areas and leave it white, to create visual interest. Such a line could emulate the diamond-like reflections on distant water. A ruler can be used, if desired, to create such a line. A razor dragged broadside over a wash surface can create a textured surface, as the color lifts from the "hills" of the paper—rough paper, particularly.

Sanding The use of sandpaper is similar to the use of the razor broadside over the surface. It would be easier than the razor to use in large areas, and more even in handling (with the razor, you run the danger of catching the sharp tips into the paper). It is useful for creating a light-mottled surface. As it scars the paper, any color laid over will be deeper in value on the top "bumps" than the surrounding, undamaged areas. This could be utilized to create a positive–negative interchange within an area, as you leave some top surface bumps white and deepen others with an overglaze.

Erasing Electric erasers can be used to lift some quite free, exciting lines which are soft-edged yet nicely defined. The danger with some electric erasers is that you may end up burnishing the paint into the paper surface rather than removing it. If staining colors are used below, the overglaze will lift, exposing that color rather than white. But if acrylic is used below, the top color will lift off especially readily. The more abrasive manual erasers can also be used to lift color, but I prefer to achieve similar effects utilizing brush and sponge lifts.

In this detail, note some of the sharp lines obtained by lifting paint along a stencil edge.

WASHING OFF TECHNIQUE

In its most simple description, this technique involves applying paint to the paper and then removing part of it by washing it back off. The part that will be removed is that which is still damp or which has been re-moistened. Some paints remove more easily than others; some lift off in part, but leave a glowing stain behind (sap green, phthalo green and blue, and alizarin crimson are notable for this).

The paint area from which the removal has occurred is characterized by a very smooth veil of remaining color, which suggests a rather ethereal light quality, and it can be useful for creating an atmospheric feeling of hazy light. Also, intriguing ragged edges are created by uneven drying.

A real advantage of this technique is the creation of expansive white or very light marks, created by the moist additive (water, retarder, or masking fluid) flowing outward into the somewhat drier wash. So often in watercolor, the white areas have the effect of a retreating space (characterized by concave edges), as other colors expand into it. In this process, though, the light marks left have an expansive effect (characterized by convex perimeters). This is nicely suggestive of the expansive character of light.

EXPLORATIONS OF WASHING OFF

Exploration 1
Soaking Paper and Lifting Paint
The paper can be submerged in a tub or tray of water, and after soaking for a few minutes, paint can be *gently* coaxed off in areas, using a stiff-bristled brush.

Exploration 2
Blasting with Water
Heavy paint can be applied directly and fairly intensely on the paper. Then, after dry or partially dry (for varied paint lift-off), blast the entire painting with a spray of water. (I use my hand-held shower sprayer in the shower stall; in nice weather, working outside with a garden hose is a possibility).

Exploration 3
Washing Off a Limited Area
To wash off a specific area within a painting, try using a trigger sprayer to blast off the moistened mark(s). The painting is held vertically (still mounted to the board) and turned in a direction that will allow the washed-off paint to drain off the paper. A moist brush could also be stroked across this surface to effect a more controlled paint removal.

Working on a floral design, I have tilted my board vertically and, while the painting is still wet, used a trigger sprayer to wash paint from the left side.

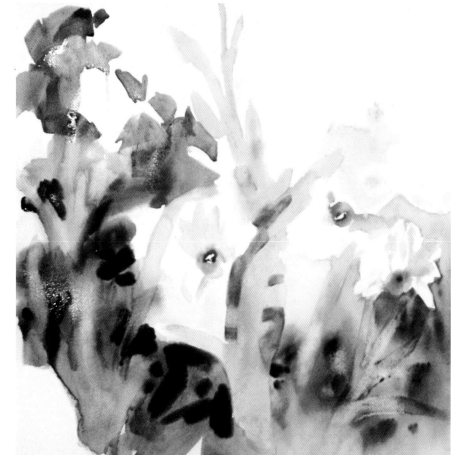

Exploration 4
Developing a Complete Painting
To develop this image, I worked generally from top to bottom following these steps:

Step 1 I thickly painted on Holbein's blue-gray and then blasted it off when it was partially dry. To tone down the intense blue, I floated in some jaune brilliant no. 1. For the roof, I floated sap green and alizarin crimson into the clear-water shape.

Step 2 For the barn, white areas are preserved by vertical strokes of acrylic medium. The spaces between the vertical board shapes will absorb subsequent washes.

Step 3 I laid down color washes for the far side of the road, then dropped in large clumps of salt. When the wash was dry but the salt still damp, I washed the area with a moist brush, leaving blotchy whites where the salt had been.

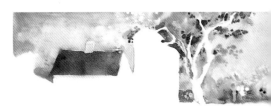

Step 1

Step 2

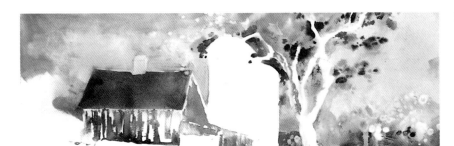

Step 3

Step 4 I put in some detail and lifted some color from the buildings. For the field in the foreground, I began by spattering masking fluid on dry paper. When this was dry, I washed on bands of color and then spattered these with masking fluid.

Step 5 Before removing the masking I lightened areas by lifting paint.

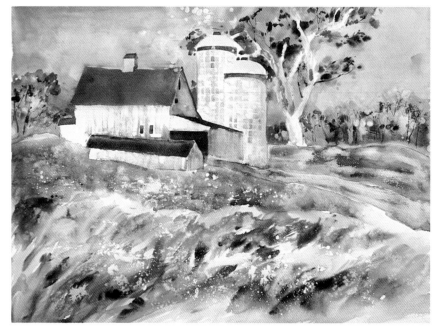

Step 4

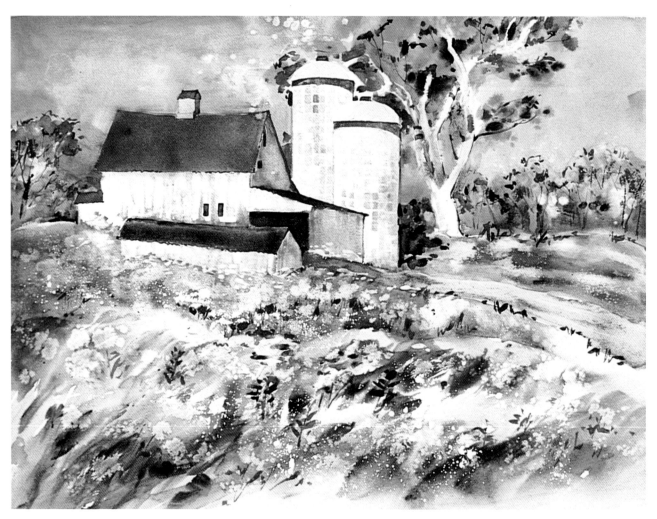

Step 5

FIELD IN BLOOM
21 x 29"

TEXTURAL EFFECTS

One of the hallmarks of wet-into-wet is the beauty of the painting's surface. The pleasurable qualities of the paint's settling on the wet surface are heightened by attention to the textural possibilities available to us. I explore these possibilities freely, without great concern as to what the various textures may represent. Once you see the variety of effects, many uses will suggest themselves to you. However, it is a good idea to use texturing techniques judiciously within an actual painting. The texture should enhance the painting—not unwittingly become its reason for existence. On the other hand, I believe that texturing techniques represent legitimate tools and should not be dismissed summarily as mere gimmicks. It is in their misuse that they may lose legitimacy.

Water and Paint

Some texturing techniques are simply variations on the application of our most basic ingredients, and they often do not require special tools. Water or paint, when introduced into a damp paint surface, will disturb and mottle that surface in various ways. Water can be introduced onto the paper first in the form of a spatter or spray, and then the paint can be charged into the water, in a greater or lesser amount. The main variables in the application of either the water or the paint are (1) the size of the droplets of liquid, and (2) the manner (including the devices) with which it is applied.

Spraying The finest application of liquid comes in the form of a spray, from a light to a coarser mist. Mist can be applied with various means. A trigger sprayer or various pump containers (for instance, empty cosmetic or household cleaning containers) are excellent for spraying water. A mouth fixative sprayer (available at art supply stores) works very well for paint, and on a more sophisticated level, an airbrush can be used. A fine spray of paint can also be applied by holding a loaded (but not too wet) toothbrush over the painting and stroking across the

bristles. This tends to result in a linear passage of spray.

As a texturing tool, spray comes dangerously close to becoming a solid covering of water or paint, so it is best to use it lightly to maintain some definition to the tiny droplets of liquid. Into the water or a light-to-medium-valued paint spray, thicker paint can be charged in at various points, to spread freely within the area of spray. Movement of the paint can be directed by tilting your paper, or even by delicate blowing. A fine spray of water, applied to a barely damp paint surface, can be allowed to settle naturally or be blotted delicately by gently floating a tissue over the surface, then quickly removing it. The water areas will attract the tissue, but the other areas remain undisturbed by the tissue if handled lightly.

Spattering When I use the term "spatter" I am referring to a coarser size of droplets than a mist contains. Their application is made through dropping, blowing, or shaking the droplets onto the paper. You can rap a loaded toothbrush (or regular paintbrush) handle against your hand to release a directional cascade of droplets. The less diluted the

paint, the smaller the droplets will be, and they will cover a smaller area. More fluid paint will distribute more freely.

Another way I like to drop in water for the effect of some small, spattery blooms is by dropping water from my fingertips. Water droplets can be allowed to expand naturally, or a tissue or paper towel can then be floated on to pick up the wettest areas. This equalizes the water content and arrests the blooming action.

Another favorite way of spattering is by stroking a paint solution across a window screen in amounts that I wish to transfer to the painting. The solution is trapped in the screen's mesh. Then, holding the screen above the painting, I blow the paint onto the paper. I have quite a bit of control as to where the paint will go when I work in this manner. But it also looks as if it has been applied quite freely and naturally. The closer I hold the screen to the paper the less the spatter will spread out from my application on the screen. Shapes, even lines, can be applied with equal ease. Different paint colors can be loaded onto the screen and then blown through in one motion. Water can be applied in this same manner and then paint

In this detail, note the spatter effect on the upper rock.

can be charged in. A handy way of creating a screen tool is by using a large embroidery hoop and setting a small section of screen into it. This is quite portable. If you use acrylic, it is a good idea to rinse thoroughly when you are done so that it does not dry into the mesh.

Spattering can be used as an excellent transition from one area to another. It softens edges and can be helpful for gradations between colors or passages from light to dark. Spattering can also neutralize the intensity of a color, especially by spattering in its complement, or bring greater life to an area by spattering in pure color. All this can be done without disturbing the underlying wash.

Spatter can be applied directly into a damp wash or a rewetted area, diffusing slightly. If a "tighter" spatter is what you desire, remember that acrylics diffuse less; this can also be

achieved with a watercolor spatter laid in directly (best done on plain white paper, so there is no underwash to disturb). Allow this to dry, and then rewet it for a slight bleed at the edges. (This works best with non-staining colors that rewet readily).

If you spatter around a shape that you plan to paint, while the spatter is still wet you can lay in the shape with clear water. Then charge your color into the shape. It will have soft edges where the spatter abuts it.

You should practice the vigorous flinging of paint on scrap paper first. Variables include the amount of water/paint in the brush, type of brush used, and the direction and movement of the flinging action itself. If you fling a pale tint, you can charge in the paint where you desire along the path of the droplets. You also have the option of wiping this light tint off if you do not like the results and trying again, before

charging in the color. If your surface is glazed with an acrylic paint or medium, you can wipe off even thicker coats of spatter until you are pleased with the look.

Loading brushes with different colors and then binding them together and flinging can produce a very interesting multicolored spatter. You can also shake these down with a vertical jab (they would have to be quite wet and overloaded in order to release paint with this motion. You could also try scumbling these brushes around, in a chopstick-like manner.

Blotting Blots are a good textural element in large paintings. In smaller paintings, though, blots become too dominant.

Blots are achieved by dropping onto the paper a controlled amount of liquid paint, resembling the appearance of a very large droplet. This can be done by loading a brush

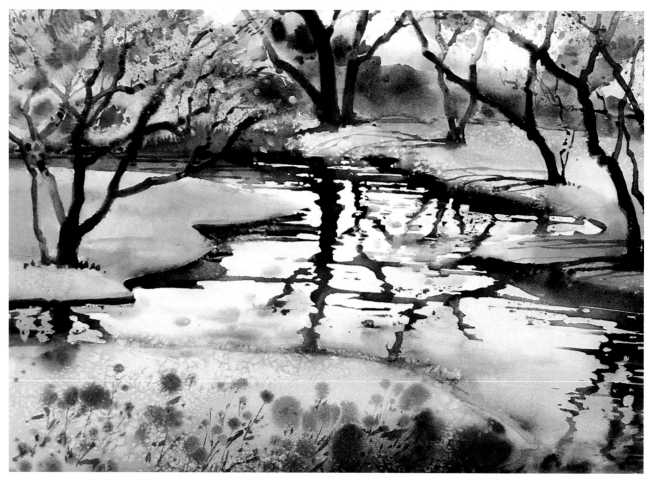

SPRING CREEK *Blots were used to create to create the mauve floral shapes in the foreground.*
21 x 28"

(generally a "round") with slightly diluted paint, holding it perpendicularly over the paper and squeezing out the paint starting from the ferrule out to the tip of the brush. The basic size of the blot depends on how much paint you load in and the size of the brush.

The degree of wetness of the paper and the type of paint (and how diluted it is) will determine the expansion of the blot. The height from which it is dropped and the force with which the paint is extruded can also affect the results. Blots also can be dropped from a syringe, baster, or eye dropper.

If you wish the blots to expand in a particular direction, angle the paper to allow them to run. Or you can cause the droplet to explode by directing a stream of air forcefully onto it. Very focused air could be directed through a straw, or, for a group of blots, a hairdryer could be used. The explosive effect is most pronounced when the paint is dropped directly onto dry paper. The blot could be of clear or tinted water, and then color could be charged in.

To create very full spatter or blot shapes, a nonporous flat surface, such as Plexiglas or clear acetate paper, can be laid directly onto the wet paint surface, in order to spread the droplets. A brayer or large, clear glass jar could also be used for some directional spreading. This flattening out can reduce some of the color intensity as part of the paint adheres to the glass surface.

Creating Blooms As we have learned, blooms arise wherever a wetter area rushes into a barely damp area on the paper. These blooms can be dropped within the damp wash or run alongside it. Either way, the excess fluid will rush into the drier area, picking up paint as it travels, and then depositing it in a sort of ruffled edge where it stops and dries. This effect can be utilized well if planned as a textural element (suggesting snowflakes, a floral edge, the silhouette of tree foliage, for example); uncontrolled, it can be detrimental to your work.

Blooms are basically the result of the uneven balance of water, and thus of irregular drying time. This can be utilized with lifting to create attractive light areas. When the area of less moisture has just dried, the still-damp bloom can be blotted up forcefully, leaving an attractively expansive white area. Or start with a wash in a staining color and allow it to dry as your base, instead of white paper, and create a glowing, colored bloom. The whole passage can even be gently brushed over with a wet brush, lifting up the excess paint at the damp outer perimeter of the bloom. This works best when the surrounding dry area does not disturb too readily (as with acrylic paints).

Salting Salt introduced onto a wash at the slightly wet-to-damp stage produces crystal- or starlike shapes. Paints do vary as to their effectiveness with use of salt. If the wash is too wet, the salt crystals will simply dissolve. If the wash is too

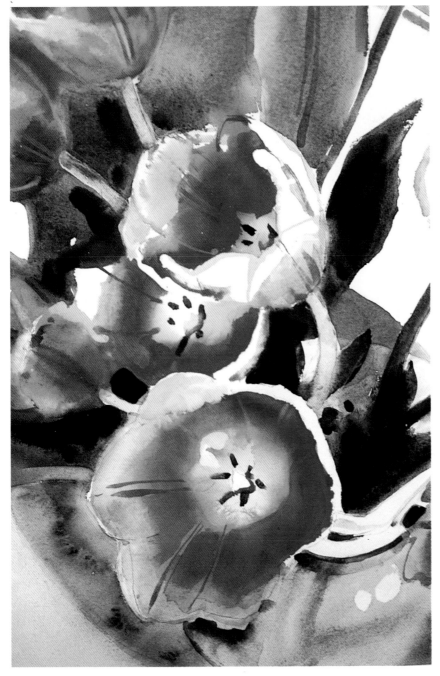

In this detail of Pat's Tulips, *note where a bloom occurred just below the bottom tulip.*

dry, the paint will no longer be attracted into the salt crystal and there will be little or no effect.

Under a range of wet conditions, color will be lifted in a soft manner; under drier conditions, the crystal shapes will appear tighter and more hard-edged.

Also, value contrast will show off the results with greater success. Darker paint with salt effects exposing the white paper can be quite dramatic. Lovely effects can also be achieved starting with a dried base layer of deep or intense color, and then dropping salt into an opaque light-colored overglaze, exposing some of the deep-colored wash.

As with lifting bloom areas, when the surrounding paint surface is dry and the salt crystals are still damp, the salted area may be blotted up vigorously or brushed over lightly with a moist brush to remove the color collected by the salt crystal. This leaves larger, more pronounced, expansive white spots than the salt crystal effect alone creates. One additional effect, which can be achieved with acrylic paint, is by pushing down hard when blotting up the salt. The dark center of the crystal is forced into the paper, leaving a lovely crystal shape with a dark center (very suggestive of a field of flowers).

For varied salt effects, try using margarita salt (large crystals), clumping grains together, tossing salt on at different angles, or angling your paper more vertically for a running of the salt lift. Stroking through the wet crystal area once the surrounding area has dried will produce interesting lift-off effects.

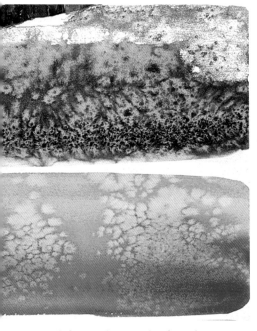

Salt can give you simple grainy textures and other, more complex textural patterns.

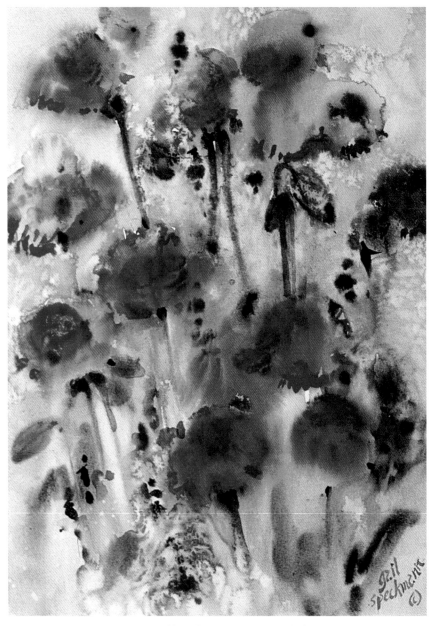

POPPIES
10 x 14"

Salt suggests an effect akin to baby's breath flowers.

REFINING EDGES

Edge quality in a painting is very important. Your basic decision regarding edges in a painting should be made early in the painting process, when the basic approach you choose will reflect your dominant edge choice: Working on saturated paper should reflect a decision for overall softness of edges; painting by sections would be the natural choice for crisp, well-defined edges; the painterly approach might reflect a choice to have variable edges. If you stay aware of your edge choices as you paint, less refining and adjusting of edges will be required to complete the painting.

Edges naturally form on dry paper, so it is helpful to consider this as one paints. On wet paper, with the board support at a slight incline, the top edges of shapes will hold a firmer edge as they dry quickly. I tend to work from the top down, often blending a new passage into the lower edges of the earlier ones, and this has a softening effect on the lower edges. This parallels the way things naturally appear; the upper edges of forms project and generally have greater definition, and the lower edges tend to merge visually into the ground or other objects.

How do we choose where to place the hard- or soft-edged areas? Hard edges demand more attention, and often are best placed at the center of interest. A logical place for the hardest edges to occur is around the untouched whites, which also often occur at the center of interest. Hard-edged objects appear to be in the foreground, where there is no effect of atmospheric softening. Hard edges suggest hard, smooth surfaces of any shape (hard does not necessarily mean angular).

Conversely, soft edges suggest distance, with its atmospheric effect. The objects themselves can actually be ones which have architectural lines and hard surfaces, but ones that are mitigated by distance. They can still have angularity, although their acuteness is blunted. Otherwise, soft edges indicate a softly fuzzed or furry surface.

I enjoy the contrast of employing rounded shapes, which have a softening effect, in the more hard-edged, sectioned approach. I also like composing with more angular shapes, which give strength (though they blur softly), in the saturated approach.

If you are painting a silhouetted image, this will call for an effective use of hard edges for the outer edges of the forms. Within the silhouette, objects or people can be massed, with a minimal soft value or color variation.

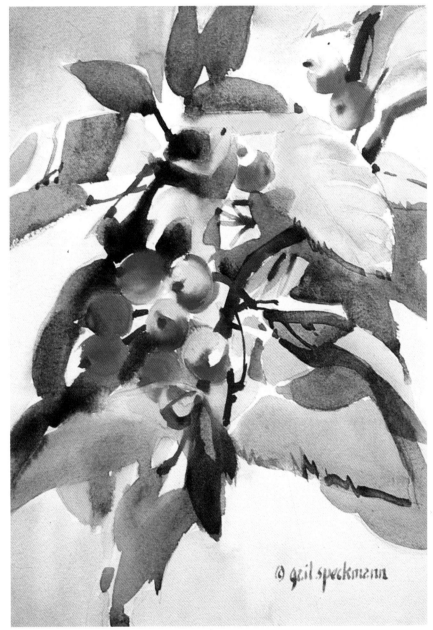

CRABAPPLES
10 x 14"

Within each painting, you will most likely want to finish up by lending some variety and balance. Soft-edged paintings may call out for some more defined edges for contrast. Hard-edged paintings will relax a bit with some blurred edges. In a painting such as this one, I like to see a mix of both.

Putting in Hard Edges

Hard edges occur as paint—a wash edge, a brushmark, a pour, or blot—meets unprotected, dry white paper or a masked edge. Spatters and sprayed paint on dry paper look hard-edged but appear soft, for they visually blur images. A rough dry-brush edge can be considered hard, even though it is broken. A softer version can be created by laying down clear water and then stroking or touching in color. This is achieved by pointing your paint-loaded brush tip into the wet bottom edge and dragging the belly of the brush along the dry paper just below.

When you come to making final adjustments, hard edges can be re-created by lifting off color cleanly against a firm edge of undisturbed paint. This can be done by using a stencil opening or edge, or by utilizing a chisel-edged brush for a lift.

Hard edges can also be created by negative painting—glazes painted *around* the (positive) objects, so that hard edges form at their perimeters. A variation on negative painting is painting around the outer edge of the shape contour and quickly fading outward into clear water. The reverse of this also works—inside the shape—painting along the contour and diluting the innermost into water. Either way leaves one hard edged side and one which blends into its surrounding area.

Softening Edges

A hard edge can be softened by stroking clear water across the edge while it is still slightly moist. Loosen an already-dried hard edge with a damp bristle brush and lift. If there is danger of a faint paint line forming at the outside edge of the lift, you can sponge that out with clean water. If an edge accidentally sets, you can still remove this in the same manner. (This type of softening gives you a very controlled method —no color running freely.)

Also, if a hard edge has dried, you can paint an area of similar value and color right up next to it. Once dried, the "seam" edge can be loosened slightly with a brush, if needed, and the paper can be moistened and over-glazed to help unify the two.

If you want to reduce value contrast, you can overglaze a hard-edged passage by floating on a slightly opaque white or light-toned paint. Or you can adjust toward a deeper value with a darker overglaze. Hard edges can also be gently loosened with a brush while this overglaze is moist. Spattering on water or salt can mottle this light opaque or deeper-toned area, if desired. These techniques help reduce the intensity of too many hard edges in an overly busy painting. Plan carefully which areas you want to preserve and which you want to soften.

A similar muting of values and edges can be achieved by spraying or spattering slightly opaque light-colored or deeper-toned paint over the area, obscuring the hard edges.

Blooms and crawlback edges can be adjusted by moistening the paper, loosening the paint from the darker area, and coaxing it into the light area. This is a natural equalizing, for you are using the same paint from the lift area and depositing it into the needed area. An overglaze may help to further blend the area.

Unwanted drips can be stroked through with clear water and blotted back thoroughly to the desired edge. It is better to catch these immediately than to fix them later.

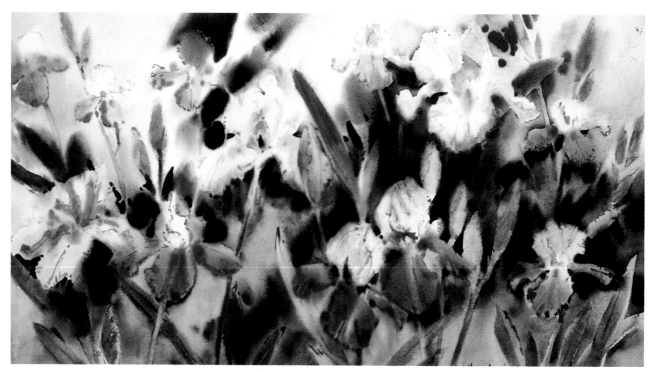

GORDON IRIS
22 x 40"

Note the exploration of round versus angular and soft- versus hard-edged passages that lends this painting its richness.

BRUSHMARKS

The brushmarks that I think of as "calligraphic" detail are often part of the process of finishing the painting. Some detail may be added as you are painting, but it is frequently best to work on the broad masses first and then assess where strengthening detail is needed—to stand back and gain some objectivity about where the painting could use finishing strokes. Often, the last touches give the painting a more realistic appearance. A minimal amount of detail can suggest that much more is present. The viewer's mind fills in the gaps, participating actively with the painting.

I prefer to add detail that provides accent and contrast. Pure, intense color can be very enlivening when used for finishing details and just the needed element to bring a painting to life. I seek areas that may benefit from a linear detail or a complementary-color spot, which can give energy to a painting whereas large complementary areas might become loud or raucous. You can thus be freer in the use of highly imaginative color choices on the level of details.

Often, defining strokes may simply be in a deeper value. If paint is applied in a lighter value, it has to be rather opaque in order to be seen. This can work at times, but it is somewhat at odds with the principles of transparent watercolor; usually, lighter details can be lifted off, exposing the white paper.

In the finishing details, more than any other part of the painting, I appreciate seeing the brushwork. Strokes that are well thought out and executed decisively have much strength, and they add a great deal of conviction to a painting. They are like calligraphy. It is usually best to challenge yourself to see how few strokes it takes to make the state-ment that you need. If you feel any indecisiveness, it may help to lay treated acetate over your painting and experiment with the strokes you desire. Then you can paint with greater confidence on the actual painting. Another way to keep the door open for revisions is to use paints that lift back easily if the brushstrokes are not successful. However, this may become a danger-ous crutch if used too frequently.

There are times when I prefer to lay down my calligraphic strokes at the start, directly on the white paper. Then, after these are dry, I pass over them with my washes. This way, I have more freedom in creating my linear details; if I do not like what I laid down, I can simply lift them off and start with the white paper again. (If I have already put a wash on the paper, it too would lift off, damaging its evenness.)

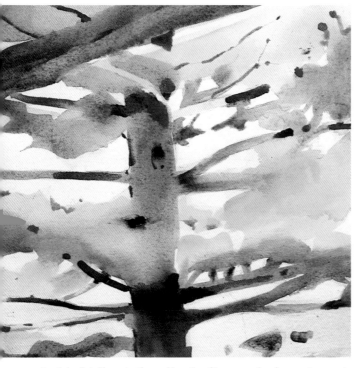

In this detail, note the enlivening linear and color-spot accents that contrast with the soft passages.

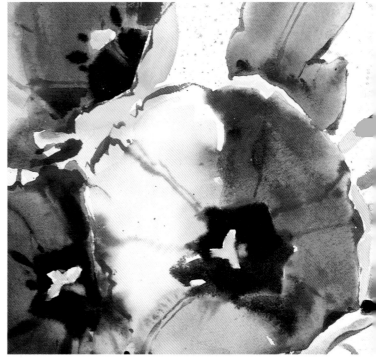

This detail shows how I went over my calligraphic brushmarks with wash colors.

5 *Applications*

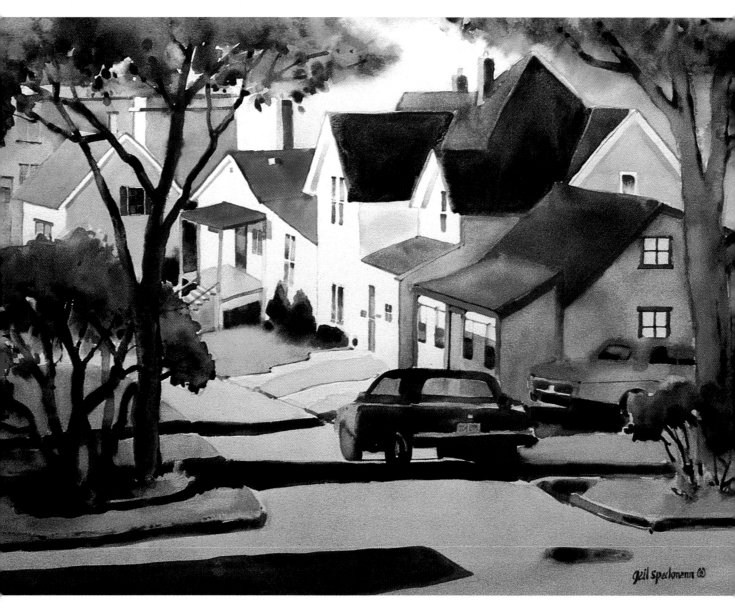

DOWN THE STREET
21 x 29"

For me, part of the desire to paint is a longing for a moment that has gone, a wish to reconnect with my subject. Your most important connection with your subject is a visceral experience of it. Be out in that weather! Feel the texture of that fruit! Climb those rocks! You will evoke a greater response to your work. Of our senses, other than sight, touch is most called upon in painting—connecting with the rough bark of the tree, feeling the moisture in the air. Texture can be indicated through your brushmarks and through the behavior of pigment on paper. When I am truly immersed in my surroundings, I just want to be fully there—in a lovely garden, in foggy weather, or a strange town. After I have lost that experience I want to re-create it. Perhaps this is why I am fond of using a camera; I can record impressions without taking time away from simply "being there," and then work in the studio later. In the following pages we will explore ways of using wet-into-wet watercolor to convey your impressions and communicate your connection to a variety of subjects, especially those found in nature.

LAND

Though the subject of land is a varied one, the face of the earth is invariably made up of planes. Thus landscapes have these in common. The ground tends to be flat or gently undulating. Changes in surface shape are gradual, not abrupt, unless you are dealing with rocks and mountains. High areas tend to be more exposed planes, having lost their covering; low-lying areas tend to be darker in value, or hold snow or vegetation. Landscapes that deal in fairly flat land (a strong horizontal emphasis) greatly benefit from some vertical relief, such as trees or silos. The diagonal lines created by hilly land and sloping shorelines can be visually exciting. Shadows help clarify the contour of the ground.

Landscape traditionally deals with foreground, middle ground, and background. The vantage point from which you view the land has a direct bearing on this. Overhead views diminish this variety of distances, the horizontal view increases the importance of these variations in planes. Either foreground, middle ground, or background needs to be emphasized in a particular painting, subduing the other two. This empha-sis, which mimics human vision and its ability to focus on only one area clearly at a given moment, gives the artist a compositional device that helps direct the viewer's attention as he or she intends.

Some paintings of lesser depth may not include all three levels of distances. A landscape may depict three areas consisting of sky, objects such as trees, buildings, cattle—whatever interrupts the earth–sky connection—and land.

Broad variations in the subject of land come from the abundance of ground coverings, which include a wide array of colors (many of which do not exist in the land itself), values, and textures.

Ground Cover

Grass and Weeds The most common ground cover, grass and weeds are natural and free in their growth on the earth's surface. Yet they should not dominate a painting. Often grass may be expressed simply as a wash of green tone, onto which cast shadows may fall.

Grass and weeds can provide lovely calligraphic or textural ele-ments in a painting. Grass can be used to echo linear movements, such as those of tree branches. Distant tall grass can be expressed by softly alternating horizontal bands of color, created either by light and shadow alternations (value change), or by green (healthy) and gold (dried) bands running side by side (color change). As grass-covered areas become closer, soft strokes of color that suggest separate blades can be laid into the wet surface. The more multiple the lines, the more they become like texturing, rather than isolated elements. For grass and weeds in close-up, calligraphic brushwork can be utilized. To keep these lines from becoming too demanding, they can be laid over (and even contained by) thinner washes of paint, that are in low contrast with the color and value of the calligraphy. A round brush or cat's tongue are good choices for painting grass and weeds.

Color can also by scraped out of the damp paint to create linear grassy strokes. (Remember that when you initially scrape into an area that is quite moist, color rushes into the "scar." When paper is approaching

just damp, color stays pushed to the edges of the scrape marks.) I like using a rounded, beveled edge, sometimes found on the end of a plastic-handled brush. A thick-to-thin stroke is easier to execute than the reverse, for it is easier to lift off from the paper gracefully than it is to land that way. I often like to charge in semi-opaque color over parts of the moist, scraped-in marks. This obscures and softens some areas. The dark "squeegeed" edges of the marks remain fairly strong underneath, and the new color fills in the scarred surface. At other times, I sponge the paint off part of the scraped area, obscuring and lightening the effect of the scraping.

Fields and Plains Fields can often appear as a patchwork of color, like a quilt thrown upon an undulating surface. Fields with vegetation tend to be in the middle-value range, ranging upward and downward of this but often having fairly subtle value contrasts. The patches of color can be laid in as sections, with their edges softly merging. On saturated paper, patches of color can also be laid down, and some linear and edge definition added as the paper dries. In panoramic land views, the planes are lighter and less contrasting in the distance and appear as flatter areas of color in the distance, but as they become closer, texture and linear elements become more important (painterly strokes work well for these). Crop rows become more visible close by, or on a hillside facing us.

Elements that are often present in field areas that help provide contrast include tree lines (often darker in value, with the possible exception of bright yellow in the autumn), ribbons of highway and the gravel edges of roads (light value), poles and fences (variably lighter or darker), cloud shadows, eroded banks, and streams.

Bare Earth Bare earth can range in color from gold, rust, mauve, tan, browns (in pale to deep tones), to black. The values range according to the degree of moistness of the soil. You often see a range, from dry (high, exposed areas) to moist (low-lying, protected areas), within a field. Moist soil is quite low in value. Bare earth areas can be enlivened by dirt clods or ground debris, created by spatter, drops of color, or loose brushstrokes of water followed by charged-in paint. Wet glazes of colors that granulate or break apart provide an excellent surface texture (acrylic breaks apart especially well).

Bare, flat land can often be expressed by use of a wash. For moist ground, deeper, more muted colors can be used. For furrowed or choppy soil, darker color can be

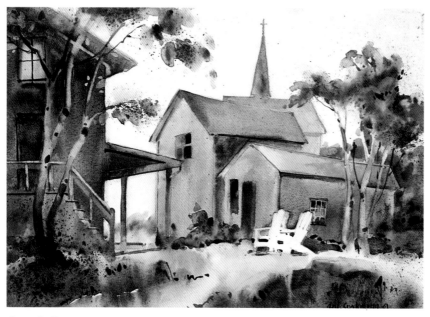

CAROL'S CHAIRS
16 x 21"

Grass color is usually quite warm, often in the bright green to olive green family, and can even be expressed by yellows and golds. It usually falls in the light to mid-light value range.

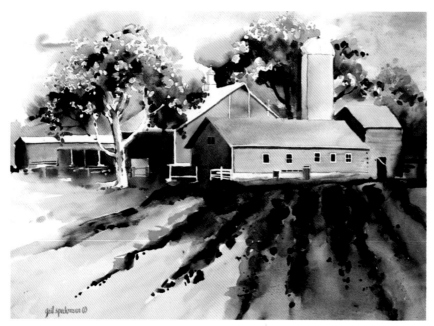

FURROWS IN THE FIELD
21 x 29"

An effective light–dark alternation can be created by furrows.

charged into washes. A painterly approach could also be used for these, loosely connecting some edges, but still maintaining some definition to the brushstrokes.

For texture, I like charging in the heavier colors, for a juicy, weighty impression. Earth colors and Mars violet work nicely. Spattering on paint will soften the lines of the furrows for the close view and will imply more definition (if using a painterly approach, rewet the overall passage with clear water, once the furrows have dried).

Sometimes there is a gradual transition from a growing field to bare earth, but with a green covering mottling into that area. Open furrows in bare fields also may have grass poking through. Water may settle into the wells of the furrows of earth or low-lying areas, providing a contrasting value exchange. Details such as these may call for the use of masking techniques.

Sand Dry sand is very light in value and can vary from almost pure white to a peachy gold to a more grayish tan. Wet sand drops down dramatically in value, but still stays in a middle- to slightly lower than middle-value range. Sand very often is painted in relation to the water's edge. The wet sand along the edge should be contrasting in value, often darker, but sometimes very light if it is reflecting overhead light. Water-sand alternations at low tide provide very attractive design possibilities.

Sand is often expressed very well by washes, incorporating wet glazing (especially with granulating paints) for luminous color and slight texturing. Beach debris provides some accents. Small rocks and litter put in as calligraphic details can create darker accents. Bleached white rocks and shells could provide white spots.

Approaches

On Saturated Paper Land painted in the saturated method has the softness of atmospheric conditions appropriate to a distant scene. Also this approach is well suited to low-light conditions, such as dusk and dawn. These are times when there would be less contrast on the surface of the land. A damp pavement surface with its soft reflections would handle well this way also.

Painting by Sections Any blocks of land surface, including sand or bare earth, work well in this approach. It provides a means of contrasting different land surfaces, particularly where distance, which obscures the livelier detail, is involved.

The Painterly Approach This approach emphasizes the great variety of texture in both ground cover and the surface of the earth itself. Closer views lend themselves particularly well to the use of brushwork.

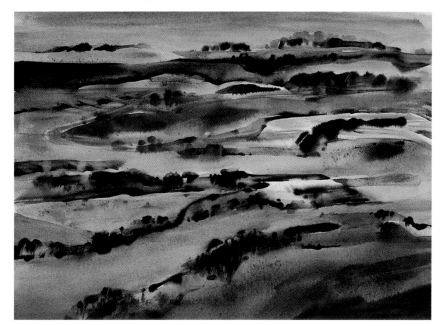

AERIAL VIEW
21 x 29"

Softly undulating hills are nicely created on saturated paper.

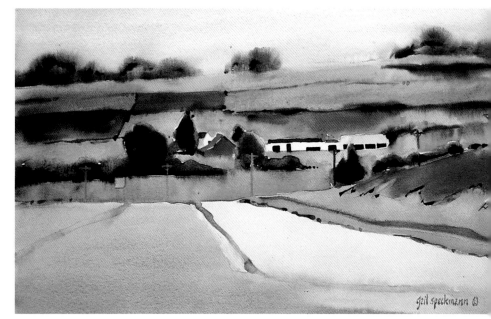

OCTOBER FIELDS
14 x 21

The patchwork created by fields handles beautifully in the sectional approach.

SKY

The subject of sky really encompasses "atmosphere": different lighting and weather conditions. One of the crucial elements the artist confronts when painting on-location is atmosphere—catching the total feeling of the moment. When gathering information, take notes to accompany sketches or photos (color and textural cues). Make an effort to consciously absorb this information.

Skies are a natural for painting wet-into-wet. Atmosphere, air, and light are wonderfully replicated, the soft forms of wet-into-wet. You can watch painted clouds grow and develop almost as they actually do in the sky. Remember that the sky will continue to progress after the paint has been applied. The wetter the paper, the better it is to overstate your color and shapes, because the

The sky changes before your eyes.

This sky study employs spattering to good effect.

water will soften both. Cloud images can dissipate right before your eyes, especially if your paper is too wet. I try to limit the number of clouds; a few good ones can be more expressive and have more impact than lots of small ones. Remember to have some size variations, too.

Skies should be laid in quickly; timing is of the essence, so you want to be ready and to set the stage well. Have sufficient paint prepared. Be aware of the degree of wetness of the paper, in view of the results you desire. If the paper is wet, tilting your paper once the color has been laid down will encourage your images to flow in one direction. This helps in unifying your sky and giving it character: vertical tilt can give the appearance of clouds yielding rain; horizontal tilt lends peace and calm; diagonal tilt expresses wind and storm. Once you achieve the look you desire, quickly level your board to prevent further paint flow. I usually try to wick off any excess fluid without disturbing the image.

I paint my sky first when composing a painting. This way I can feel free, having invested little time in the piece so far. The resulting sky sets the tone and the mood for the rest of the painting. If your sky dries too light, or simply needs improvement, you can rewet it and try again.

You should carefully consider the content of the rest of the painting as you decide which approach to use in painting the sky.

Elements

Texture Skies are soft. The hardest edge you would ever find would be the upper edges of billowing cumulus clouds. Even these should have some lost edges, and the shape is rounded, not angular. You would not want to come up against a hard, dry edge in painting clouds. It usually best not to be overly concerned about creating a specific cloud form. Brush in the basic "seed" strokes for the clouds and allow them to develop. Just remember to lay down interesting strokes, so that you do not end up with circular or square shapes.

Spattering or droplets of paint or water can enliven your skies. Salt also can be used for cloud edges or starry skies. Once the paint has dried, I like to lift salt back off with a moist sponge. The image left is less crystal-like.

Color A wide range of color can be brought into the sky area. Overall you may wish it to "read" as a blue or gray area. I like to bring in color from other areas in the painting, in order to provide unity. Oftentimes, I lay in a warm color underneath to capture the feeling of light (a warm peach color, such as Holbein's jaune brilliant no. 1 is effective) and a cool color on top.

Blues with a strong underwash of yellow suggest warmth. The danger of creating a green sky can be avoided by using an ochre underwash rather than a true yellow. Or use a lavender or gray overglaze, instead of blue, over a yellow underwash.

Blues with a cool red underwash suggest to me cool, dry autumn weather particularly. Whenever you add reds or purples to a wet glaze, the time of day suggested is either sunrise or sunset.

Value The sky provides you with a wonderful compositional tool. Your value can be made darker or lighter in order to accentuate foreground images. Skies with greater value contrast within them lend drama to the painting. When the value stays fairly consistent within the sky, it becomes more of a backdrop for the rest of your painting.

Sky–Ground Relationship I like to think in terms of the sky and the land mass as being in contrasting values. They read better as separate elements. But this is only a guideline. There may be times when you wish to have a subdued distinction between sky and horizon. Perhaps you want the viewer's attention to be directed elsewhere. I do like to have similar values connecting at least a few points along the horizon in order to weave the one area to the other.

Types of Skies

Clear Often a basic wash can express "sky" and become a backdrop for your painting. Color vibrations can be created by wet glazing more than one color. This produces an atmospheric glow, particularly if you use paints that granulate. A simple graded wash is also effective for a clear sky, blending down into a light, warm color near the horizon. But consider reversing the direction when layering washes; this can create interest and color opposition.

If you wish to create a smooth sky with no evidence of brushmarks, consider pouring or dropping paint of creamy consistency onto a wetted surface. You can create a very fluid appearance. Tilting helps to smooth and elongate the shapes, but you may prefer at times to keep the drop shape. Sedimenting paints or ones which brush on unevenly would be good candidates for pouring. Make sure that they are mixed thoroughly before using.

Overcast A solid overcast sky is also a simple sky, and it is one that will sit back and not dominate the painting. The overglaze and dominating color is grayish, though this can be created from various colors. I find it best not to use the more primary colors. Secondary or earth colors are more subdued to begin with, and thus work well. The more heavily overcast the sky, the less yellow, and then red, you should put into the sky layers. The cooler shades take on more strength and intensity in the landscape and objects, too.

Cloudy Skies Clouds are often flat on the bottom, and they cast shadows onto each other and onto the ground—a great design tool to enliven your landscape. Parts of the clouds away from the sun's rays appear in shadow. Clouds reflect light and color bounce. The undersides are often warm in tone (the nearer to you, the warmer) as they reflect the earth below.

Stratus clouds, the calmest and simplest, can be created by laying horizontal strokes into your sky wash. You can increase the horizontal effect by tilting your board left or right, or rocking gently between the two directions. For cumulus, or "fair weather," white clouds, you can wet or pre-saturate the sky and then negatively paint the blue in around the clouds. Remember that the blue area will expand. You can always regain some white clouds, too, by lifting paint off with a moist sponge. I have also used salt on the edge of the painted area to hold the color back and to create a soft texture for the edge of the clouds. Retarder just inside the white edge also keeps the color from entering the cloud.

Sometimes I paint this type of sky laying in the blue sky patches directly onto the dry paper. Then I approach the edge of the blue areas with clear water, starting within the cloud shape. I do this to loosen the blue edge. Paint will not expand so far into my clear-water area as to leave another edge. Later I may rewet the clouds with clear water and softly charge in a tint for the undersides.

Storm and rain clouds are nimbus and cumulo-nimbus clouds, which can be the most exciting with their strong value contrasts and turbulent movement. The same colors dominate as in the heavily overcast skies: the cooler colors take on a glow and the warm colors become more muted, as they are muddied by the cooler light.

Approaches

On Saturated Paper When painting skies on saturated paper, you can actually have a fair degree of stability in the cloud shapes you form. Because the paper itself is saturated, you need a little less surface water and, thus, the image you create with brushstrokes is less likely to dissipate. On the other hand, if you want very free, loose images to form, give yourself more surface water to paint into. This image will be more vulnerable to dissipating than one on just-wetted paper, because it will take even longer for the paper to dry (saturated paper has nowhere for the liquid to soak in).

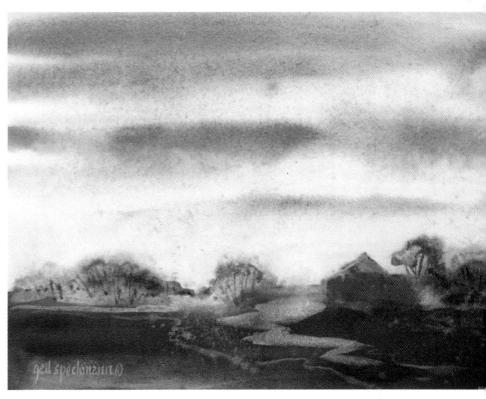

ERNIE'S FARM
10 x 14"

To accentuate the luminosity of a sky passage, contrast it with darker clouds surrounding it or against a dark foreground.

In order to lay a wash, have enough liquid for the paint to flow and for the strokes to meld and blend. Some pigments lay down in this type of wash more readily than others. Sedimentary paints are prone to "stripe"—that is, have an uneven appearance. Having enough water remaining on the paper surface, with some visible gloss, will encourage paint flow. A slight tilting of your support board will also encourage the melding of your strokes.

Painting by Sections In this process, I would basically treat the sky as one large section. Very possibly, I would have painted clear or lightly tinted water around my horizon line, and everything above would be stroked with clear water. For a smooth, clear, or solidly overcast sky, a flat wash, a graded wash, or wet glazing would be employed.

When I am laying down paint that I want as an even color coating in an area that is already wet (either from clear water, a previous wash, or on saturated paper), I do what I call touch-downs: touching my loaded brush lightly down at spots, and at intervals, so that the touches will expand and meld together. This is something for which one has to develop a feel. It is influenced by the amount of water on the paper surface, the type of paint used, its dilution, and the type of brush used.

When the wash has just enough moisture left in it to run a little bit, I sometimes pull down a little portion of it here and there into the scene below to help unite the two areas. Paint could be pulled down into roof shadows, for instance. I often then charge some additional color into the roof shadows. Otherwise it is very easy to end up with a sky that looks as if it were cut out and pasted onto the scene.

The Painterly Approach This approach would best define a dappled, or mackerel, sky. It would give a very active surface to the sky, and the danger could be that it might come across as too hard-edged. One way to minimize this difficulty is to put in your painterly strokes in a very light value. Then, as somewhat deeper color is charged in here and there, the overall impression is soft because of the diffusion of that paint into the still-wet, direct strokes.

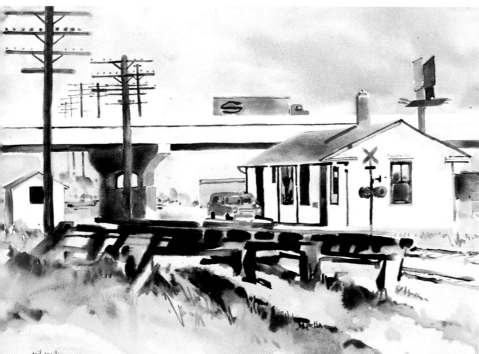

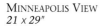

HOPKINS' RAILROAD
21 x 29"

Tilting has helped me smooth and elongate the dropped-in paint for the sky.

MINNEAPOLIS VIEW
21 x 29"

Painting on saturated paper gave the sky for this snowy cityscape the atmospheric quality it needed.

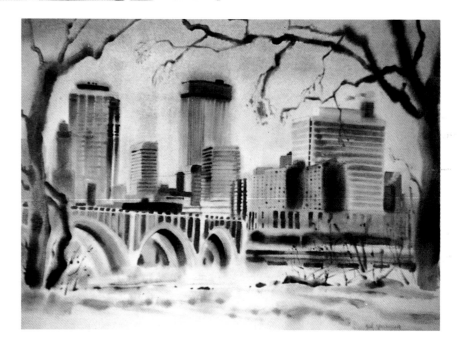

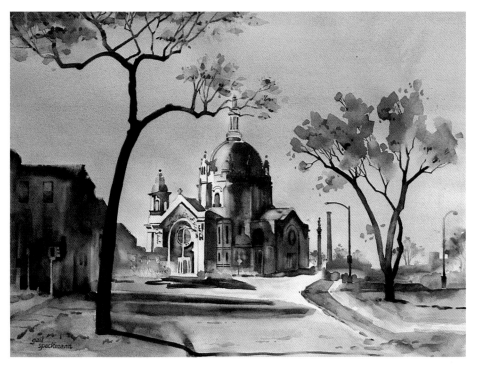

CATHEDRAL
21 x 29"

"Touch-downs" of paint have melded subtly to give me this soft, late-day sky.

BLUSTERY SHORELINE
14 x 21"

An active, painterly sky will encourage the artist to keep more fluidity in the working of other parts of the painting. The sky and ground need to have some relationship in the way they are handled, or viewers may feel that they are really looking at two separate paintings.

WATER

There can hardly be a better medium than watercolor for expressing the elusive qualities of water. But it is important to study the nature and behavior of water in order to bring it to life in our paintings. Its mercurial properties can make it seem quite challenging, but water is actually quite consistent in its responses. With water, perhaps more than almost any other subject, it is important to be able to paint with confidence and conviction, not fretting unduly about highly specific details.

Water Conditions

Quiet water can be quite glassy and mirror-like, but it can be helpful when rendering it to provide some slight rippling or other indication that this is water—it is more alive than a mirror. Transparent washes, often graded to mirror the sky's variation, can express the calm surface simply. When the surface of the wash begins to lose its shine, an occasional slight ripple could be indicated by charging in a thin line of deeper value. Or, at that same stage of dampness, a damp brush could be used to lift out a thin horizontal line.

Shadows rest on the surface; reflections go straight down, as if into the water—an intriguing optical illusion. It is a good idea to create some slight rippling in order to say "water." If you are seeing the bottom of a stream and its reflective water surface at the same time, paint from the bottom surface up. Allow the bottom layers to dry on the paper surface before the next application. Rewet the area and

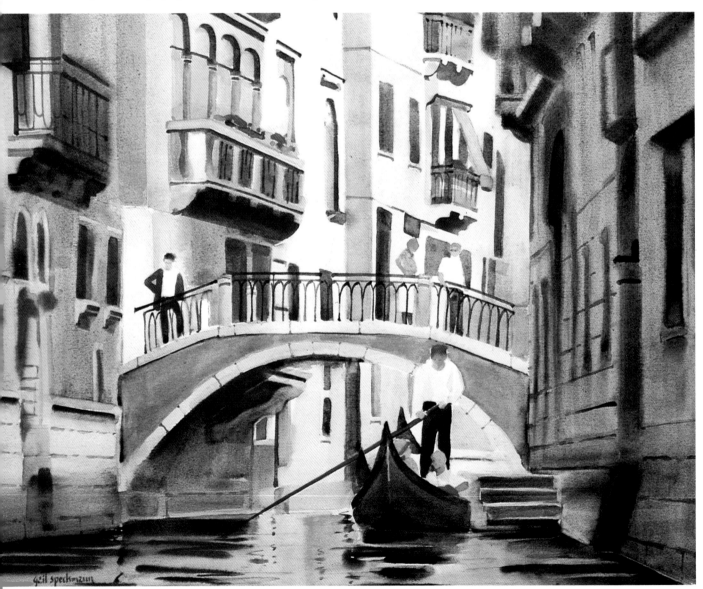

VENICE
21 x 26"

Investing the water's surface with shifting horizontal bands, you capture a zigzagging, rippled image.

float on the next layer. Semi-opaque white paint, floated on as reflected shapes over a "below-the-surface" layer, can create intriguing dimension. If you have foam or plant life on the water surface, you may want to paint around them negatively, or block them out with masking fluid and paint them in later. They should "sit" on top of the paper.

Rough water is characterized by little or no reflection and by a pattern of waves, which increase in size from background to foreground. Variable though they are, waves tend to be low triangular shapes, the top edges being the more distinct.

Churning water, tumbling over rocks or in a waterfall, foam, and spray are expressed as white areas, allowing their form to be described by the slightly calmer area surrounding them or the darker objects being struck. The white shapes have soft, disappearing edges, and can be tinted lightly with color in a loose, lacy manner, to indicate slight shadowing or openings where color shows through.

Reflections Sky has the greatest influence on the reflective water surface, lending both its color and approximate value. When the sky is less bright due to heavy overcast skies, the water often drops in value dramatically, particularly if surrounded by dark trees, which reduce the impact of the available light. The values and color of reflections are usually muted, compared with the actual object.

Waves and ripples tend to catch light on one side and reflections on the other. When objects are mirrored into waves, this creates the broken images that are often seen. As the reflection, which usually appears to drop straight down from the object, descends, the front side of the wave reflects the sky or dominant influence (surrounding forest or canyon wall) and only the back side of the wave reflects the object. A wave ripple running through a dark reflection can be shown as an attractive light–dark reversal as the front part of the wave reflects a midtone, lighter than the dark reflection but darker than the sky reflection into which it passes.

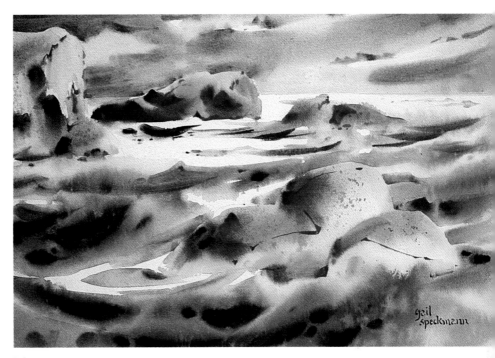

WAVES
14 x 21"

White caps at the crests of the waves or foam and spray where waves hit against rocks are easily suggested by unpainted and lifted whites.

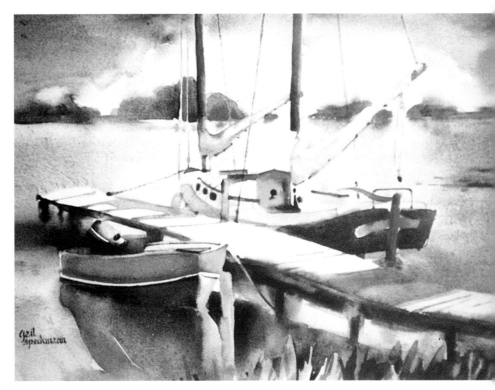

GREEN BAY BOATS
10 x 14"

Generally, reflections are more dominant than shadows, which rest flat on the water's surface. When they overlap, the shadows all but disappear as the light of the reflections bounces into them.

Value

Though individual scenes will vary, the water surface does tend to be brightest in the distance, reflecting the greater light at the horizon. The brightness of both sky and water at the horizon can be utilized to minimize the horizon line, and thus attention can be drawn to other more interesting areas of activity. It may be helpful much of the time to alter the value between sky and water to some degree; often the water is slightly darker.

Water in the foreground is often deeper in value, reflecting the deeper sky tone at its zenith. This helps contain the brightest area within the picture frame, a good directing device.

Rough water tends to be quite a bit darker than the overcast and even the stormy sky. The darkness of the water may be broken up by the lightest value passages created by foam and spray.

Values can be reversed dramatically, depending on design. Consider a stream running through a meadow: it could become a dark passage cutting through the land, particularly if depicted on an overcast day, or if surrounding trees cut off light from the water. Conversely, the stream could be painted as a very light passage if there is strong light reflecting from it. A frothy stream also could be very light in value.

Approaches

On Saturated Paper The soft edges of rolling waves are expressed readily by painting with fairly undiluted paint on a saturated surface. They will keep their form, but with gentle edges. Reflections on calm water, such as soft, distant tree reflections, call for soft-edged forms. Glowing sky and cloud reflections, and fog and haze with their gentle reflective effects work well on saturated paper.

Painting by Sections When the water area does not dominate the whole painting, it can often be laid in as a section with clear water. Then reflected areas can be charged in. The color within this will mingle quite freely as the water sits on the surface of the section. After this has dried, other contained reflections can be painted in clear water and then paint charged into them.

You can work a large water area as a section. Glazing will give the water surface an appearance of depth and luminosity. If you find it too large to work with comfortably for wet glazing (or if you wish to preserve the first wash as it is), allow the first

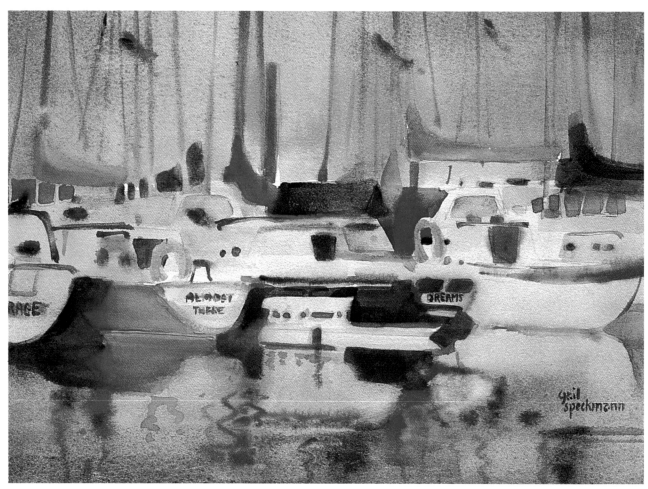

LAKE PEPIN BOATS
10 x 14"

Note that in this painting on saturated paper I have only generally captured the boats' images in the reflections, rather than trying to re-create them photographically.

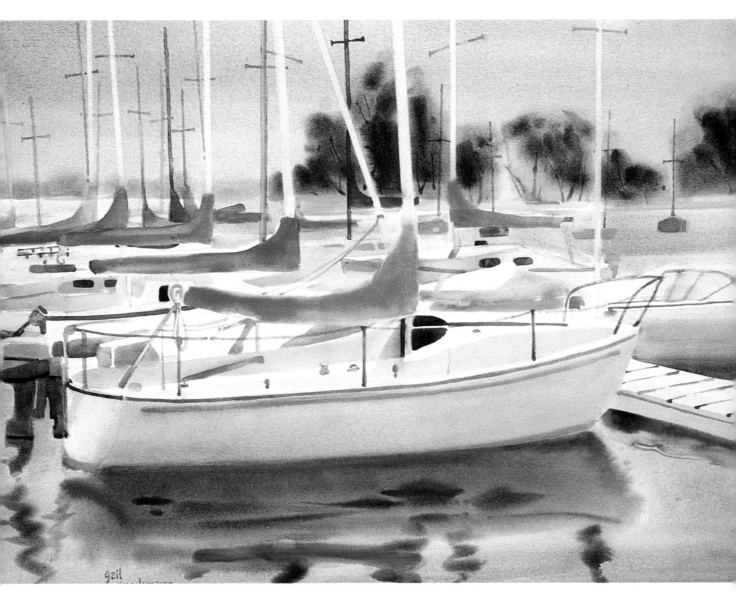

layer to dry. For subsequent washes gently rewet the area, either with a soft brush or a spray of water, and charge in your next layer.

For sunlight shimmering on the distant water, salt could be dropped in at the damp stage. When the paint surface is dry but the salt crystals are still wet, the area can be wiped off to create little points of light.

The Painterly Approach Distant water can be drybrushed in with a light tint, creating the impression of diamonds of light dancing on the water. As the tint is brought down the page, it can be unified into a wash and perhaps graded to a deeper tone. Or you can dapple in horizontal, oval-like brushstrokes, smaller in the distance and increasing in size.

This creates the impression of water slightly disturbed by light breezes and shimmering in the sunlight. It could also depict a calm water surface broken up by a rainfall. Deeper color can be charged in to roughly indicate reflections.

The freely squiggling lines of masts and other linear reflections are expressed well through direct brushmarks laid down in lightly tinted water; then deeper color can be charged in. This gives you a more fluid look than you can achieve by painting directly on dry paper. The broken reflections of objects and even waves can be handled in this manner. Charging color into the clear, wet wave shapes gives a softer look than painting hard-edged shapes on paper directly.

WHITE BEAR BOATS
21 x 29"

After painting in the water as a section, I rewetted the area and put in the separate, more detailed reflections.

ROCKS AND MOUNTAINS

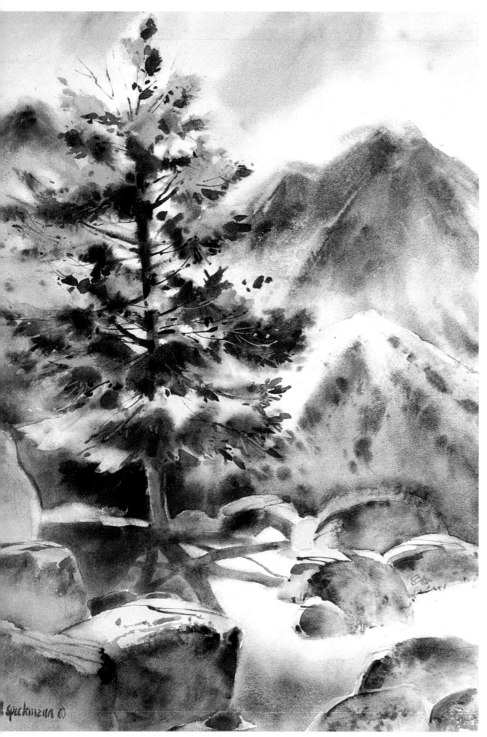

LONE PINE
21 x 29"

Because rocks can appear fairly randomly, they can be positioned within your picture as your composition dictates.

Rocks, shapes of mass and bulk, can provide a great antidote if you ever feel that you are getting too fussy in your work. Space on your pictorial surface will be filled with geometric shapes—spherical, trapezoidal, and so on. They are usually a combination of the more basic shapes. The edges themselves will be primarily rounded (allowing for some straight edges also) or angular.

Rocks can be represented by a flat area of dark color in a silhouetted manner, under backlighted conditions. When used in this way, they can become an enlivening design tool (for example, rock shapes on a beach). In greater mass, they can provide a dark backdrop for a foreground subject.

Rocks that receive some sunlight on their surfaces have their planes clearly described. Often it is helpful to start off toning in masses (groups) of lit rock area and shadow rock area. Think large to small, planning the major rock surfaces in light or shadow first. Smaller rocks and surface variations within the larger rocks can then be worked. The patterns created by rock cracks and crevices call for decorative, calligraphic strokes. The better you understand the planes of rock surfaces and how this affects the lit and shadow areas, the more freely you can create rock areas. Rocks can vary in quite a range of values, so this is also a flexible element in creating your painting design.

Rocks provide a wonderful opportunity for positive–negative value exchanges. Groups of rocks can shift back and forth from sunlit to shadow areas. It may be helpful at times to simplify and eliminate some of these shifts, in order to keep your value exchanges from becoming too jumpy. Within the calligraphic work, there is also ample opportunity to echo the dark–light alternation. A crack can shift from a dark line, showing its depth, to a very light line where the sun is catching a beveled edge which may occur along the length of the crack.

Elements

Edge, Shape, and Texture Rocks' outer perimeters should be clearly defined (except where obscured by something, such as grass at their base). Creating good, solid—usually convex—shapes for your rocks will give them the weight they need. Outer edge and shape are very important because within the rock itself there can be very soft edges and textures—ideal for wet-into-wet treatment. Edges within a rock shape can be sharp (expressing angularity) or gradually gradating (expressing a curving surface), depending on the type of rock.

Texturing can be done rather freely, for it is usually approached most successfully by suggestion, rather than by detailed rendering. Spattering or dropping in paint (or water); lift-offs through scraping and sponging; stamping paint in with a sponge; dropping in salt or sand; sanding the paper surface lightly; and incising are all texturing methods for rocks. With all these options, it is best to limit yourself to two or three methods, at least for a given rock, to avoid overworking.

The rock's surface can be soft, mottled, and varied in color. One can build up texture by pulling acrylic medium or an acrylic color over the top bumps of the paper only (hold your brush at a very low angle). Allow this to dry, then wet the surface and charge in paint. It should settle in the wells. After this dries, you can even lightly sponge off the tops of the bumps to make the textural contrast even more pronounced.

Value and Color Rocks in full sunlight should usually be kept fairly high in value. Rock surfaces are quite reflective, and the lighter the value, the brighter your sunlight will appear to be.

Midday sunlight would bathe most of the rock surface in light. The rocks' shadows would be of middle value or higher, because of some reflected light from nearby surfaces (sand would boost this effect; black earth would minimize it).

Crevice areas are much darker, since very little light penetrates them.

At early or late hours, more of the rock area is expressed in shadow. Light coming from behind creates cool, dark, silhouetted shapes. This can be useful in developing strong, larger, compound shapes. It simplifies the composition. There will also be shadows, cast by the rocks, coming toward the viewer.

Value contrasts drop dramatically on overcast days. Rock masses can be created in fairly low values. Cast shadows are quite muted.

Wet rocks drop into very dark values. However, rocks on rainy days will have highly reflective, wet surfaces, so the upper planes that face perpendicularly into the light can be almost white in value.

Wet glazing can give you luminous color, yet maintain a rather neutral feel and convey the reflective surface of rocks, as they take on some of the color of the light.

Shadow areas of rocks (on them and cast by them) are luminous when created by midday sunlight. Wet glazing of warm and cool paint layers creates this exciting interplay of color. Rock shadows in the early-day sunlight are cool, in blues and violets; late-day rock shadows are cool, too, but slightly warmer than in the morning. Shadows on overcast days are somewhat warm (often brownish), in contrast to the cool light.

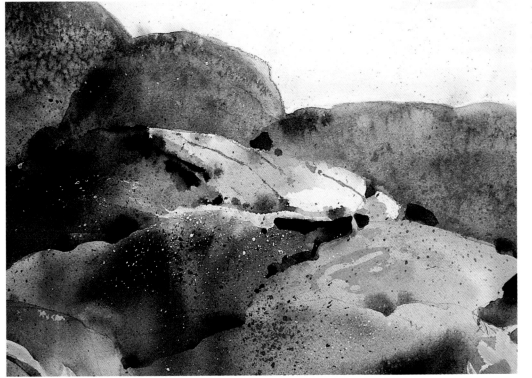

Spattering, salting, scraping, and sponging to create rock surfaces can yield quite decorative results in both texture and pattern.

Approaches

On Saturated Paper Working on saturated paper is a good way to express rocky masses under atmospheric conditions. This may involve rocks seen at a distance, allowing the atmosphere to make the less distinct edges seem reasonable for a hard-edged subject. As the paper dries, more distinct edges can be worked into the painting. Overcast lighting, with its softer shadows and transitions, is well suited for this approach.

Painting by Sections This approach is ideal for expressing the massive, well-delineated light and shadow passages on rock formations. Because you can define edges, angularity is accomplished beautifully. The soft, wet approach can be utilized within the surface areas. Flat areas of shadow patterns can be created readily, but you can also create value gradations and color reflections by charging deeper color into small areas within a wet section.

"Attaching" your rocks to the ground or calm, reflective water can be achieved by creating a fairly strongly painted area in the deeper tones at the base of the rocks. Allow this to dry a bit and then pull down with a brush, or by spraying, some of the paint into a prewetted area below, which until this point was separated from the rock by a thin line of dry paper. Your board can be flat or tilted at various angles toward or away from you to control flow, as you wish. If the base of the rock is in grass, charge in some grass or weed color, perhaps lifting out some blade shapes.

Rocks in a frothy stream will have more of a lacy bottom edge as the border between the rock and the water creates a positive–negative interchange. Sprinkle salt at first lightly and then more heavily toward the base of the rock; then, while it is still slightly wet, wipe the salt off with a damp sponge. As you move into the whiter froth, dark rock-colored spatter or spots can be sparsely touched in. When dry, whisk over these with a damp sponge to soften edges (harmonizing with the shapes left by the salt).

The Painterly Approach This approach helps create a lively surface indicative of multiple rocks, or of highly faceted surfaces, and it implies the presence of sunlight. It would usually be the dark areas (silhouettes, shadow areas, or dark rocks on an overcast or rainy day) that would be expressed by the brushstrokes; lit areas would be simply left as untouched or lightly tinted paper. For reducing the implication of strong sunlight (if you want to create an overcast or rainy scene), put in a toned underwash.

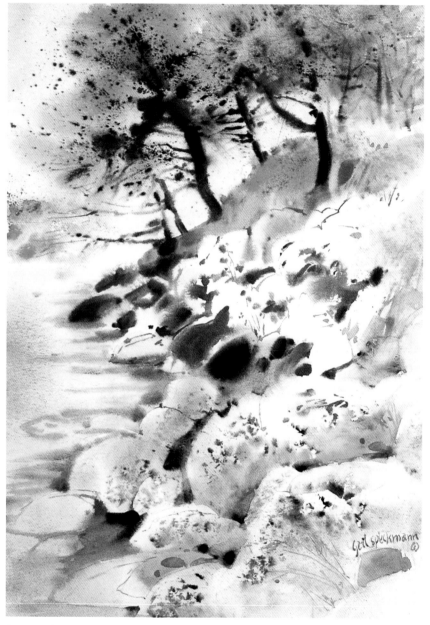

AUTUMN LAKESHORE
14 x 21"

Working on saturated paper, I used acrylics, which do not expand as greatly as regular watercolor, and achieved shapes that are quite convincing as rocks.

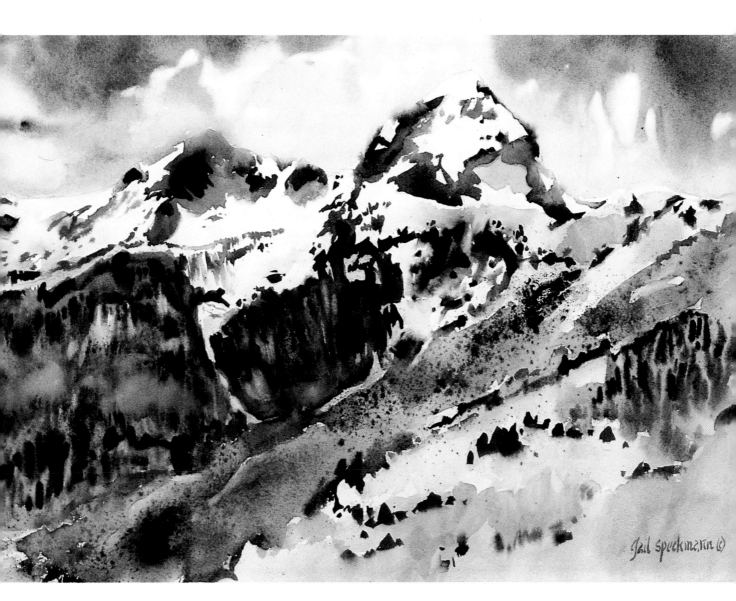

Mountains

In painting mountains, remember that by virtue of their size we are viewing them at a distance when they fit within the perimeters of a painting. It is necessary to look for the very broadest expressions of rock formation (and often snow) to capture the scene. Details that would need definition in nearby rocky forms become simple texture instead. The larger your paper surface, the more detail or dramatic texture you can include.

Angularity is often more expressive of mountains than rounded shapes are. Often, slightly irregular or "jogging" linear detail can delineate the ribs of snow and rock. To create the impression of snow, streams, or even fog, rivulets of water can be shot through granular wash passages (which have larger particles to float and separate—acrylic paint works especially well).

A saturated approach has great value for use in painting mountains, because there is an increased effect of atmosphere. Painting in sections can work well also, but it will be important to allow for some softening of edges. This can often be achieved by allowing side-by-side sections to merge their edges gently. The same need for softening edges applies to the painterly approach, so that the mountains will sit back into the distance. With calligraphic brushwork, which is painterly by nature, you can develop the linear elements.

PETER'S MOUNTAIN AIR
14 x 21"

Spatter and blotches can be very suggestive of scrubby mountain plant life or areas littered with rocks.

SNOW

Because so much of a snow scene is left white or very lightly tinted, it becomes all the more important to get the rest of the scene right, since it is so exposed. The white sets the stage for the center of interest and other areas, so it becomes very important to have well-designed shapes. Snow scenes almost automatically have good contrast, since white is a dominant value in them. Even the middle to light values have contrast next to pure white.

A snow scene also provides a good exercise in restraint. It would be a bad type of painting to overwork. Your very lightest areas are the most vulnerable to damage from the layering and lifting off that too much working involves.

Snow scenes have a built-in unifier: the white blanket covering everything. The characteristics of snow are consistent, compared with the diversity within rocks, trees, and so on. Snow is generally soft in texture, highly reflective, and defined mostly by its shadow areas or the edges where it borders other surfaces. The shadows are a great design variable. Shadow lines define the contour of the snow, the curves of the drifts and mounds, and the edges of the snow banks. The artist has some latitude in developing the surface form of the snow, allowing the creation of rather free undulations in the shadow areas.

Thawing can create some exciting patterns using contrast, particularly where streams or rocks are exposed. The snow bank along the edge of a running stream is rimmed with dark mud. Areas of earth can show through where the snow has melted. You can decide for design purposes where these features will appear. Footprints and trampled snow can likewise provide lively, and flexible, design options. Work them in where you wish to strengthen your design and to lead the eye.

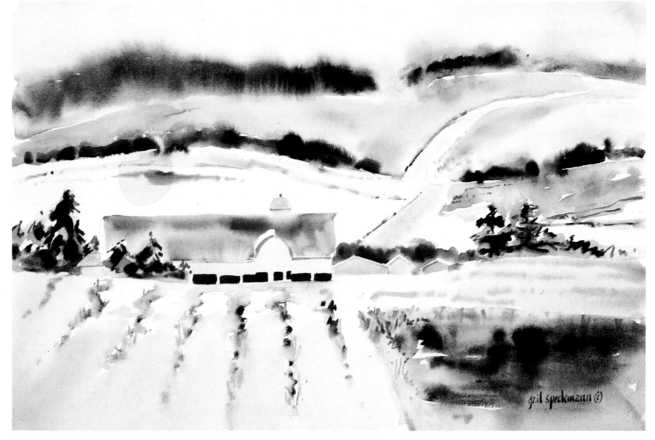

FARM AT BAKER'S
14 x 21"

Entire patches of fields (or roofs) can be exposed while others (where less sunlight reaches) retain full snow cover.

Elements

Texture and Edge In snow scenes, the edges most often seen are the shadows cast upon it. Shadows follow their own rules—darkest closest to the object which casts them, most sharply etched in the strongest light, and shaped according to the contours of the surface they fall upon. The more diffused the light, the softer the edges of the shadows will be. The surface of snow is usually flat or softly curved, yielding shadows that are straight or undulating and rarely angular.

I find that areas where snow has melted away, exposing the wet earth below, provides a great opportunity for moist, velvety edges.

Using salt, you can enhance or suggest the sparkling appearance of snow, or create the appearance of falling snow, by sprinkling it on lightly and fairly evenly. You can sprinkle it along a snow-surface edge for texturing. You can also create falling snow by spattering water into a barely damp sky wash. White paint can also be spattered into a saturated (but not too wet) paper surface. If done onto a dry surface, the paint would sit rather artificially and not blend softly into the atmosphere of the sky.

Value and Color Snow, in full light, should be white or a very lightly tinted wash. For controlled white or tinted areas, you can use the masking approach. Wet the paper surface and drop removable masking fluid along the areas you wish to retain as whites. Allow this to dry. Apply your wash and let it dry. Remove the masking. Finally, blend and tint, if desired, to soften the brightness of the white.

Snow often takes on a tint of the sky color. Early or late in the day, it can actually appear quite peach or pinkish in hue. It should grade down very close to white. During the middle of the day, there is often a warm influence to the snow color in the sunlit areas. I prefer to stay away from too strong a yellow tint, but buff titanium or jaune brilliant no. 1, and even lemon yellow, can provide suitable warm-tinted wash. If you apply, and then wash off, this tint, you can keep the color very subtle.

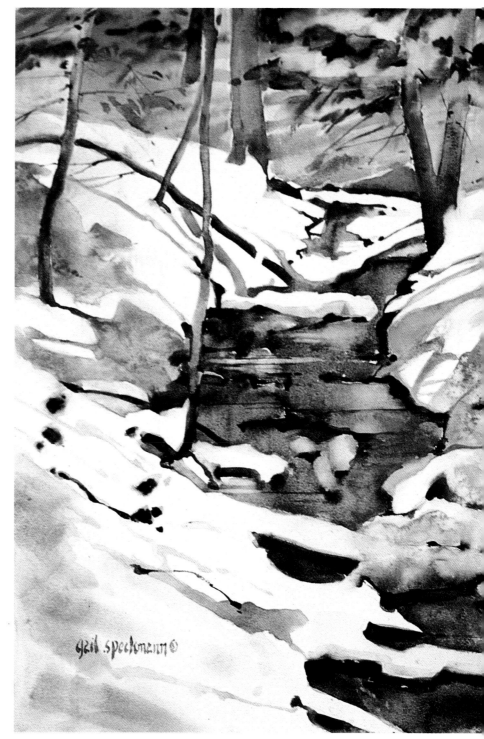

WOLDSFELD WOODS
14 x 21"

With the painterly approach I can give a brushy look to my shadow and tree renderings.

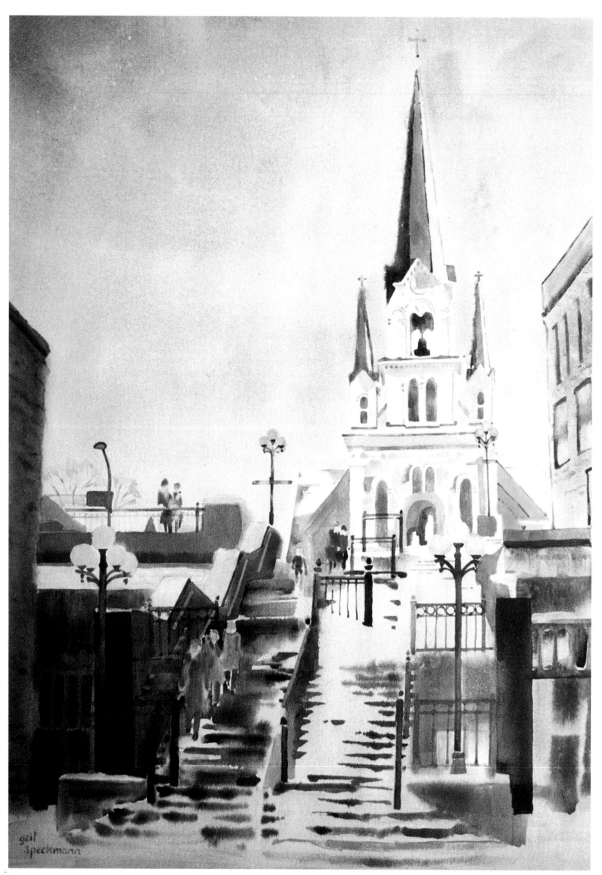

OUR LADY OF LOURDES
21 x 29"

The steps that show through the covering of snow were put in as sections.
Note the effect achieved in the bleeding of paint in the detail at right.

Washing-off technique (see pages 96–98) works nicely for the softly expansive clumps of snow on tree branches or other objects. To begin, lay down your background wash directly on the dry paper. When it is nearly dry, flick or drop in water where you want your snow "blobs" to be. (Short lines—to indicate covered branches—can be lightly pulled out of these drops with a brush or medicine dropper.) When the surrounding area has dried (you can speed this along with a hairdryer), blast off or stroke the surface with water. Where the surface remained moist, the color washes away, leaving generous white shapes.

Because snow is so highly reflective, there is much light that bounces back into the shadows. At least some portion of a snow shadow should be no deeper than a middle value. I work quite wet and grade washes representing deeply shaded large areas to a lighter value, to retain their believability as a snow.

Shadows invariably have some cool, blue influence from the sky. Late in the afternoon, snow shadows can become very blue and quite glowing. In midday sunlight, the shadows will have a luminous quality, with the warmer "color-bounce" from the sunlit areas vibrating with the cool influence. Wet glazing is the way to capture this look. Take care not to veer too far from the blue range—your shadows will lose their believability. Always make sure that some light (from your paper) still shines through.

Approaches

On Saturated Paper This approach is best suited for scenes in diffused lighting—overcast or snowing conditions. The fuzzy edges express well the nature of the falling snow and soft, sometimes deep-toned, shadow areas are created. Using thick paint, the more defined forms can be laid in. Their edges will fur softly, but the basic shape will be retained.

Painting by Sections When you seek to have broad areas of contrast, with edges of variable clarity, painting by sections would be a good approach to use. You have the ability to float in large areas of luminous shadow color through wet glazing. Edges of sections can be kept defined or be merged with one another.

An area of water can be laid down, and then color can be floated into just part of the area. This will describe a rounded shadow; the area of the water section left white is its vanishing edge. When painting snow-capped objects or heavily laden pine boughs, I paint the mounds of snow this way. Afterwards I paint in the portion of the object that still shows through the snow.

The Painterly Approach Certain parts of snow paintings lend themselves especially well to this approach. Tree shadows, with their linear calligraphy, are convincingly rendered when painted with water and then charged with color. A line of footprints or thoroughly trampled snow can have painterly, loosely brushed edges; their irregular impressions are ideal for this type of handling. Snow-laden branches, with their complexity, could be expressed with lively brushwork.

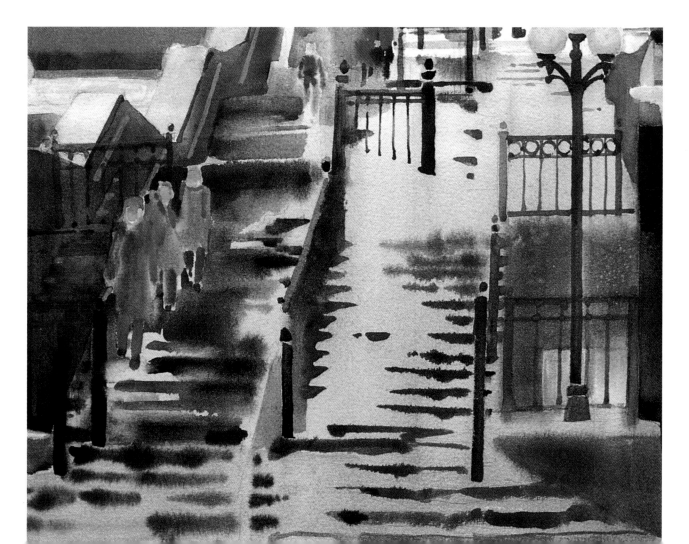

TREES

Trees provide a wonderful design tool, and you can make them grow wherever you need them, within reason. You have some flexibility in making the value of your tree foliage lighter or darker in varying degrees, to enhance your design. Even the tree shape can be used to echo or contrast with other subject matter (for example, pine trees with their angular shapes are harmonious with the angles of buildings).

In the distance, trees are treated as masses, either consisting of foliage or smoky, textured masses of bare twigs and limbs. To isolate linear elements is to demand more attention. They are like figures, already pulling our attention naturally, so we often need to subdue their presence. If you choose to make a tree the dominant element, then invest it with personality and uniqueness.

Elements

If you are painting the entire tree, the important thing is to get the outer shape, its silhouette, right. I solved a long-term drawing and design problem when I figured out that I should start by sketching or painting the tree's outline and then working out the spatial relationships within that. When I used to make my trees "grow" from the trunk outward, they invariably got larger than I intended. Painting from the top down also works well in terms of pulling down color as you work. It works with the natural flow of the paint.

Pay attention to the angles at which the limbs separate from the trunk (and so on, down to the twigs). Also be aware of the relative length of trunk to limbs to branches to twigs. The undulations of trunks and branches are usually fairly subtle. Keep them in balance or you may end up with a cartoon-like exaggeration. In twigs or in more distant tree forms, a mere wiggle of the brush may be more appropriate than pronounced curves and turns.

In trees that are fully foliated, become aware of the major clumps of foliage. Shadows where these foliage masses turn away from the light should be in keeping with their rounded forms. For soft, diffused shadows, paint them into the wet, lighter-value tones. Openings in the foliage masses often reveal branches, which disappear into the deeper shade of the tree, or sky.

The base of the trunk melds with the ground and grasses. Branches and twigs disappear into other branches, end in foliage, or make a haze of multiple twigs. Tiny, scratchy lines are inharmonious with the full shapes of wet-into-wet painting.

Trees massed in the distance should be given only enough detail to indicate their separation (paint in a few trunks or lift out the negative spaces between trunks). Keep your distant tree colors cooler or more muted.

Texture Most of the time, leaves should only be suggested by the ragged or lacy edge of the foliage masses. The leafy edges can be more visible wherever there is a significant value contrast. Up close, of course, leaves can become separate entities.

The surface texture of the trunk can be important, depending on the type of tree. Texture is most apparent where there is the greatest value contrast—usually where the shadow appears as the tree turns away from the light, or at a silhouetted edge.

Trunks and branches can be made with flat brushes or with a large round pulled along while pressed down for full contact with the paper, to keep the width of the stroke fairly consistent. If using a flat brush, one corner can be charged with a deeper color, to suggest shadow.

Studies of grouped trees. Usually subdued, such groups fit nicely into many compositions in which they are not the center of interest. Grouping them allows you to explore abstract qualities in a picture.

I often freely stroke in twigs with a script brush and then broaden the strokes (go over with a heavier stroke) that I choose to be the limbs. You can do this by first using a very light tint, and, if you are pleased with your shapes, charging in deeper color and broadening your larger branches.

Foliage or leaf masses can be created nicely by using a mop brush, laying down clear water on dry paper and then charging in paint. Large round brushes also work well. On saturated paper, I use brushes that can suggest the basic profile of the leaf mass, since the texture will simply be a soft, furry edge.

Pine needles can be painted with a fan or grass brush. Their split hair ends suggest evergreen needles. Use the brushes as they are or manipulate part of the bristle by squeezing or further separating the bristles with your fingers—I suggest wearing plastic gloves if you do this. You could also splay the hairs of a round brush by pressing on the belly of the brush and using it as a grass brush.

The spaces between trees or, in a close-up, between branches can be masked out. Then paint can be freely poured onto the exposed surface. Additional color can be charged in at various places. The spaces can be toned with a wash either before applying the masking fluid or after removing it. If the paint is allowed to dry, you can blast the surface with water (before the masking is removed) to lighten areas.

A variation on the non-brush application is to cut acetate stencil shapes of trees. When you have the stencil on your paper, spatter on clear or lightly tinted water, taking care not to expand to the edges with much density. Then charge paint in at various points, to create your tree images.

Value and Color Notice the values of tree trunks relative to those of the branches and twigs. Weather conditions and time of year can affect the values. In spring, when it is wet, the trunks often appear much darker than under drier conditions.

I am fairly free with color so long as it suggests "tree." I enjoy using wet glazing to obtain a richness of color,

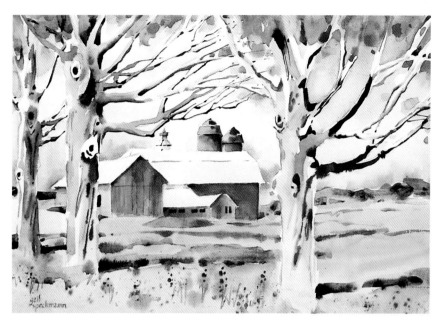

DOOR COUNTY MAPLES
14 x 21"

Trees can provide some vertical counterpoint to the horizontal planes of water, land, and structures.

often with a warm yellow or golden undertone, with the cooler color on top. Quite a range of color glazes can be interpreted as green foliage. Trunks and branches overall tend to read gray—for which many luminous glaze combinations can be created.

For a luminous backlit effect, paint the foliage masses with varied dark washes and paint in the sky glowing through the spaces with a heavier, expansive light paint (such as lemon yellow).

Try squeezing blots or spatters of lightly tinted water onto your paper. Then press down water-repellent paper, glass, or Plexiglas to increase the size and spread of the blots; lift off and then charge in colors. This should work especially well on paper that is quite absorbent (with minimal sizing); the paint is forced into the paper rather than beading onto the glass. (Try this on different papers and finishes.)

Spray droplets onto the paper and then drop in color by touching a charged brush in at various points. Run a script or rigger brush through, for the branches, while the painting is still wet. After drying it, you can rewet and gently lift off some paint to give the impression of sun overwhelming the form by shining through.

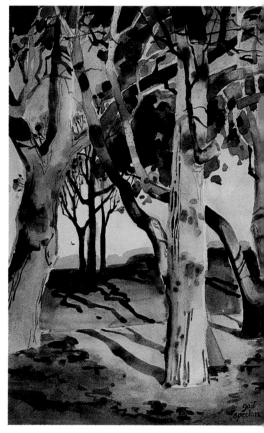

AUTUMN TREES
14 x 21"

In autumn, tree forms are exposed but the tree is both softened and enlivened by the remaining foliage.

SUNLIGHT THROUGH
THE PINE TREE
10 x 14"

*I achieved the backlighted
effect here by masking the
background areas and
pouring light colors into
dark.*

Approaches

On Saturated Paper Painting trees on saturated paper is an appropriate choice when the scene conveys misty, hazy, or snowy weather, which would obscure the sharper edges of trees. It is somewhat more difficult to use this method when bare trees are the focus, since there is a natural expansion of form on saturated paper and the linear shapes might expand beyond your wishes. The dilemma here is that it is easier to do this in a large format, and yet, the larger you work the closer the subject appears to be and thus you would expect greater clarity and sharper edges.

Painting by Sections Tree foliage would be laid in (with clear water, of course) more roughly than usual in a sectional approach because you need a loose, lacy edge. Color could be charged in a light value, and then deeper color, suggestive of foliage, could be dropped or dappled in. Trunks and branches would be sectioned in with cleaner edges, using clear water and then charging in paint. Wet glazing can be utilized to great advantage for rich color.

The Painterly Approach This approach enhances the lively surface of the foliage. The effect is busier, emphasizing multiple shapes of leaves merging into larger masses but broken in appearance. Dappled light on the trees, falling leaves in the breeze, and filigreed foliage are depicted readily in the painterly method.

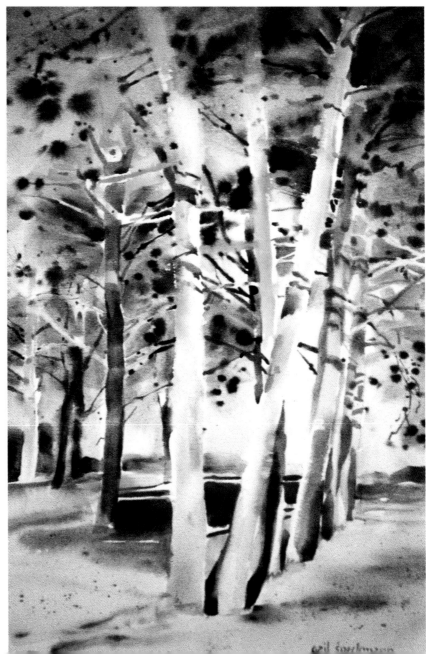

ENCHANTED WOOD
21 x 14"

*Leaves can be suggested by
texturing—spattering,
droplets, or dash-like strokes.*

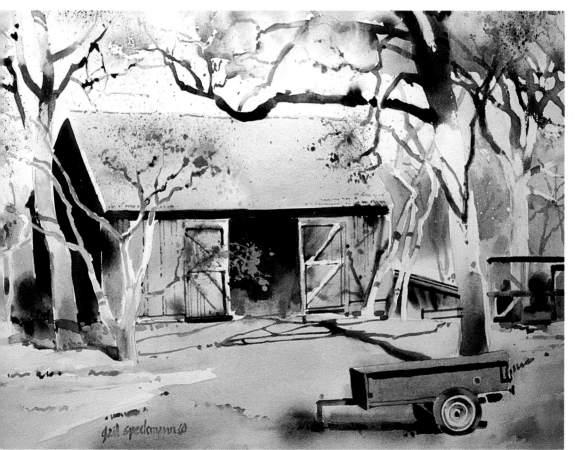

CROSBY FARM
14 x 21"

Trunks and branches can be painted with a flat brush such as the one-stroke or with a larger round. Pull the brush along while pressing it down for full contact with the paper. This will keep the stroke consistent.

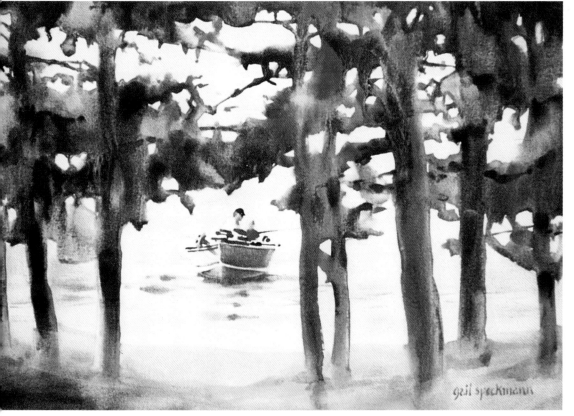

NEIL'S BOAT
14 x 21"

Here paint was charged into clear-water sections that are loose and ragged for foliage and clean-edged for the trunks.

STRUCTURES

Buildings, boats, and other angular, architectural forms present a challenge when painting wet-into-wet: the structure must be believable and yet the lush feeling of the process should be incorporated into them. We will not discuss architectural perspective or the structures themselves here—there are many good books devoted to these subjects—but simply how to handle these motifs within the format of the wet-into-wet process.

When you work with structural forms, you are working with subjects that are quite precise. Your variables are in your viewpoint and your lighting more than in the subject itself. Once you have selected your subject, then you are faced with choosing which details to keep and which delete or obscure. The simpler you can keep the structure, the more you can suggest without filling in all the details, the better. Determine which details are crucial and which are not. This applies both to the main shape of the structure and the shapes within it. For instance, it is more important to show the peak of a roof than a portion along the horizontal roofline, which could be lost in foliage. You can show the door to the building without needing to render its frame or the clapboard siding.

The salient details, or ones that you choose as your accents, can be put forth forcefully with strong edges and good value and color contrast. That part of detail work can be the final boost to give your painting the punch and impact it needs. The problem that artists often face is wanting to put in all the detail with the same degree of weight and importance. The detail becomes too soft and blending, or it tends to be overly demanding and strident. Artists also try to replicate too directly exactly what they see without making design decisions, and thus include too much.

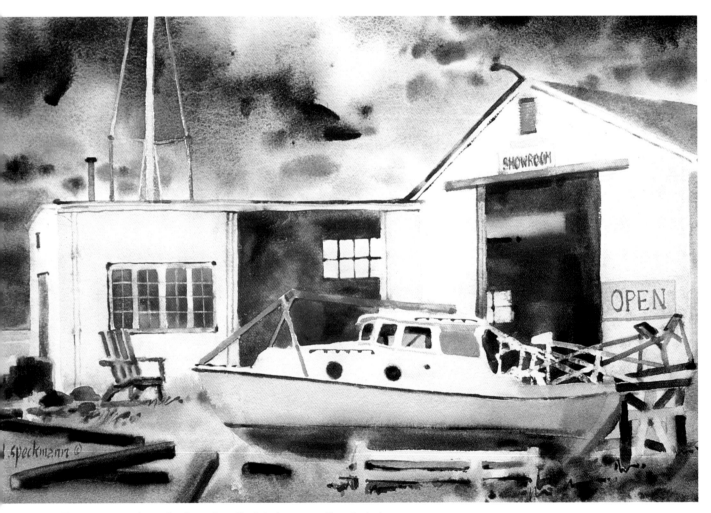

BOATYARD
14 x 21" *An underglaze gives the interior areas, though dark, a warmth that contrasts with the cool exterior light.*

You can soften the impact by unifying abundant detail with an overglaze. Detail can be de-emphasized by keeping it in low value contrast to its surrounding area. The viewer's eye can fill in the blanks. Also, grouping details, or setting them into a rhythm, helps keep the eye circulating and not getting hung up on separate strokes. You can simply suggest a little detail—it may appear that the rest is there, but just lost in a bleaching sunlight or in shadow.

For distant subjects, detail can sometimes be represented by texture rather than by specific linear work.

Elements

In its most simplified form, a structure may appear as a silhouette. For a complex subject, this backlit treatment may provide a good way of handling its magnitude. It also provides drama. Another way of keeping simplicity (if you choose) in your subject is to downplay value changes within the structural form; even if they are very high-key for the light subject or low-key for the dark subject, they will read correctly.

Because structures sit on the ground or water, but project up into the air, the upper edges should have stronger definition, provided by value and edge contrast. Their side edges often touch or merge with other structures, creating more complex forms. Their bottom edges are anchored to the plane they rest upon, and it is often appropriate to merge midtones of the structures to midtones of the earth or water below. The lower part of the object often is the receiver of reflected light, thus being somewhat lighter in value than the upper edge of the structure.

Interior and Exterior Light
Whether you are looking from an interior to the outside area (as in a still life with a window backdrop), or from outside the structure to the interior, if the light outside is cool, then by contrast the light of the interior should have warmth to it; the reverse would be true also—warm exterior, cool interior. Even if the interior is dark, a warm underglaze of color lends warmth. The exception to this would be when windows reflect back an image or light from outside.

Planes and Dominant Shapes
Upward-facing planes, such as roofs and boat decks, are often light in value as they receive the full force of the light. Overhang areas are not always dark or gray, being the receivers of reflected light or "color-bounce" from the plane below. Shadows across the face of a structure can be very descriptive of the form's changing planes. If the structure is side-lighted, shadows will account for all or most of the detail you need to furnish.

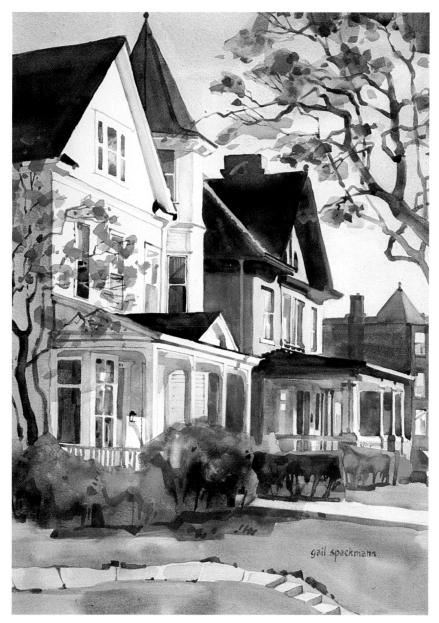

THE OLD GUARD
21 x 29"

Patterns of warm and cool color occur as planes of architectural forms face one way and then another, resulting in pleasing temperature contrasts. Here, note the far-left cool shadow of the house and the warm color-bounce on the porch.

If you wish to soften the angular architectural lines, look for elements within the building shapes that are more flowing—arches, flowery window boxes, sagging roofs. You can also minimize the effect of the sharp angles by reducing value contrast at those points.

Approaches

On Saturated Paper Lay in the groundwork for buildings by approximating the colors and forms you will ultimately desire. Edges that are more defined can be added later. Areas that need strong contrast of edge and value can be masked, then softened later to harmonize with the surrounding areas. Sharper edges can

also be put in by lifting paint. I tend to use the saturated approach in a painting which emphasizes overall softness and atmosphere, not one which really wants to play up the architectural qualities.

Painting by Sections This is the best approach to use for an exciting interplay of architectural shapes, often accentuated by light and shadow. Starting at the upper areas, which are more clearly defined against the background, color can be pulled down into continuing structural shapes and on into the base, where color can be merged into the ground.

Bleeding together areas of like value in side-by-side joinings also

contributes to the fresh and fluid look. Overglazing or underglazing can have a unifying effect.

When varying paint along the length of a section, consider holding the value fairly constant and simply vary the hue, unless it makes sense for the value to shift.

The Painterly Approach The definition of forms may be more freely executed using the painterly approach. Lively brushwork is emphasized, so somewhat loose, disjointed strokes, merely suggestive of architectural lines and details, might be in order here. One way to employ the painterly approach is to make brushstrokes apparent even within large, solid-appearing masses.

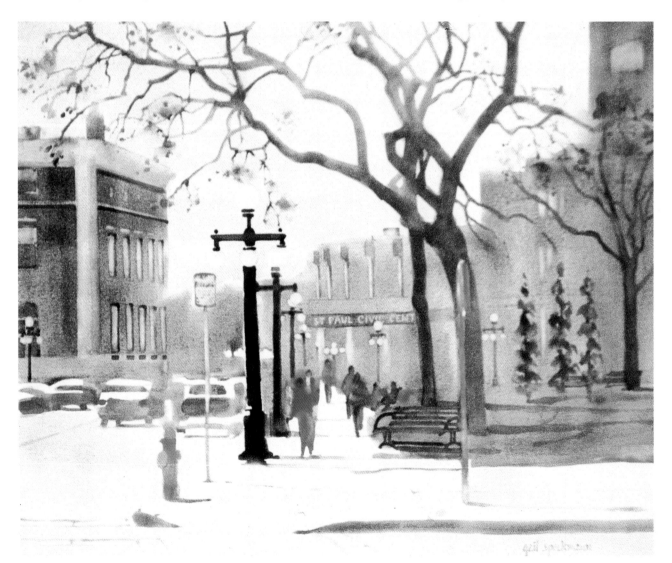

ORDWAY *Starting with a saturated approach will lend atmosphere and mood to a cityscape.*
21 x 29"

*In these street
scenes, crisp
sections are fluidly
colored and glazed,
keeping them fresh
and glowing.*

Shopping
19 x 29"

FLOWERS

Years ago, while in the florist business, I rarely painted flowers. My days were filled with them—who needed more? But after I left, I kept trying to paint them back into my life.

Flowers provide us with an opportunity to analyze geometric forms and re-create them with brushstrokes. The flower heads are often compound geometric forms, the leaves often simple forms. Moreover, bold geometric background shapes can offset the busier floral shapes, showing them off to advantage.

I like to utilize stems and leaf shapes as "stage setters," providing rhythm and repetition and leading the eye to the focal point—the blossoms themselves—and through the painting. Varying the directions and sizes of flower heads and leaves contributes to the rhythm and animation of the design. Unifying foliage into strong shapes whenever possible generally keeps them from becoming too fussy.

HARPER AMARYLLIS
21 x 29"

I save the greatest value contrasts and most exciting color and calligraphy for the blossom.

RED AMARYLLIS
21 x 27"

I prefer close-ups of flowers. I love their geometry, and this can be best expressed at close range.

Value and Color

In designing a floral picture, the main challenge is to avoid having your subject read simply as a light object on a dark background, or vice versa. I try to concentrate, for one thing, on "weaving" the foreground and background areas together by alternating light and dark portions in each. Looking creatively at the space around the flowers and foliage, to carve good shapes for these areas, is another resource. A variation of edges, now vanishing, now crisp, thus seeming to project or recede, locates them in a foreground or background space and also helps prevent isolating your subject.

To bring out the vibrant colors of flowers, it is helpful to keep the background colors more subdued. Pulling some of the floral color into the leaves can help unify your subject.

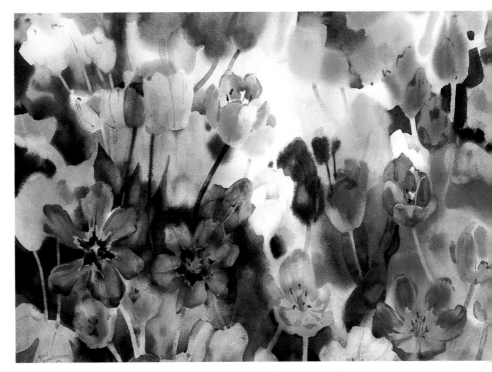

SOMMERSTAD TULIPS
21 x 29"

"Lost and found" edges between foreground and background prevent the isolation of a floral subject, a common problem.

In this detail, note how the subdued complementary background brings out the yellows of the blossoms.

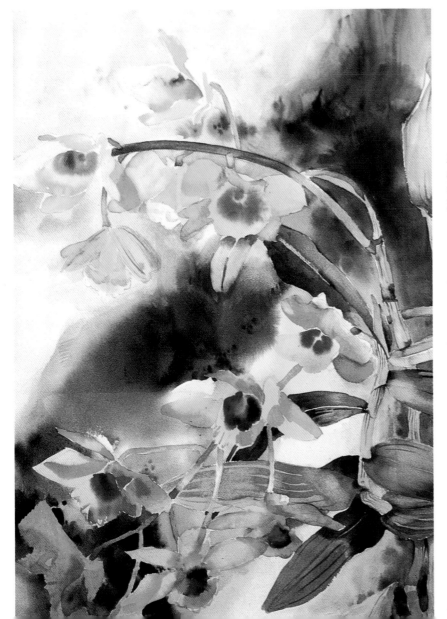

Approaches

On Saturated Paper The soft-edged, expansive shapes typical of painting on saturated paper automatically suggest floral forms. Flowers that nicely lend themselves to this treatment include tulips, irises, pansies, and roses. As you move from loose, blurred shapes when the paper is wettest to more defined shapes as the paper loses moisture, think about clarifying important edges. I often choose the saturated approach when I want a repeated, overall design and atmosphere. I would not choose this approach if I wished to emphasize light and shadow contrasts of strong directional lighting (discussed under "Still Lifes," pages 138–139).

Painting the background, including distant floral shapes, on saturated paper is very effective. The foreground floral can, by contrast, be painted in either a section-by-section or painterly approach.

Painting by Sections This approach provides for the greatest shadow and sunlight opportunities. I like to link shadows and do a lot of wet glazing within them and also pull color down from upper sections to link them to what follows.

Crisp, contrasting edges and details and luminous glazed passages are the hallmarks of this approach. Even the sections of very light values can be rich with color and clearly defined. On the other hand, hazy, receding edges can be created easily as a wet edge is joined to another or graded away into clear water. Maintaining a variation of edges, balancing between sharply defined edges and receding, "lost" edges, is a technical challenge of which to be mindful, for it lends beauty to almost any floral painting. Flowers which are well matched to this approach include amaryllis, lilies, sunflowers, and other varieties which have sharp or angular shapes.

The Painterly Approach The brushstroke and geometric form are fused in this approach. It is excellent for emphasizing the parts of the flower—petals, leaves, stems. Small flowers, such as wildflower varieties, or compound flowers (sweet peas, delphiniums, lilacs), can be put together with clear-water strokes that you charge with lively colors.

Painterly technique can capture the quality of flickering sunlight, suggesting the fleeting moment. It is a good idea, though, to leave some less active passages—larger areas of unbroken color—for balance and unity.

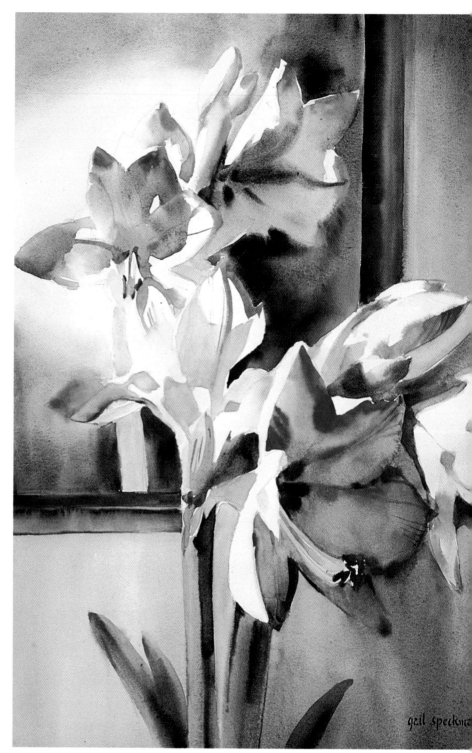

REFLECTION
21 x 29"

Painting by sections, you can rim petal edges with another color as the outside area (bordering the dry paper) stays defined. Within the blossom the color can bleed softly.

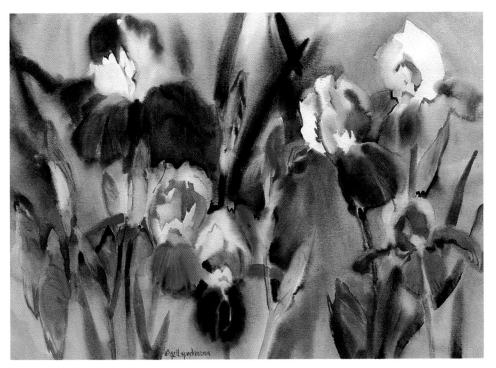

SJOLANDER IRIS
21 x 29"

Saturated paper is ideal for painting irises, but give clarity to edges (see top right) to avoid monotony.

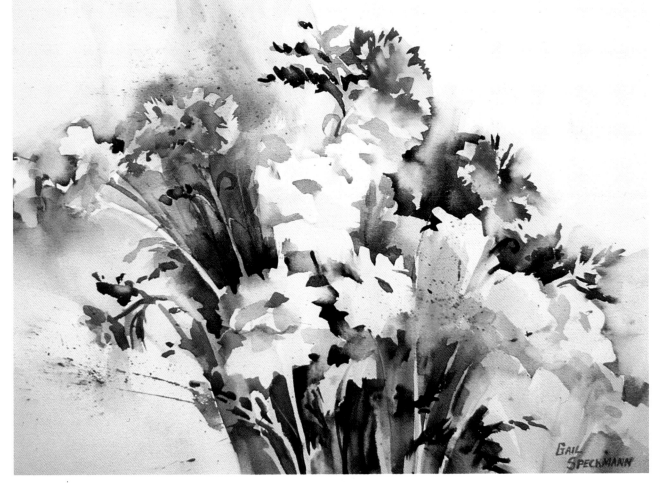

SUMMER'S OFFERING
17 x 23"

You can almost feel the breeze blowing because the painterly approach has imparted a vibration to these delicate flowers.

STILL LIFES

Because you can control so many factors (choice of objects, placement, lighting) that cannot always be controlled in other genres of paintings, still life provides a great opportunity to develop good compositional skills. Often, a good still-life setup can work well from many different angles and under various lighting conditions. I encourage you to continue to explore these options before settling on your chosen view. Sometimes, I find it helpful to set my arrangement on a sheet of Fomebord supported by a heavier board. Then I can move the arrangement around to see different lighting and background options. (Another option is to move around your light source, assuming it is not the sun.) If you want to introduce reflected light or color-bounce into shadow areas, you can set up a white or strongly colored board at approximately a right angle to your light source.

Color, Value, and Light

There is no end to the objects you can place in a still life. What is easy to forget is that the background is also a major element of the picture. If designed well, it will be an integral, harmonious part of the picture.

If the still life fills the frame to some or all of the edges, the background is best kept simple and in contrasting value to the subject. If the subject is more isolated within the picture, it may be better to "weave" it into the background, through color, value, and shape similarities, still leaving sharp value contrasts around the most important edges. A somewhat graded effect also works, though, as you let same-value color bleed out from the objects, then gradually shift into more contrasting value and color in the background; something of a halo effect derives from this.

Also, a background that alternates, so that light foreground objects appear against darkness and dark foreground objects appear against light areas, provides interest and visual diversity.

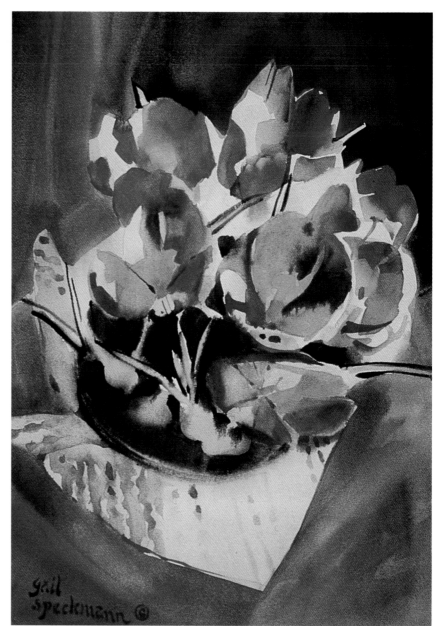

CROCUS
10 x 14"

Sharp value contrasts maintain important edges as, overall, the still life is integrated by color to the background.

For me, strong directional lighting that yields light-and-shadow contrast is the heart and soul of a still life. Light and shadow define three-dimensional forms, and still lifes are quite shallow in depth; there is scarcely any opportunity for atmospheric effects of distance on color and value.

With backlighting, subjects are often simplified and united by the deep values of shadow. An intriguing exception arises when light behind translucent objects—such as flower petals—causes them to take on a glow. If the immediate area behind the object is dark, you can create an exciting contrast, especially if the

dark area is an object silhouetted against a light background.

Sidelighting casts long shadows. If your lighting is directly from the side, your objects may be too evenly divided between light and shadow to be interesting. With frontal lighting, shadow is often virtually eliminated. The effect is very flattening.

The closer and more dead-on the light, and the brighter and more intense it is, the lighter will be the values of the objects in your still life. Color can bleached out. Then you will find your richest color in the shadows. If there is a single, strong light source, the shadows will also be dark. These, however, can be glazed with reflected color bouncing off nearby walls and other objects. If you have your most intense color in lighted areas, then your shadows can be darker and charged with a cool color for contrast, and can even be somewhat opaque.

Two or more sources of light illuminate shadow areas to a greater or lesser extent, thus bringing up the values.

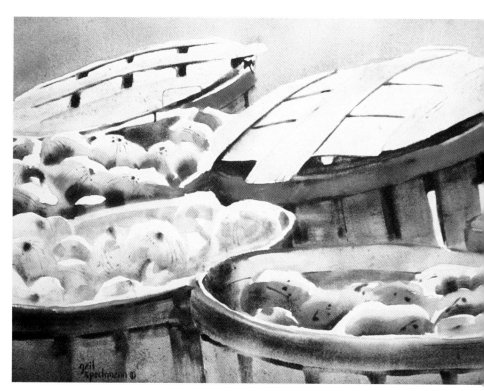

PRODUCE
16 x 21"

Backlighted objects are sometimes rimmed by edges that catch the light.

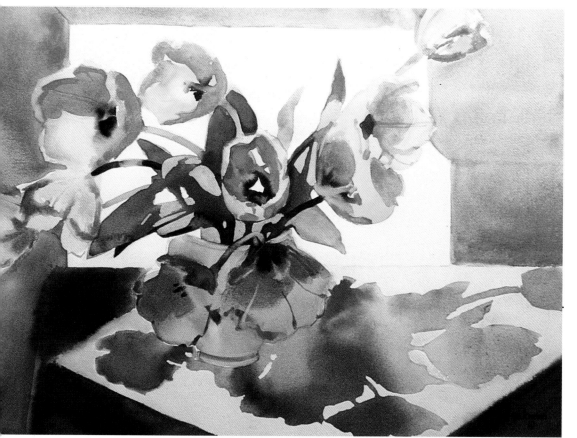

TULIP SHADOWS
21 x 29"

Overhead lighting on hollow shapes such as tulips provides distinctive shadows that "skirt" the bottoms of the objects.

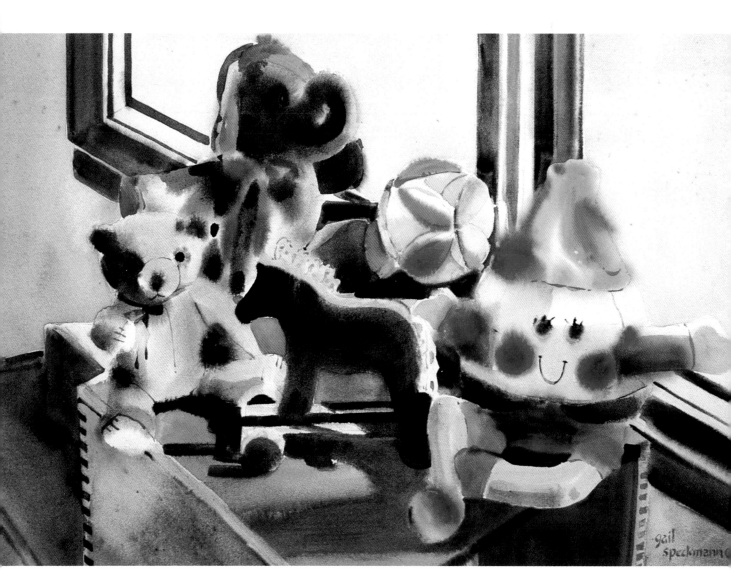

FAVORITE TOY
14 x 21"

I prefer the sectional approach for the fairly flat design of the still life.

Approaches

On Saturated Paper Because the subject is close at hand and there is little opportunity for hazy atmospheric effects, we should reserve this approach for subjects in diffused lighting or with soft edges. As the paint moves to the damp stage, greater detail can be laid in with less diluted paint. For definition of forms, try lifting out areas, perhaps by sponging from within acetate stencil shapes after the paint has dried.

Painting by Sections Because much of what still life is about is shape, the sectioned method is ideal. The clearcut light and shadow areas are attainable with plenty of opportunity for luminous wet glazing, as shadows move down or across the paper. Side-by-side sections can be joined with a damp brush, allowing their edges to intermingle. This can be done to merge areas of like value, or when you want an expansive color to radiate into a neighboring shape.

The Painterly Approach This approach captures the dappled quality of light on a still life scene and can be used to advantage when painting many-faceted surfaces or complex forms. Areas that are lively with brushmarks may need to be balanced by some large areas of calm. If done in loose or rough-edged sections, these balancing areas harmonize with the more brushed-looking strokes.

WISHING YOU WELL
10 x 14"

For still lifes lit by diffused light, the saturated approach works best.

SWEET PEAS
10 x 29"

Complexity of form is communicated more successfully using the painterly approach.

SHADOWS

There are two basic types of shadows: (1) the shadow created *on* an object itself—the portion where light cannot reach—and (2) a "cast" shadow—one created by an object blocking the path of the light's rays—that extends outward *from* the object.

Shadows are a flexible design element that can tie a painting of unrelated objects together. Patterns of light and shadow, while descriptive of shape and dimension, are decorative at the same time. When you change the light direction and thus the shadows, you can entirely change your picture design. Once we understand some of the principles of shadows, we can improve upon a design by altering the lighting within it.

Cast shadows are heavily influenced by the color of the light—for instance, the bluish light of the sky. Shadows on objects are altered by light hitting other surfaces nearby and then bouncing into the shadow. If the area from which light bounces is of a strong color, this color can be infused into the shadow on the object.

The Light Source

One needs to be aware of the quality of the light creating the shadows. Frequently this is sunlight, which is affected by the time of day, the season, and the geographical location. The higher in the sky the sun is, the whiter (or pale yellow) its light tends to be; the lower in the sky, the more golden and even orange-red it becomes. When the sun is very high (as at noon, in summer, or near the equator), color bleaches from sunlit surfaces, and shadows provide the liveliest color. It is best to create rich, luminous shadows, where cool and warm vibrate against each other. This is done nicely through wet glazing. Bright-day shadows have a lot of color bouncing into them, and their edges are sharply defined. Paintings of this type of daylight are expressed well in high-key, true hues.

When the sun is low in the sky (in early morning and around sunset, during the winter, and away from the equator), contrast is provided from raking light. Cast shadows are long and descriptive of the terrain. Shadow edges are sharpest near the light source, becoming more diffused farther away. The warm-colored light gives surfaces a luminous glow. Shadows, in contrast, are cool—bluish or violet—and somewhat opaque. In misty conditions, the more distant shadows are veiled as the atmosphere reflects the golden light. When this occurs, you will notice less value contrast between the lit and shadow areas.

Elements

Texture and Edges Of course, cast shadows are influenced by the surface upon which they fall. For instance, a shadow cast on pebbles would exhibit a rough texture and edge. Also, as a cast shadow extends out from the light source, its edges become less defined. This can be approached by first sponging some water onto the far end of where the cast shadow will fall, then lifting progressively more moisture as you move along the shadow area, leaving dry paper closest to the object which casts the shadow. Then you paint in the cast shadow, moving from the dry to the damper area, where more diffused edges are the result.

It is generally best to keep the texture soft and fluid-looking within shadow areas. Textural interest can be added with wet-into-wet spattering or stippling of color.

Value A common mistake made by artists is creating cast shadows that are too dark throughout their length; these appear too "cut-out." The area nearest the object casting the shadow can be quite dark, but the shadow should lighten as it moves away.

Shadows can show a gradual modeling of values, whereby the core of the shadow appears darkest while progressively lighter bands or rings surround it. This can occur in shadows cast by more than one light source (interior lighting), or because of the movement of the object casting the shadow—a flickering effect, as from tree branches in a breeze. These shadows can be created by painting your broadest band of

WINTER SHADOWS
14 x 21"

Shadows describe the shape of the forms that they fall upon. Note the rounded tree trunks and the gentle curve of the snow on the uphill ground.

shadow with your thinnest tint and charging in several narrower but more saturated bands of color. You can let the paint dry between bands, then wet each inner band with clear water and charge in color. Loosen edges here and there, if desired.

If you want to create the appearance of strong midday sunlight, keep your shadows fairly light in value by rimming their edges (while still wet) with a deeper value or with a temperature contrast to the lit areas. This will accentuate the shadows without making them too dark.

Approaches

On Saturated Paper The soft shadows of overcast-to-rainy days, of indoor lighting, and of misty atmospheric conditions are executed in this approach. Shadows can be laid in either very wetly for softness, or with greater degrees of firmness and clarity as the moisture is leaving the paper. Shadow edges can be sharpened after the paint is dry by lifting edges with a damp bristle brush or sponge (even sharper if you use a stencil edge to sponge away from).

Painting by Sections I use this approach particularly when there are fairly uninterrupted large shadow areas that call for the crisp edges of midday sunlight. Painting by sections lends itself well to linking shadow areas. If your painting design favors flat areas of color, linked shadow areas will help describe form and lend the picture depth.

The Painterly Approach If shadow patterns are somewhat intricate, paint them first. You can make adjustments and changes more easily on plain white paper than on a more easily disturbed underwash. Once it is dry, you can wash any color over that. Otherwise, paint your wash color(s) in acrylic. Then, when you are working your shadow area, you can make changes without disturbing that layer.

Painting by sections is ideal for colorful wet glazing of shadows, as this detail of a still life shows.

BOOKS
10 x 14"

Color within shadows can be used as a design tool to connect objects within a painting. Here, in the shadow on the apple, the color of the sunlit book is reflected. Indeed, I have done this more freely than reality suggests, to animate the color in the painting.

INDEX